Theronimus bolch

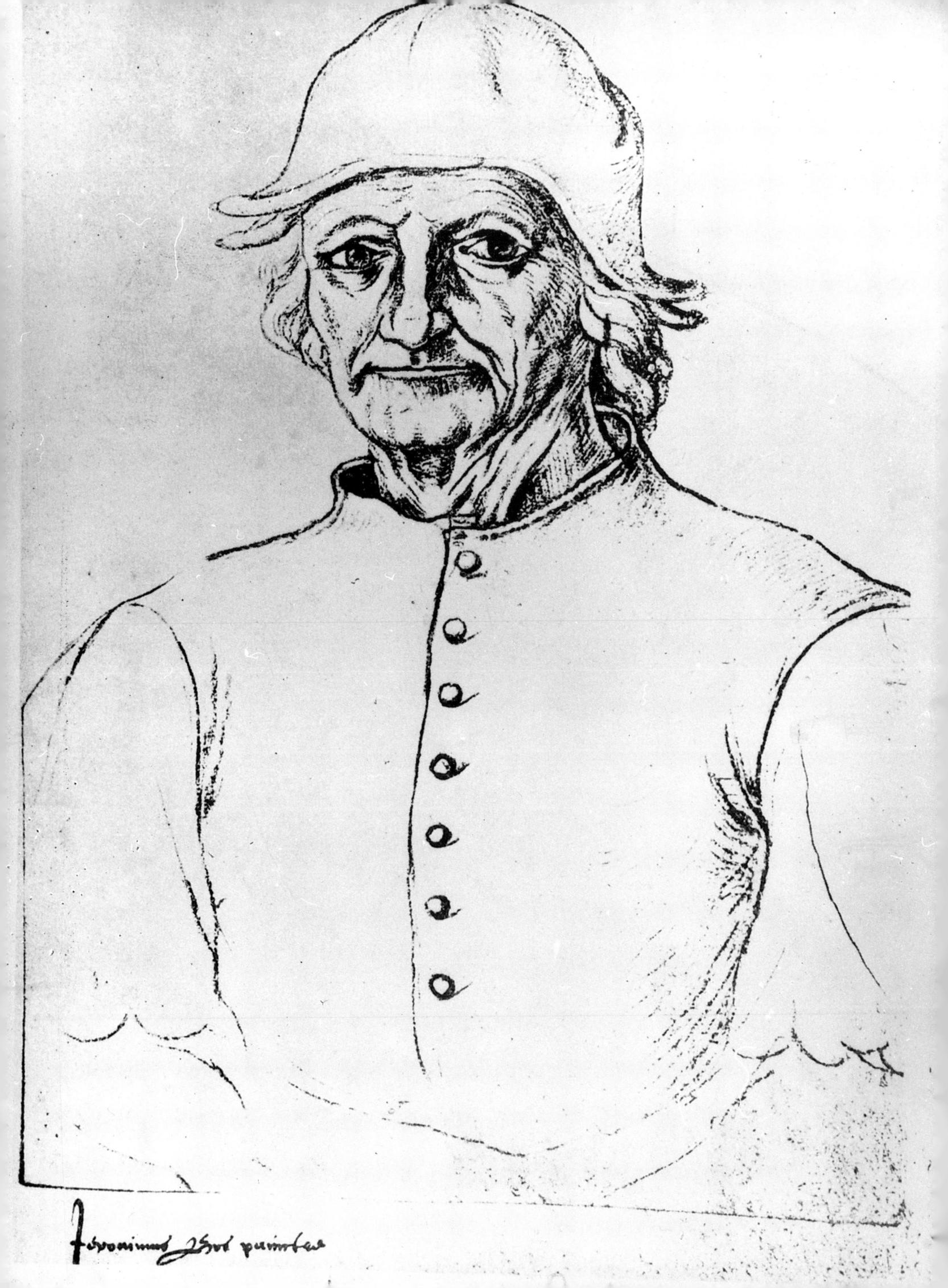

Walter Bosing

HIERONYMUS BOSCH

c. 1450-1516

Between Heaven And Hell

FRONT COVER:

Flight and Failure of St. Anthony (Detail) Left wing of the triptych "Temptation of St. Anthony" Oil on panel, 131,5 × 225 cm Lisbon, Museu Nacional de Arte Antiga

PAGE 2 AND BACK COVER:

Portrait of Hieronymus Bosch(?)

Pencil and sanguine, 41 × 28 cm Arras, Bibliothèque Municipal d'Arras

This book was printed on 100 % chlorine-free bleached paper in accordance with the TCF standard.

© 1994 Benedikt Taschen Verlag GmbH Hohenzollernring 53, D–50672 Köln © 1973 for the text by Thames & Hudson Ltd., London Edited by Ingo F. Walther Cover design: Angelika Muthesius, Cologne Printed by Druckhaus Cramer GmbH, Greven

> Printed in Germany ISBN 3-8228-0563-7 GB

Contents

7 Introduction

11 Life and Milieu

17 Artistic Origins and Early Biblical Scenes

25 The Mirror of Man

33 The Last Judgement

45 The Triumph of Sin

61 The Pilgrimage of Life

69 The Imitation of Christ

79 The Triumph of the Saint

Introduction

The strange world of Hieronymus Bosch ist best studied in the Museo del Prado in Madrid. Here, in one of the upper galleries, are gathered no less than three major altarpieces and several smaller pictures by Bosch and his workshop. They present a dramatic contrast to the other Netherlandish paintings hanging in the room. The coolly observed and precisely rendered details of Robert Campin's »Betrothal of the Virgin« and the dignified restraint of Roger van der Weyden's »Descent from the Cross« have nothing in common with the devil infested landscapes of Bosch's »Haywain« or his »Garden of Earthly Delights«. The art of the older masters is firmly rooted in the prosaic, substantial world of everyday experience, but Bosch confronts us with a world of dreams, nightmares in which forms seem to flicker and change before our eyes.

Bosch's pictures have always fascinated viewers, but in earlier centuries it was widely assumed that his diabolic scenes were intended merely to amuse or titillate, rather like the »grotteschi« of Italian Renaissance ornament. Philip II, it is true, collected his works more for edification than for entertainment, but the Spanish were in the minority. As the Spaniard Felipe de Guevara* complained in the earliest account of Bosch's art, written about 1560, most people regarded him merely as »the inventor of monsters and chimeras«. About a half-century later, the Dutch art historian Carel van Mander* described Bosch's paintings chiefly as »wondrous and strange fantasies…often less pleasant than gruesome to look at«.

In our own century, however, scholars have come to realize that Bosch's art possesses a more profound significance, and there have been many attempts to explain its origins and meaning. Some writers have seen him as a sort of fifteenth-century Surrealist who dredged up his disturbing forms from the subconscious mind; his name is frequently linked with that of Salvador Dali. For others, Bosch's art reflects esoteric practices of the Middle Ages, such as alchemy, astrology or witchcraft. Perhaps most provocative, however, are the attempts to connect Bosch with the various religious heresies which existed during the Middle Ages. An example can be found in the thesis proposed by Wilhelm Fraenger*. Because of their popularity, Fraenger's theories deserve consideration; they also vividly illustrate the problems encountered in interpreting Bosch.

According to Fraenger, Bosch was a member of the Brethren of the Free Spirit, a heretical group which flourished throughout Europe for several hundred years after their first appearance in the thirteenth century. Little is known about this sect, but it is supposed that they practised sexual promiscuity as part of their religious rites, through which they attempted

The Tree ManPen and bistre, 27,7 × 21,1 cm
Vienna, Albertina

^{*} Felipe de Guevara: »Commentarios de la pintura«, Madrid 1788.

^{*} Carel van Mander: »Das Leben der niederländischen und deutschen Maler«, München/Leipzig 1906.

^{*} Wilhelm Fraenger: »Hieronymus Bosch. Das Tausendjährige Reich. Grundzüge einer Auslegung«, Coburg 1947. – »The Millennium of Hieronymus Bosch. Outlines of a New Interpretation«, Chicago 1951, London 1952.

Head of a Woman (Fragment)Oil on panel, 13 × 5 cm
Rotterdam, Museum Boymans-van Beuningen

to achieve the state of innocence possessed by Adam before the Fall; hence they are also called Adamites. Fraenger assumes that the »Garden of Earthly Deligths« was painted for a group of Adamites in 's-Hertogenbosch, where Bosch lived, and that the unabashedly erotic scene of the central panel represents not a condemnation of unbridled sensuality, as is generally believed, but the religious practices of the sect. Fraenger has also linked other works by Bosch to the Adamites and their doctrines.

Although most scholars object vigorously to Fraenger's thesis, it has received widespread attention in the public press and popular magazines where, in fact, the central panel of the »Garden of Earthly Delights« is reproduced almost as frequently as the »Mona Lisa« and the »Night Watch«. The great appeal of this interpretation lies partly in its novelty and its sensational character, but even more in the fact that it accords well with twentieth-century conceptions of free love and uninhibited sexuality as positive values in themselves, and as remedies for various psychic and social ills. Indeed, one advocate of what might be called "therapeutic sexuality", Norman O. Brown (»Love's Body«, 1966), points to Bosch's »Garden of Earthly Delights« as an illustration of his own theories put into practice.

Despite the attraction which Fraenger's interpretation exerts on modern sensibilities, however, his basic premise is very questionable. We have no historical evidence that Bosch was ever a member of the Adamites or that he painted for them. In fact, the last certain reference to this group in the Netherlands appears at Brussels in 1411. But even if the Adamites survived somehow undetected into the early sixteenth century, Bosch himself can hardly have been anything other than an orthodox Christian. He was a member of the Brotherhood of Our Lady, a guild of clergy and laity devoted to the Virgin Mary and quite different from the Brethren of the Free Spirit. Bosch executed several commissions for this brotherhood and was also patronized by highly placed members of the Church and nobility, one of whom probably commissioned the »Garden of Earthly Deliaths« itself. The religious othodoxy of these patrons can scarcely be doubted. After the middle of the sixteenth century, a number of Bosch's works, including, once more, the »Garden of Earthly Delights«, were acquired by the most conservative Catholic of them all, Philip II of Spain. This was the time of the Reformation and the Counter-Reformation, when the Inquisition took on new life and men everywhere were peculiarly sensitive to guestions of dogma and doctrine. Thus, it is highly unlikely that Bosch's pictures would have been acquired so avidly had there been any suspicion that he was associated with any heretical sect. Only towards the end of the sixteenth century were his works regarded by some in Spain as »tainted with heresy«, but this charge was soundly refuted by the Spanish priest Fray José de Sigüenza in 1605.

Fraenger's theories may thus be dismissed for lack of historical proof. The attempts to see Bosch as a secret adept of one of the more esoteric arts can be challenged on similar grounds. This ist not to deny that he may have derived some of his imagery from these sources; but the assertion by some writers that he was a practising alchemist, for example, cannot be proved. Equally unfounded are suggestions that Bosch painted under the influence of hallucinogenic drugs.

^{*} Dirk Bax: »Ontcijfering van Jeroen Bosch«, 's-Gravenhage 1949. — »Hieronymus Bosch, his picture-writing deciphered«, Rotterdam 1979.

Finally, the tendency to interpret Bosch's imagery in terms of modern Surrealism or Freudian psychology ist anachronistic. We forget too often that Bosch never read Freud and that modern psychoanalysis would have been incomprehensible to the medieval mind. What we choose to call the libido was denounced by the medieval Church as original sin; what we see as the expression of the subconscious mind was for the Middle Ages the promptings of God or the Devil. Modern psychology may explain the appeal Bosch's pictures have for us, but it cannot explain the meaning they had for Bosch and his contemporaries. Likewise, it is doubtful that modern psychoanalysis can help us to understand the mental processes by which Bosch developed his enigmatic forms. Bosch did not intend to evoke the subconscious of the viewer, but to teach him certain moral and spiritual truths, and thus his images generally had a precise and premeditated significance. As Dirk Bax* has shown, they often represented visual translations of verbal puns and metaphors. Bosch's sources, in fact, should rather be sought in the language and folklore of his day, as well as in the teachings of the Church. If we examine the »Garden of Earthly Delights« and his other pictures within the contemporary culture, we will discover that, no less than the altarpieces of Robert Campin and Roger van der Weyden, Bosch's art mirrored the hopes and fears of the waning Middle Ages.

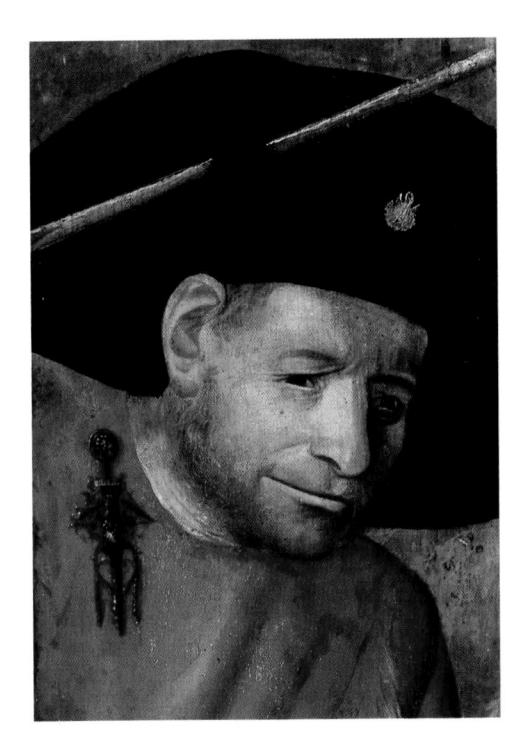

Head of a Halberdier Oil on panel, 28 × 20 cm Madrid, Museo del Prado

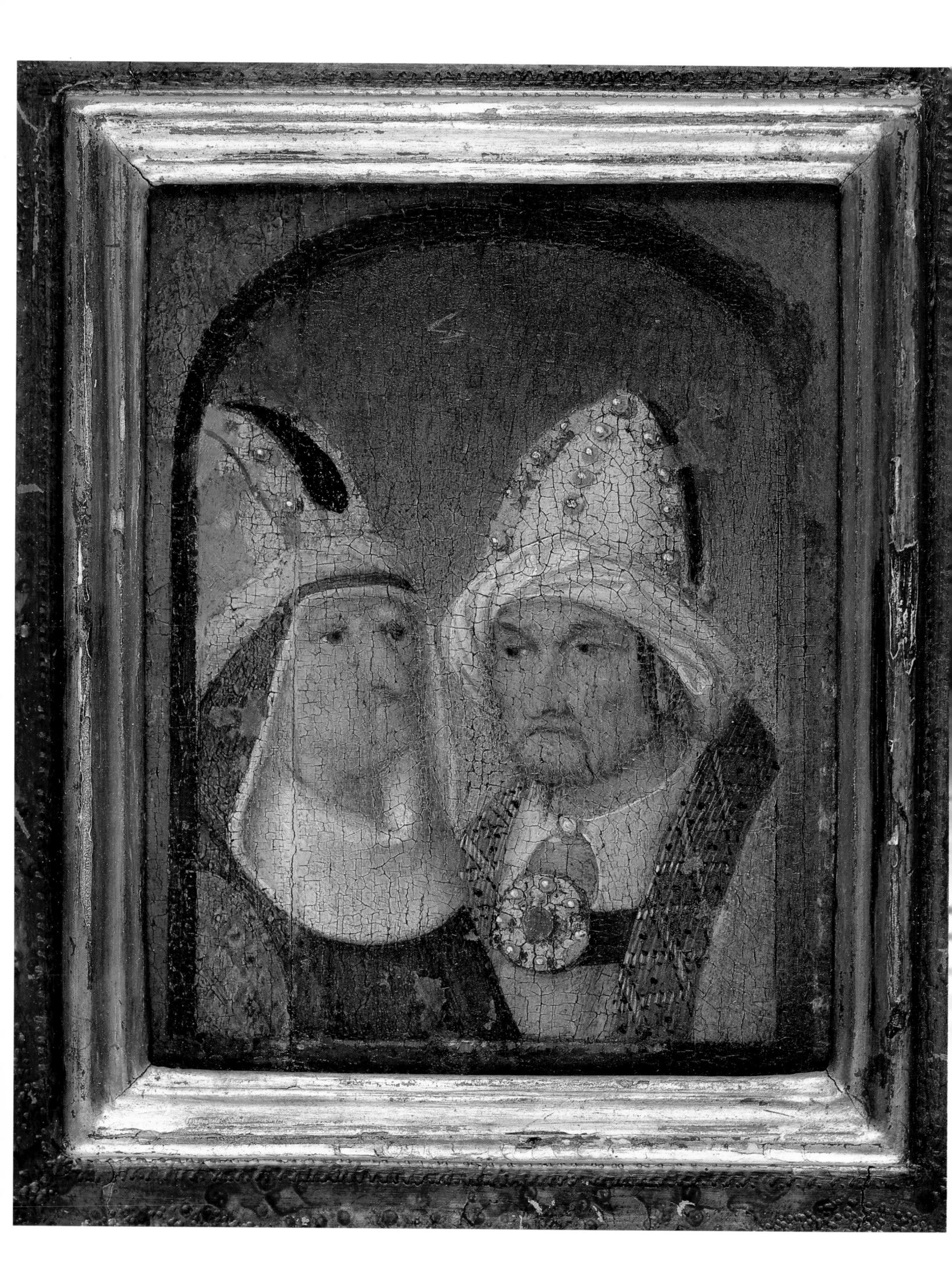

Life and Milieu

Hieronymus Bosch lived and worked in 's-Hertogenbosch, the place from which he takes his name, an attractive but fairly quiet Dutch city not far from the present-day Belgian border. In Bosch's day, 's-Hertogenbosch was one of the four largest cities of the duchy of Brabant, which formed part of the extensive territories of the ambitious dukes of Burgundy. The other chief Brabantine cities, Brussels, Antwerp and Louvain, lie to the south, in what is now Belgium; 's-Hertogenbosch is in the north, geographically close to the provinces of Holland and Utrecht and the Rhine and Maas rivers. In the late Middle Ages, 's-Hertogenbosch was a thriving commercial town, the centre of an agricultural area, with extensive trade connections with both Northern Europe and Italy. Although its cloth industry was important, the city was especially famous for its organ builders and bell founders.

The predominantly middle-class commercial population must have determined much of the city's character, for 's-Hertogenbosch lacked the active court life of Brussels or Malines; unlike Louvain, it possessed no university, nor was it the seat of a bishopric, as were the other major cities of Brabant. Yet a vigorous cultural life was by no means absent. 's-Hertogenbosch had a famous Latin school and, by the end of the fifteenth century, could boast of five »rederijker kamers« or chambers of rhetoric, literary associations which presented poetic and dramatic performances on various public occasions.

Religious life seems to have been particularly flourishing; a great number of convents and monasteries were situated in and around the city. Of special interest are the two houses established by the Brothers and Sisters of the Common Life. A modified religious order without vows, this brotherhood originated in Holland in the late fourteenth century in an attempt to return to a simpler and more personal form of religion, which was called the »Devotio Moderna«. Its character is well exemplified in the famous devotional treatise, the »Imitation of Christ«, generally attributed to Thomas à Kempis, which, as we shall see, must have been well known to Bosch and his patrons. The »Devotio Moderna« played an important role in the religious revival of the fifteenth century and probably contributed to the extraordinary increase in the number of religious foundations in 's-Hertogenbosch. Indeed, by 1526, just ten years after Bosch's death, one out of every nineteen persons in 's-Hertogenbosch belonged to a religious order, a much higher proportion than can be found in other Netherlandish cities at that time. The presence of so many cloisters and their economic competition seem to have attracted considerable hostility from the townspeople, an attitude which we shall also see reflected in Bosch's art.

Two Caricatured HeadsPen and bistre, 13,3 × 10 cm
New York, Lehmann Collection

Two Male HeadsOil on panel, 14,5 × 12 cm
Rotterdam, Museum Boymans-van Beuningen

Despite frequent criticism of the religious order, however, the moral authority of the medieval Church had not, as yet, been seriously shaken. Religion still permeated all aspects of everyday life. Each guild had its own patron saint, and every citizen participated in the great feasts of the Church and in the annual religious processions. The two impulses of life in 's-Hertogenbosch, the sacred and the secular, found their finest expression in the great church of St John, at once the symbol of the still-intact medieval faith and a testimony to the civic pride and commercial prosperity of the city. Begun in the late fourteenth century on the site of an older structure and only completed in the sixteenth, it is a fine example of Brabantine Gothic, noteworthy for its wealth of carved decoration. Of particular interest are the rows of curious figures, monsters and workmen, sitting astride the buttresses supporting the roof, some of which bring to mind the fantastic creatures of Bosch.

The church of St John was in the early phases of construction when Bosch's ancestors settled in 's-Hertogenbosch in the late fourteenth or early fifteenth century. Their family name, Van Aken, suggests that they originally came from the German town of Aachen (Aix-la-Chapelle). In 1430 – 31 appears the first certain reference to Bosch's grandfather, Jan van Aken, who died in 1454. Jan had five sons, at least four of whom were painters; one of these, Anthonius van Aken (died c. 1478), was the father of Hieronymus Bosch.

Unlike Albrecht Dürer, Bosch left no diaries or letters. What we know of his life and artistic activity must be gleaned chiefly from the brief references to him in the municipal records of 's-Hertogenbosch and especially in the account books of the Brotherhood of Our Lady. These records tell us nothing about the man himself, not even the date of his birth. A portrait of the artist, perhaps a self-portrait (p. 2), known only through later copies, shows Bosch at a fairly advanced age. On the assumption that the original portrait was done shortly before his death in 1516, it has been supposed that he was born around 1450. Bosch first appears in a municipal record of 1474, where he ist named along with his two brothers and a sister; one brother, Goossen, was also a painter. Some time between 1479 and 1481. Bosch married Aleyt Goyaerts van den Meervenne, evidently some years his senior. She came from a good family, however, and had considerable wealth of her own; in 1481 there occurred a lawsuit between Bosch and Aleyt's brother over family property. It is assumed that Bosch and his wife lived in 't Root Cruys (the Red Cross).

In 1486-87, Bosch's name appears for the first time in the membership lists of the Brotherhood of Our Lady, with which he was to be closely associated for the rest of his life. This brotherhood was one of the many groups devoted to the veneration of the Virgin which flourished in the late Middle Ages. Founded some time before 1318, the Brotherhood at's-Hertogenbosch comprised both lay and religious men and women. Their devotions were centred on a famous miracleworking image of the Virgin, the »Zoete Lieve Vrouw«, enshrined in the church of St John where the Brotherhood maintained a chapel. Attracting members from all over the northern Netherlands and Westphalia, this large and wealthy organization must have contributed significantly to the religious and cultural life of 's-Hertogenbosch. Its members engaged singers, organists and composers

EpiphanyOil on panel, 74 × 54 cm
Philadelphia, Philadelphia Museum of Art

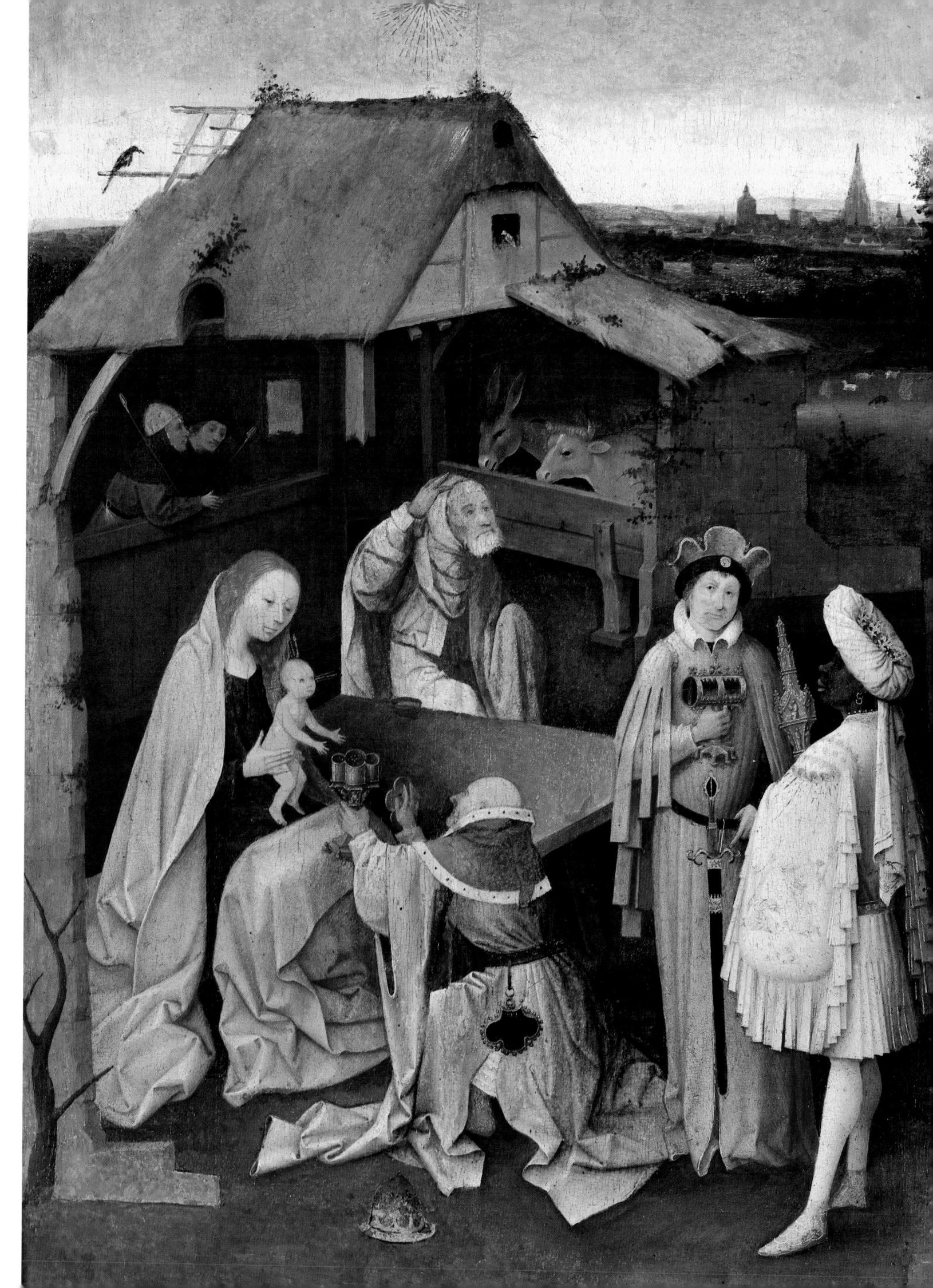

Group of Male Figures Pen, 12,4 × 12,6 cm New York, Pierpont Morgan Library

to supply music for their daily masses and solemn feasts. They also commissioned works of art to embellish the chapel of Our Lady, and in 1478 they decided to construct a new and more splendid chapel attached to the north side of the unfinished choir of St John. The project was entrusted to the church architect, Alart du Hamel, who later engraved some Boschian designs.

Most of Bosch's family belonged to the Brotherhood, and were employed by them in various tasks, frequently to gild and polychrome the wooden statues carried in the annual processions. Bosch's father, Anthonius van Aken, seems also to have acted as a sort of artistic adviser to the Brotherhood. In 1475-76, for example, he and his son were present when the Deans of the Brotherhood discussed the commission of a large wooden altarpiece, completed in 1477 for their chapel.

Hieronymus Bosch may have been one of Anthonius's sons present at these negotiations. However, his first recorded transactions with the Brotherhood occur in 1480-81, and thereafter he received a number of commissions from them. These included several designs, one in 1493-94 for a stained-glass window in the new chapel, another in 1511-12 for a crucifix, and a third in 1512-13 for a chandelier. The small fee he received for executing the last-named project suggests that he did it mainly as a benevolent gesture.

There is no documentary evidence that Bosch ever left his home town. However, a sojourn in Utrecht is suggested by certain aspects of his early work, while the influence of Flemish art on his mature style indicates that he may also have travelled in the southern Netherlands. It has been proposed that Bosch painted his »Crucifixion of St Julia« during a trip to northern Italy, where the cult of this saint was especially popular, but it is more likely that this work was commissioned by Italian merchants or diplomats residing in the Netherlands, as was, for example, the Portinari triptych of Hugo van der Goes.

One final entry in the accounts of the Brotherhood of Our Lady records Bosch's death in 1516; on 9 August of that year, his friends in the Brotherhood attended a funeral mass in his memory in the church of St John.

There are only a few other references to Bosch's works. From several seventeenth-century sources we learn that other paintings by him were to be seen in St John's church. In 1504, finally, Philip the Handsome, duke of Burgundy, commissioned an altarpiece from »Jeronimus van Aeken called Bosch«, the first time, incidentally, that the painter was referred to by his place of origin. The altarpiece was to depict the Last Judgment flanked by Heaven and Hell; its huge dimensions (nine feet high by eleven feet wide) would have approached those of Roger van der Weyden's »Last Judgment« in the Hospital at Beaune. This work is lost, but some scholars believe that a fragment of it survives in a small panel now in Munich, while others identify the »Last Judgment« triptych in Vienna as a reduced replica by Bosch of Philip's altarpiece. Neither suggestion is entirely convincing. Of Bosch's paintings in the church of St John there remains no certain trace today. They probably disappeared when 's-Hertogenbosch was taken from the Spanish in 1629 by Prince Frederick Henry and his Dutch troops. and Catholic splendour was replaced by Calvinist austerity.

Ecce HomoOil on panel, 75 × 61 cm Frankfurt am Main, Städelsches Kunstinstitut mit Städtischer Galerie

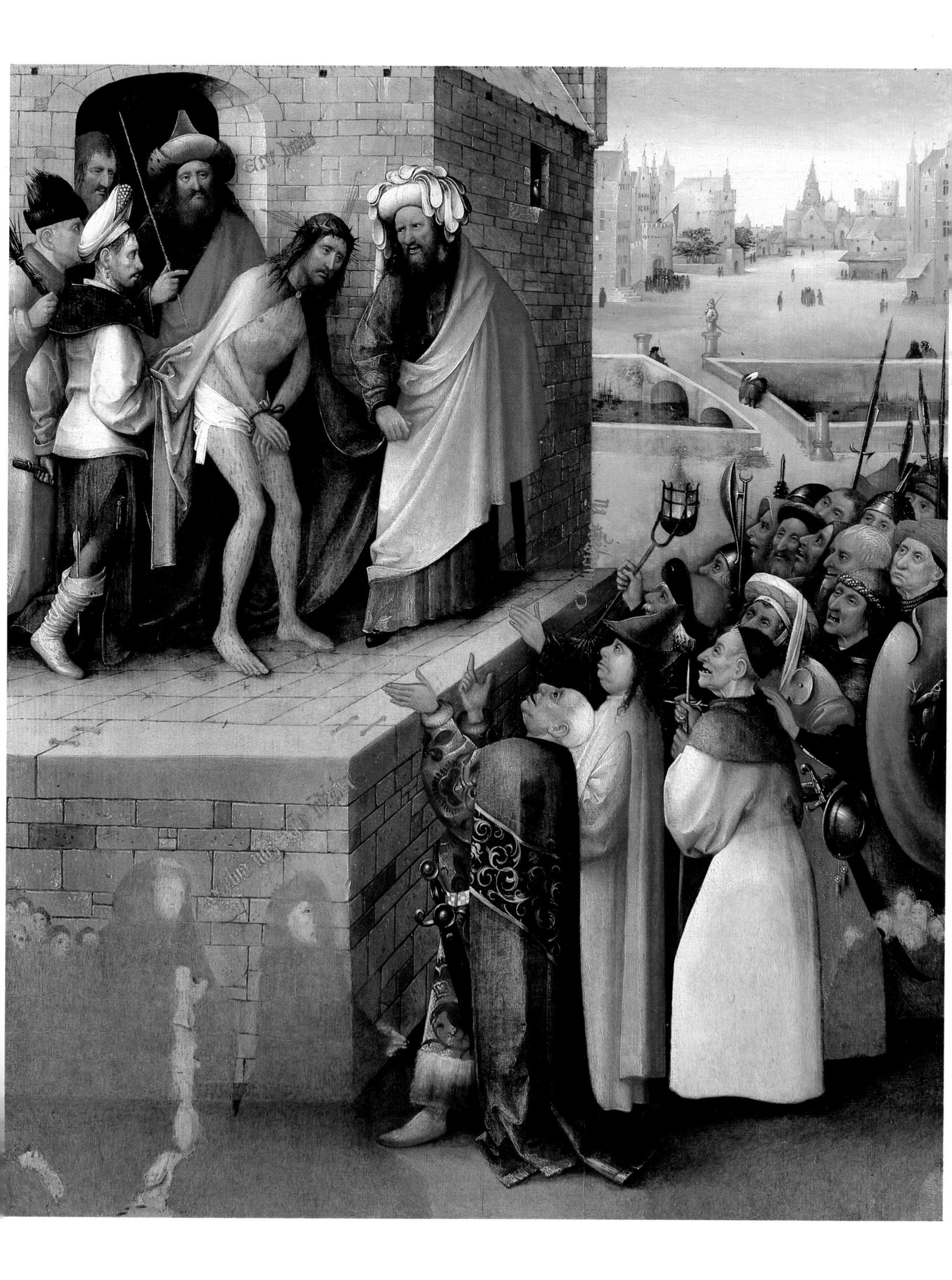

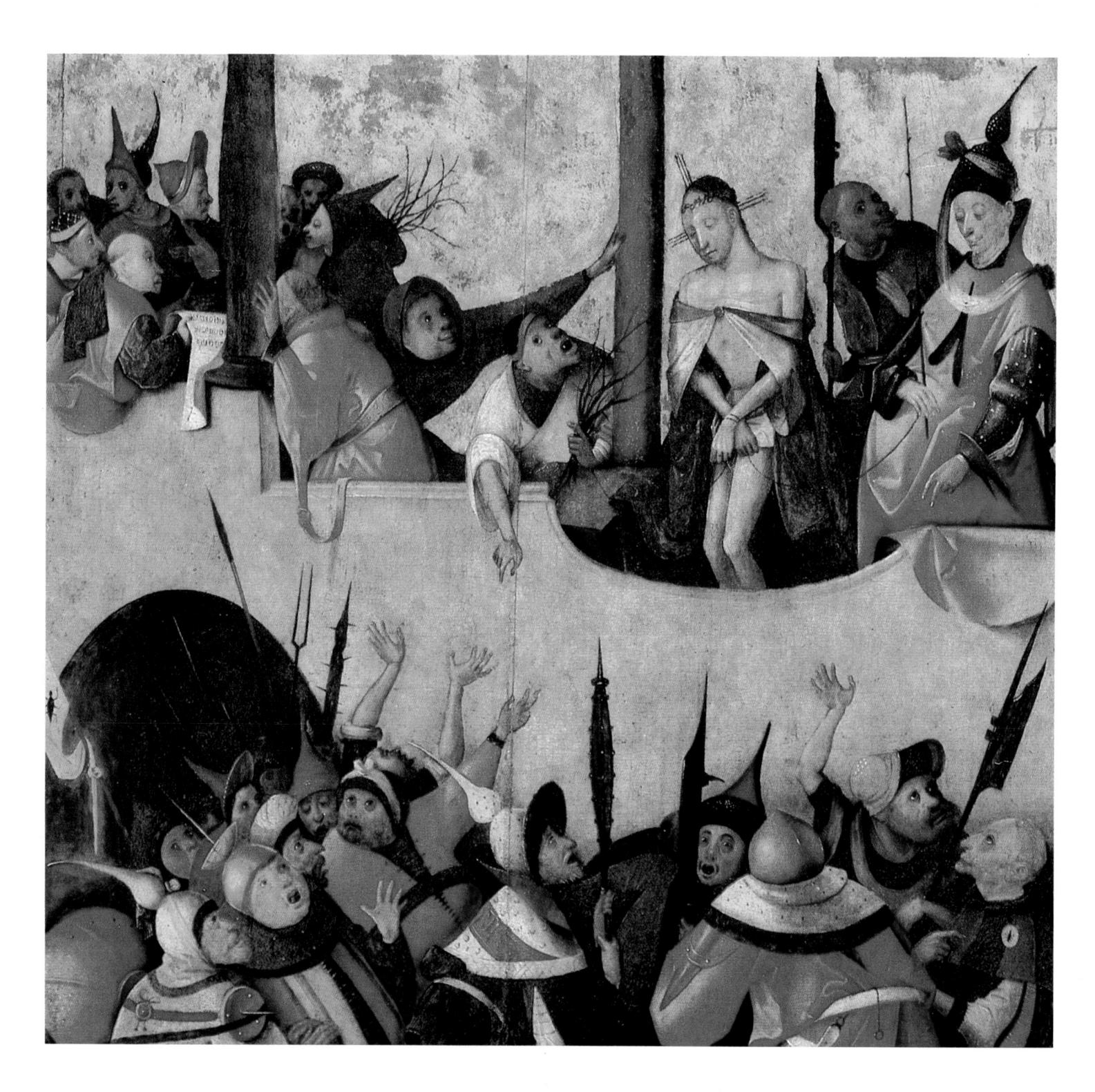

Ecce HomoOil on panel, 52 × 53,9 cm
Philadelphia, Philadelphia Museum of Art

Numerous paintings bearing Bosch's name can be found in museums and private collections in Europe and the United States. Many of these are only copies or pastiches of his original compositions, but over thirty pictures and a small group of drawings can be attributed to him with reasonable certainty. Except for his early works, however, the chronology of these paintings is difficult to determine with any precision. None are dated, and some have been so heavily damaged and overpainted that it would be hazardous to base a chronology on subtle nuances of style and technique. It is more rewarding to study Bosch's paintings according to their subject-matter; only after a thorough examination of his imagery may some insight be gained into the nature of Bosch's artistic development.

Artistic Origins and Early Biblical Scenes

If we know little about Bosch's life, we know even less about his artistic background. It is generally assumed that he was trained by his father or one of his uncles, but all their paintings have been lost, including those commissioned by the Brotherhood of Our Lady. Some light can be cast on the stylistic origins of Bosch's earliest works, however, by considering them within the context of fifteenth-century Netherlandish painting in general. By the time his name began to appear in the records of 's-Hertogenbosch, the first great masters of the Flemish school, Jan van Eyck and Robert Campin, had been dead some thirty years. Roger van der Weyden had also died, but his cool and restrained art was continued, somewhat ineptly, by his followers in Brussels; it had also profoundly influenced Dirk Bouts, now at the end of his career in Louvain, and Hans Memling in Bruges. A more independent style was emerging in the powerful compositions of Hugo van der Goes in Ghent.

During Bosch's lifetime, the northern provinces of the Netherlands were neither as wealthy nor as politically powerful as Brabant and Flanders, and they had neither the extensive patronage nor the large workshops of the cities to the south. Many early Dutch paintings, moreover, were destroyed in the iconoclastic riots of the Reformation and so relatively few have survived. Nevertheless, it is evident that a fairly significant school of painting existed at Haarlem under Geertgen tot Sint Jans and his followers, while the anonymous Master of the Virgo inter Virgines worked in Delft during the last two decades of the century. Although only a few panel paintings can be connected with Utrecht, this ancient city, seat of a bishopric, seems to have been an important centre of manuscript illumination whose originality and significance have yet to be fully recognized. The stylistic unity of Flemish painting, dominated as it was by the genius of Roger van der Weyden, is absent in the northern Netherlands, where local and individual styles were more predominant. The Dutch artists, nevertheless, have many qualities in common, including deeply felt, expressive interpretations of biblical narrative and, especially in the case of Geertgen tot Sint Jans and the illuminators, a vision of man and the world based more on direct experience than on artistic convention.

Because 's-Hertogenbosch was a part of Brabant and the church of St John represents the high point of Brabantine Gothic, many writers have sought the origins of Bosch's art in the traditions established by Robert Campin, Roger van der Weyden and other artists who worked in the southern Netherlands. Bosch's later works, it is true, show many connections with Brabant and the south, but his earliest paintings display more affinities with Dutch art, particularly with the manuscript illuminations.

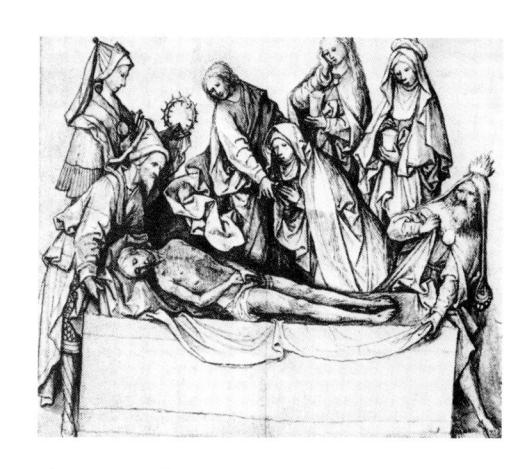

The EntombmentInk and grey wash, 25 × 35 cm
London, British Museum

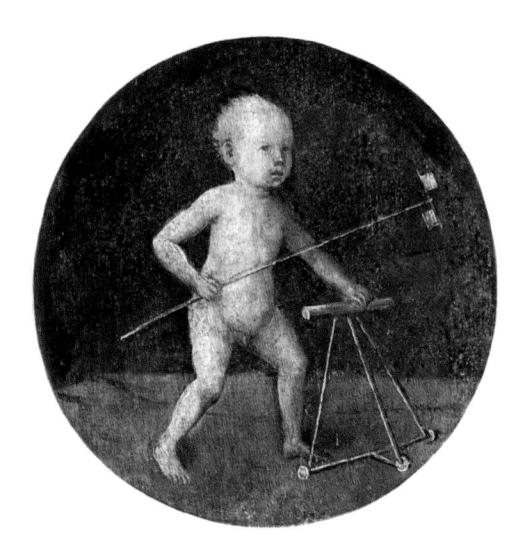

Christ Child with a Walking-Frame Reverse of »Christ Carrying the Cross« Oil on panel; diameter of roundel: c. 28 cm Vienna, Kunsthistorisches Museum

Among the works generally ascribed to Bosch's first period of activity (c. 1470-85) may be included several small biblical scenes: the »Epiphany (Adoration of the Magi)« in Philadelphia, the »Ecce Homo« in Frankfurt (with a related version in Boston, Museum of Fine Arts) and an altar wing in Vienna, the »Christ Carrying the Cross«. Their early date is suggested by their relatively simple compositions and their adherence to traditional compositional types.

This early style is especially well exemplified in the charming »Epiphany« in Philadelphia (p. 13). The dignified comportment of the Kings is set off by the impulsive gesture of the Christ Child, while the aged Joseph stands discreetly to one side, removing his hood as if abashed by the presence of the splendidly dressed strangers. From behind the shed two shepherds look on with shy curiosity. At this early date, Bosch's grasp of perspective was apparently none too firm; particularly ambiguous is the spatial relationship of the stable to the figures in the foreground, although the crumbling walls and thatched roof have been painted with a loving attention to detail. In the distance at the upper right can be seen a pasture filled with grazing cattle and the shimmering towers of a city.

The intimate, almost cosy atmosphere of the Philadelphia »Epiphany« is replaced in the Frankfurt »Ecce Homo« by the brutality of his Passion (p. 15). Crowned with thorns and his flesh beaten raw by the scourge, he now stands with Pilate and his companions before the angry mob. The dialogue between Pilate and the crowd is indicated by the Gothic inscriptions which function not unlinke the balloons in a modern comic strip. From the mouth of Pilate issue the words »Ecce Homo« (Behold the Man). There is no need to decipher the inscription »Crufige Eum« (Crucify Him), the cry which rises from the people below; their animosity is unmistakably conveyed by their facial expressions and threatening gestures. The third inscription »Salve nos Christe redemptor« (Save us, Christ Redeemer) once emerged from two donors at lower left, but their figures have been painted over. As with the Magi in the Philadelphia »Epiphany«, the heathen character of the men surrounding Christ is suggested by their strange dress and headgear, including pseudo-oriental turbans. The scene's essential wickedness is further indicated by such traditional emblems of evil as the owl in the niche above Pilate and the giant toad sprawled on the back of a shield carried by one of the soldiers. In the background appears a city square, the Turkish crescent fluttering from one of its towers. The enemies of Christ have been identified with the power of Islam which in Bosch's day, and long afterwards, controlled the most holy places of Christendom. The buildings, however, are late Gothic; only the oddly bulging tower in the distance evokes a feeling of far-off places.

The Dutch character of these two early works is unmistakable. The Philadelphia »Epiphany« represents a reworking of a composition which had long been used by the Dutch manuscript illuminators. Likewise, the homely faces and animated gestures of Christ's tormentors in the »Ecce Homo« recall Passion scenes in Dutch manuscripts of the second and third quarters of the fifteenth century, where we encounter similar physical types, slight in proportion, flatly modelled and often unsubstantial beneath their heavy robes.

Christ Carrying the CrossOil on panel, 57,2 × 32 cm
Vienna, Kunsthistorisches Museum

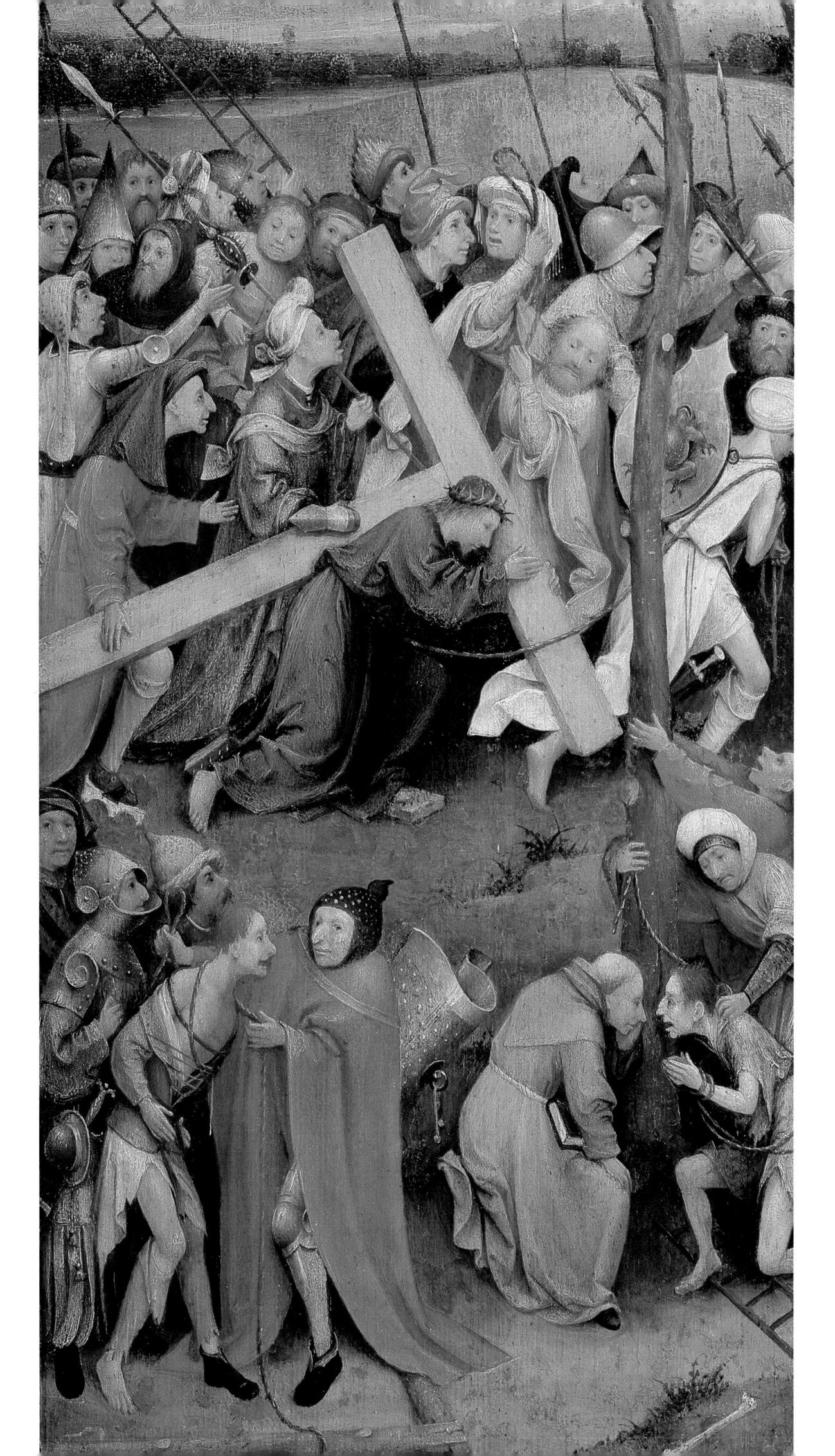

Beehive and Witches Pen and bistre, 19,2 × 27 cm Vienna, Albertina

The same style appears in the Vienna »Christ Carrying the Cross« (p. 19), where the head of Christ is silhouetted against a dense mass of grimacing soldiers and ill-wishers, one of them bearing the familiar toad on his shield. Christ's physical agony is heightened by the spike-studded wooden blocks which dangle fore and aft from his waist, lacerating his feet and ankles with every step. This cruel device was frequently represented by Dutch artists well into the sixteenth century. The high horizon is old-fashioned, as is the lack of spatial recession in the middle distance. In the foreground, soldiers torment the bad thief while the good thief kneels before a priest. The almost frantic intensity of his confession, well-expressed by the open-mouthed profile, contrasts vividly with the passive response of the priest who seems to suppress a yawn. The very presence of the priest is, of course, an anachronism, probably inspired by what Bosch had witnessed at contemporary executions; the same motif appears in the great multi-figure »Christ Carrying the Cross« which Pieter Bruegel the Elder was to paint almost a century later.

This urge to embellish the biblical text with details drawn from everyday life is characteristic for the later Middle Ages, it appears in the mystery plays and in such devotional books as the »Meditations on the Life of Christ« attributed to St Bonaventure. The Dutch illuminators, above all, frequently interpreted the sacred stories in common everyday terms in order to make them more immediate to the spectator.

This very human quality is no less apparent in another work which, although not a biblical subject, belongs to Bosch's early paintings. This is the »Conjuror«, now lost but known through a faithful copy at Saint-Germain-en-Laye (right). A mountebank has set up his table before a crumbling stone wall. His audience watches spellbound as he seems to bring forth a frog from the mouth of an old man in their midst; only one of the crowd, the young man with his hand on the shoulder of his female companion, appears to notice that the old man's purse is being stolen by the conjuror's confederate. The myopic gaze of the thief and the stupid amazement of the frog-spitting victim are superbly played off against the amused reactions of the bystanders, while the slyness of the mountebank is well conveyed in his sharp-nosed physiognomy. As in the »Christ Carrying the Cross«, Bosch exploits the human face in profile for expressive purposes. Although the »Conjuror« may possess a moralizing significance, as we shall see, it must have been inspired by a real-life situation closely observed. The perceptive, spontaneous humour of this little picture would be difficult to match in contemporary Flemish painting, but parallels can again be found among Dutch manuscript illuminators, such as the Master of Evert van Soudenbalch, active in Utrecht during the 1450s and 1460s.

Other biblical scenes may be ascribed to Bosch's early years: the »Marriage Feast at Cana« (Rotterdam) and the badly damaged »Crucifixion of St Julia« (Venice, Palace of the Doges), of which only the central panel is from Bosch's hand (p. 84). In addition, there are several compositions which have survived only in copies of indifferent quality, including the »Christ among the Doctors» and »Christ with the Woman Taken in Adultery«, both of which recall the »Conjuror« in style. Among the early drawings are a sheet of animated male figures looking towards the right (New York, Morgan Library; p. 14), perhaps a study for an »Ecce Homo«

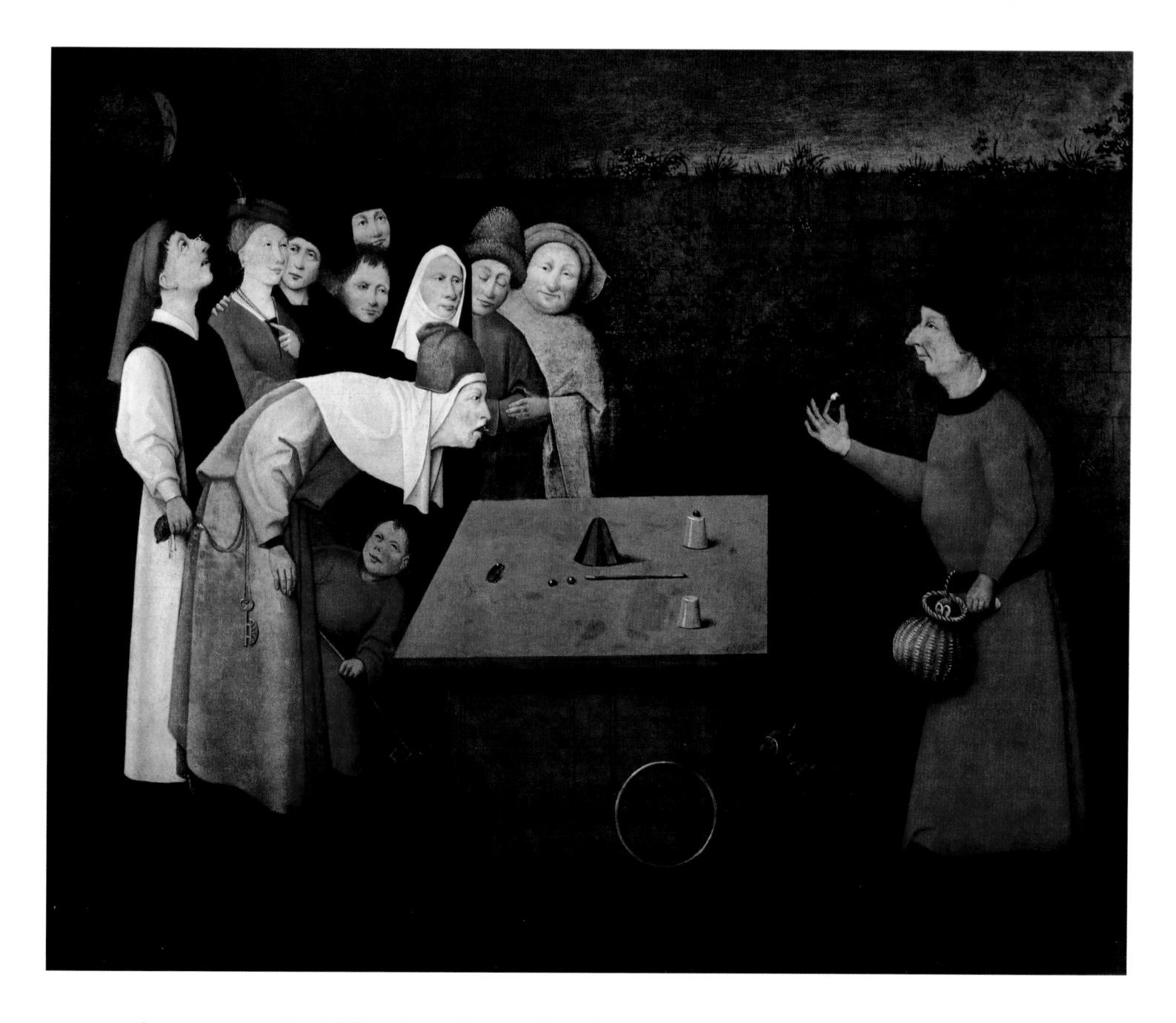

scene, and a monumental, relief-like »Entombment« (London, British Museum; p. 17).

Only a few of the early paintings depart significantly from traditional iconography, but these exceptions anticipate the innovations of his later work. The treatment of the two thieves in the »Christ Carrying the Cross« is apparently without precedent, but still more unusual is the reverse of this panel, depicting a naked child pushing a walking-frame (p. 18). This is the Christ Child, whose first halting steps clearly parallel Christ struggling with his Cross on the obverse, while the toy windmill or whirligig clutched in his hand probably alludes to the Cross itself. Thus Bosch gives us a touching picture of Christ in all his human frailty as he begins the road to his Passion.

Even less traditional is the »Marriage Feast at Cana« (p. 23), painted towards the end of Bosch's early period. The picture is not in good condition; the upper corners have been cut off, many heads have been repainted, and a pair of dogs at the lower left may have been added as late as the eighteenth century.

The ConjurorOil on panel, 53 × 65 cm
Saint-Germain-en Laye, Musée Municipal

In the large Dutch bible previously mentioned, an assistant of the Soudenbalch Master had presented the first miracle of Christ, the transformation of water into wine, as a rustic wedding feast; with characteristic humour, he showed one guest thirstily emptying a pot of wine, as if to explain just why Christ's miracle was so urgently required. Bosch's interpretation, on the other hand, is more serious in mood and much more complex in meaning. The marriage banquet has been placed in a richly furnished interior, most probably a tavern, the setting for the Cana story in at least one Dutch Easter play of the period. The miracle of the wine iars takes place at lower right; the guests are seated around an L-shaped table dominated at one end by the figure of Christ, behind whom hangs the brocaded cloth of honour usually reserved for the bride; he is flanked by two male donors in contemporary dress. Next to the Virgin at the centre of the table appear the solemn, austerely clad bridal couple; the bridegroom must be John the Evangelist, for his face closely resembles the type which Bosch employed elsewhere for this saint. Although the bridegroom remains nameless in the New Testament account, he was frequently identified as Christ's most beloved disciple. It was believed that at the conclusion of the feast, Christ called to him, saving: »Leave this wife of yours and follow me. I shall lead you to a higher wedding.« According to some writers, moreover, the abandoned bride was none other than Mary Magdalene. Thus the feast at Cana embodied the medieval ideal of chastity as more perfect in the sight of God than carnal union.

This medieval dualism between the flesh and the spirit receives further elaboration in the Rotterdam panel. Christ and his friends are pensively absorbed in some inner vision, unaware of the evil enchantment which seems to have fallen upon the banquet hall. The other wedding guests drink or gossip, watched by the bagpiper who leers drunkenly from a platform at the upper left. On the columns flanking the rear portal, two sculptured demons have mysteriously come to life; one aims an arrow at the other who escapes by disappearing through a hole in the wall. From the left, two servants carry in a boar's head and a swan spitting fire from their mouths; an ancient emblem of Venus, the swan symbolized unchastity. This unholy revelry seems to be directed by the innkeeper or steward who stands with his baton in the rear chamber. On the sideboard next to him are displayed curiously formed vessels, some of which, like the pelican, are symbolic of Christ, while others possess less respectable connotations, such as the three naked dancers on the second shelf.

The precise meaning of all these details remains unclear, as does that of the richly gowned child, his back turned to the viewer, who seems to toast the bridal couple with a chalice. However this may be, Bosch has undoubtedly employed the tavern setting as an image of evil, a comparison popular in medieval sermons, thereby contrasting the chaste marriage feast at Cana with the debauchery of the world.

In its transformation of a biblical story, the »Marriage Feast of Cana« introduces us for the first time to the complexity of Bosch's thought. It presents, on the one hand, a moral allegory of man's pursuit of the flesh at the expense of his spiritual welfare, and on the other, the monastic ideal of a life secure from the world in contemplation of God. These two themes were to dominate almost all Bosch's later art.

Marriage Feast at Cana
Oil on panel, 93 × 72 cm
Rotterdam, Museum Boymans-van Beuningen

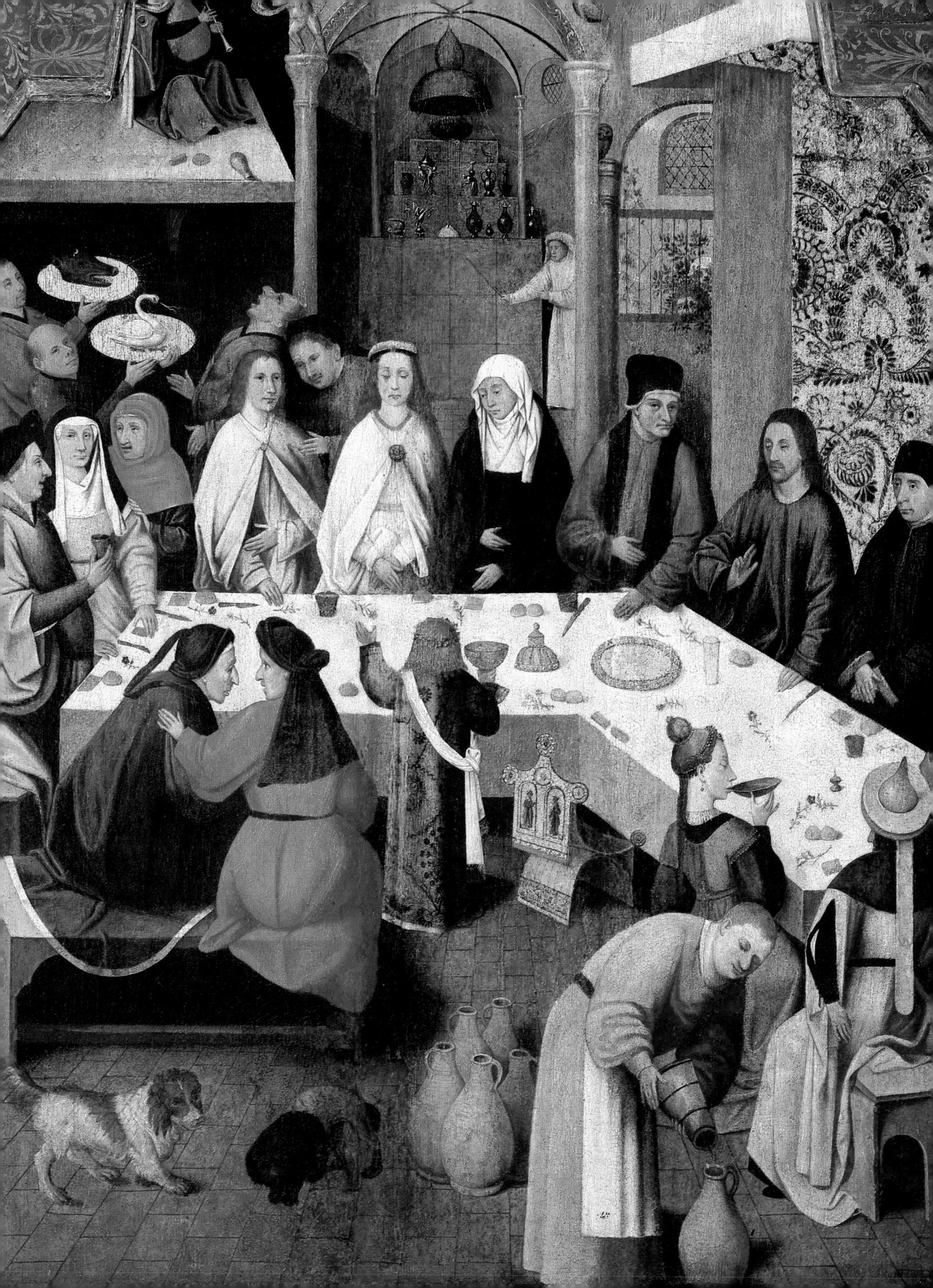

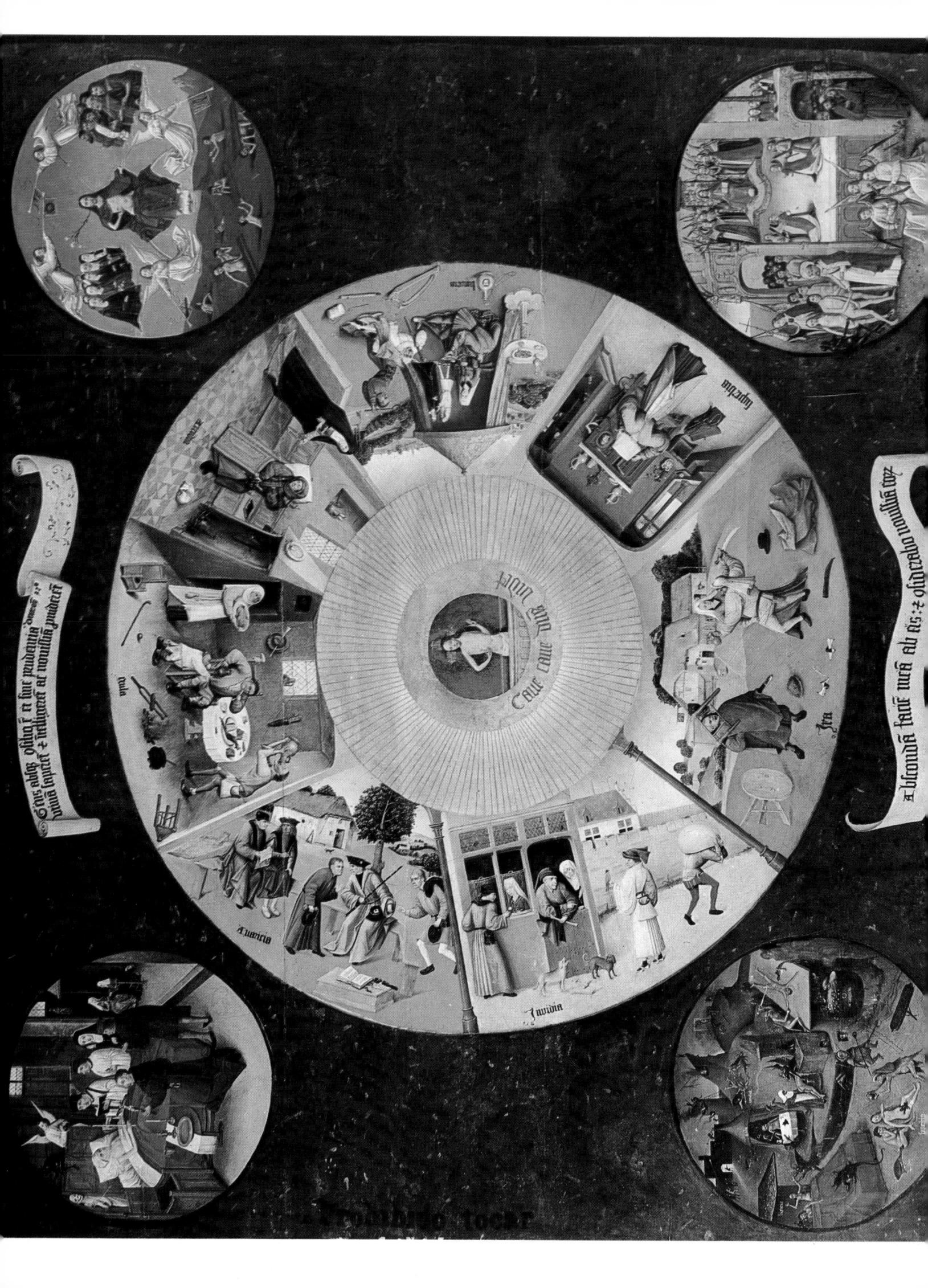

The Mirror of Man

In his »Oration on the Dignity of Man«, composed around 1486, the young Florentine humanist Pico della Mirandola celebrated the excellence and felicity of mankind. Man is unique among creatures in possessing a free will, the power to determine his nature and destiny; and through the proper exercise of this will he can attain the state of angels. »For it is on this very account«, exclaims Pico, »that man is rightly called and judged a great miracle and a wonderful creature indeed.« Some eight years later, Sebastian Brant published the first edition of his »Ship of Fools«, a series of poems satirizing humanity's failings and foibles. »The whole world lives in darksome night«, Brant complains, »in blinded sinfulness persisting, while every street sees fools existing. « The difference between these two conceptions of man is vast but explicable. Pico reflects the optimistic faith of the Italian Renaissance in man's abilities. Brant, however, like many of his contemporaries in Northern Europe, still lived in the shadow of the Middle Ages which took a much dimmer view of human nature: corrupted through the sin of Adam, man struggles weakly against his evil inclinations, more likely to sink to the level of beasts than to rise with the angels.

It is this medieval attitude which inspired Bosch's transformation of the »Marriage Feast at Cana«, and which he developed more comprehensively in the »Tabletop of the Seven Deadly Sins and the Four Last Things« (Madrid, Prado; left). Here the condition and fate of humanity is presented in a series of circular images. The central image, formed of concentric rings, represents the Eye of God, in whose pupil Christ emerges from his sarcophagus, displaying his wounds to the viewer. Around the pupil are inscribed the words »Beware, Beware, God sees«; and just what God sees is mirrored in the outer ring of his eye, where the Seven Deadly Sins are enacted in lively little scenes taken from everyday life. The Latin name of each sin is clearly inscribed at the bottom, but the inscriptions are as superfluous here as in the Frankfurt »Ecce Homo«. There is no need to inform us, for example, that the men greedily consuming all that the housewife brings to the table represent the sin of Gluttony, or that the well-fed gentleman dozing by the fire personifies Sloth; in this case, the neglect of spiritual duties is indicated by the woman who enters the room from the left, reproachfully holding out a rosary. Lust shows several pairs of lovers in a tent; and in Pride a vain lady admires her new hat, unaware that her mirror is held by an extravagantly bonneted demon. Similar genre scenes illustrate Anger (two men guarrelling before a tavern), Avarice (a judge accepting bribes) and Envy (a rejected suitor gazing jealously at his rival). For the most part, these little dramas are placed against views of the Dutch countryside, or within well-constructed interiors.

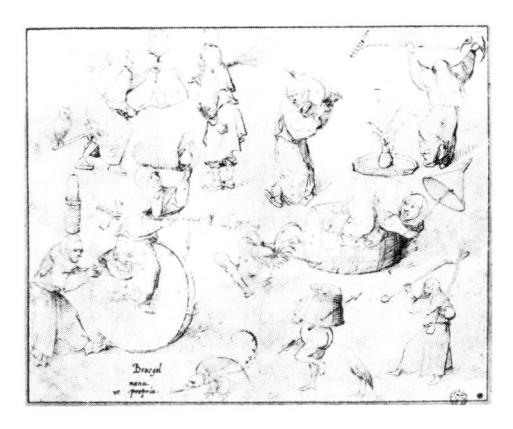

WitchesPen and bistre, 20,3 × 26,4 cm
Paris, Louvre, Cabinet des Dessins

Tabletop of the Seven Deadly Sins and the Four Last Things Oil on panel, 120 × 150 cm Madrid, Museo del Prado

The Ship of Fools in Flames
Pen and bistre, 17,6 × 15,3 cm
Vienna, Akademie der bildenden Künste

The short, sturdy, and rather awkward figures are generally unlike those which we encounter elsewhere in Bosch's art; equally untypical are the hard surfaces, dark outlines and flat, bright colours, dominated by green and ochre. The general crudeness of the execution formerly led scholars to place this picture among Bosch's earliest works, but, as later observers have pointed out, certain details of costume in the Prado »Tabletop« reflect styles which did not come into fashion until around 1490. Therefore it is more likely that the »Tabletop« represents a workshop production from Bosch's middle period (c. 1485-1500). However, Bosch must have been responsible for the original design, and perhaps his collaboration in the actual painting may also be discerned in some passages of higher quality, such as the Avarice scene and several figures in Envy.

The circular disposition of the Seven Deadly Sins conforms to a traditional scheme. As many writers have assumed, this wheel-like arrangement probably alludes to the extension of sin throughout the world, but the motif was immeasurably enriched when Bosch transformed the circular design into the Eye of God which mirrors what it sees. Here, too, he had ample precedent. The comparison of the Deity to a mirror occurs frequently in medieval literature.

That those who have abandoned God have just reason to dread his glance is affirmed by the banderols which unfold above and below the central image of the Prado »Tabletop «. The upper one reads: »For they are a nation void of counsel, neither is there any understanding in them. O that they were wise, that they understood this, that they would consider their latter end. « On the lower banderol is written: »I will hide my face from them, I will see what their end shall be « (Deuteronomy 32:28-29, 20). What their end will be is shown in no uncertain terms in the corners of the panel. Here, in four smaller circles, appear Death, Last Judgement, Heaven and Hell, the Four Last Things of all men as understood by Bosch and his contemporaries, and popularized by Denis the Carthusian (1420-71) who spent his last years in a Dutch monastery. The execution of these scenes is even coarser than that of the Deadly Sins and must be attributed entirely to Bosch's workshop. No hint of his apocalyptic nightmares appears in the Hell circle, where the Deadly Sins are punished in separate tableaux, all carefully labelled and arranged like displays at a country fair.

The notion of God spying on mankind from the sky may strike us as unpleasant, but to medieval man it appeared as a salutary deterrent to sin. The German humanist Jakob Wimpheling (1450-1528) tells us that the sight of an inscription in a church at Erfurt, »God Sees«, was enough to turn him from youthful follies towards a more devout life. Bosch's Eye of God was intended to achieve a similar effect, for in reflecting the Seven deadly Sins, it functions as a mirror wherein the viewer is confronted by his own soul disfigured by vice. At the same time, however, he beholds the remedy for this disfigurement in the image of Christ occupying the centre of the Eye. It seems likely that the Prado »Tabletop« was used as an aid to meditation, particularly that intensive examination of one's conscience which every good Christian was urged to undertake before going to Confession.

Within its framework of the Seven Deadly Sins, the Prado »Tabletop« embraces all men and conditions of life; in Avarice, however, the reference

The Stone OperationOil on panel, 48 × 35 cm
Madrid, Museo del Prado

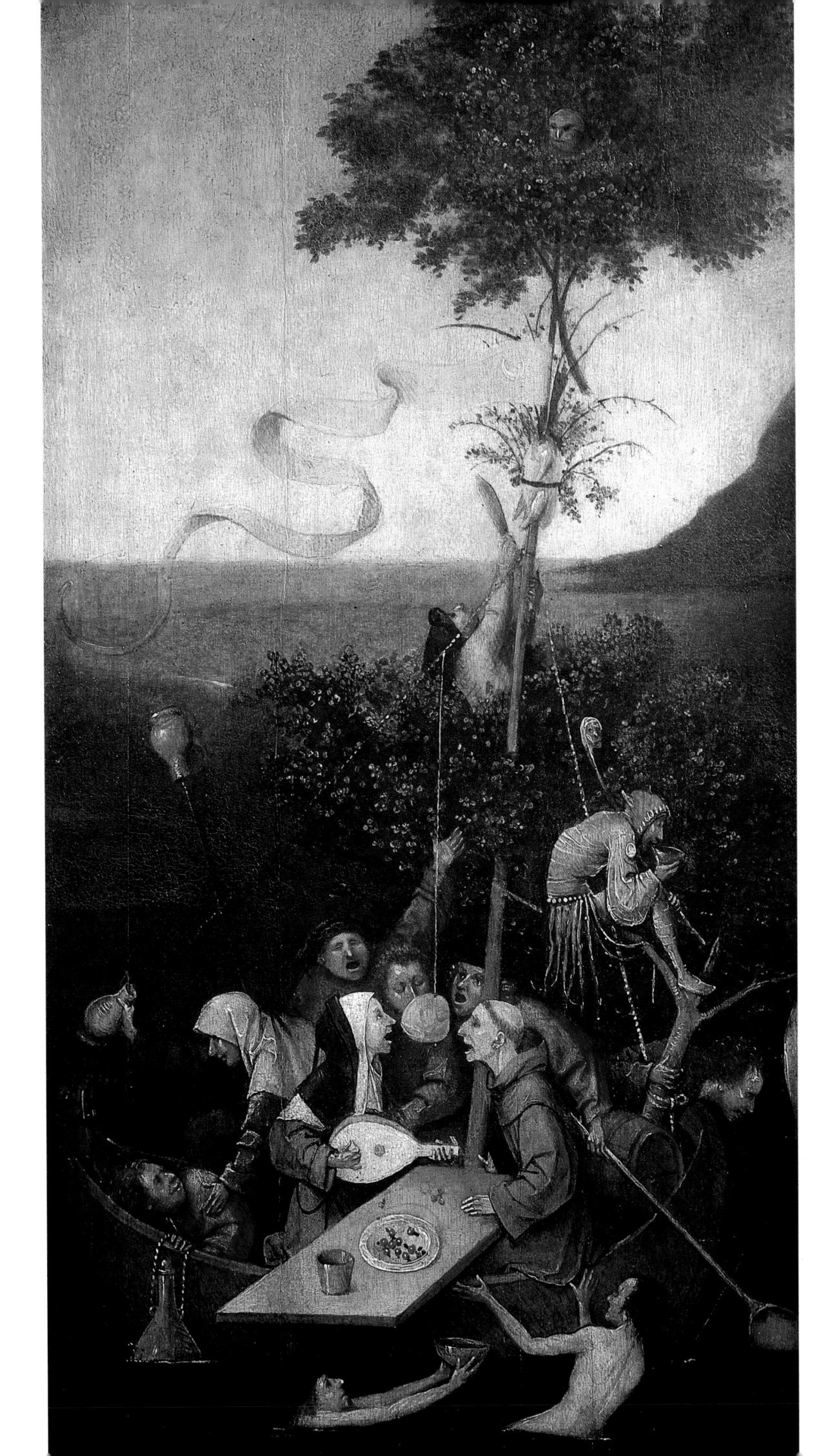

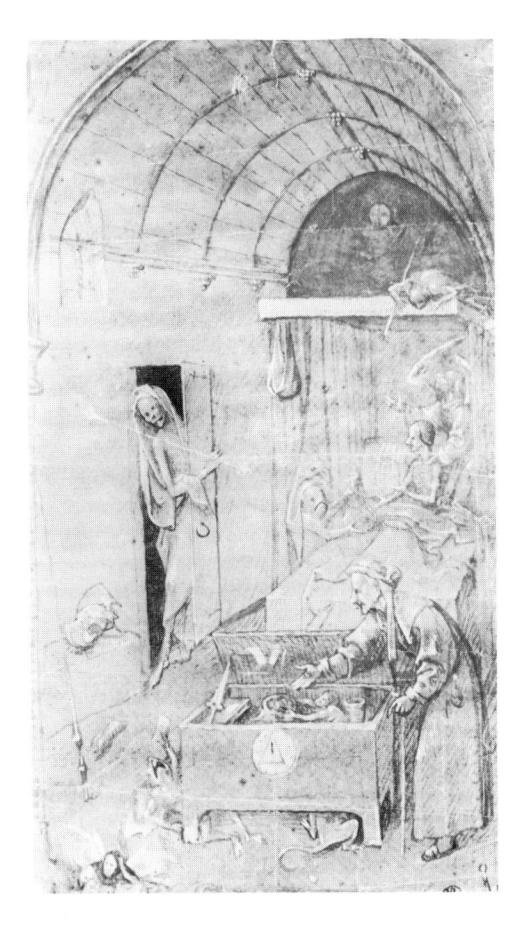

Death and the Miser Study for the painting in Washington 25,6 × 14,9 cm Paris, Louvre, Cabinet des Dessins

Fools«, whose great popularity is demonstrated by the six editions and numerous translations which appeared even during the author's lifetime. Bosch might well have known Brant's poem, but he need not have turned to it for inspiration, as the ship was one of the most beloved metaphors of the Middle Ages. A popular image was the Ship of the Church manned by prelates and the clergy, which brings its freight of Christian souls safely into the port of Heaven. In Guillaume de Deguilleville's »Pilgrimage of the Life of Man«, the Ship of Religion bears a mast symbolizing the Crucifix, and contains castles representing the various monastic orders.

A Dutch translation of this famous work was published at Haarlem in 1486, and it is tempting to suppose that Bosch was familiar with Deguilleville's ship of the monastic life, of which his own boat could easily be a parody. The flapping pink banner carries a Turkish crescent instead of the cross, and we find an owl lurking in the foliage at the top of the mast. Three representatives of the cloistered life have abandoned their spiritual duties to join the other revellers. The monk and one of the nuns are singing lustily, the latter accompanying herself on a lute; they resemble the amorous couples depicted in medieval love gardens, who make music as a prelude to making love. The allusion to the sin of Lust is reinforced by other details drawn from the traditional Garden of Love – the plate of cherries and the metal wine jug suspended over the side of the boat which Bosch had employed for the same sin in the Prado »Tabletop«. Gluttony is undoubtedly represented not only by the peasant cutting down the roast goose tied to the mast, but also by the man who vomits over the side of the boat at the right, and by the giant ladle which another member of the merry party wields as an oar. Alongside the boat appear two nude swimmers, one holding out his wine cup for replenishment. The tree-mast may refer, as some authorities believe, to the Maypole or May tree of the spring folk festivals, generally a time of moral licence for folk and clergy alike.

The disreputable nature of the boat is conveyed, finally, by the guzzling fool in the rigging. For centuries the court jester or fool had been permitted to satirize the morals and manners of society, and it is in this capacity that he appears in prints and paintings from the midfifteenth century on, distinguished by his cap adorned with ass's ears and carrying a baton topped by a small replica of his own vacantly grinning features. He frequently cavorts among revellers and lovers, as in the Lust scene of the Prado »Tabletop«, pointing to the folly of their lewd behaviour.

Lust and Gluttony had long been pre-eminent among the monastic vices; and these and other charges were levelled against the religious orders with increasing frequency during the fifteenth century. This period saw the rapid growth of religious houses, some of which supported themselves through weaving and other crafts. That they were more dissolute than before, despite various attempts at monastic reform, would be difficult to determine with any certainty, but it is clear that their considerable wealth and economic competition with the craft guilds brought them into conflict with the secular authorities. In 's-Hertogenbosch, the town fathers sought to limit the possessions and economic activity of the cloisters within their jurisdiction. While other cities of the time took comparable measures, the situation must have been particularly acute in

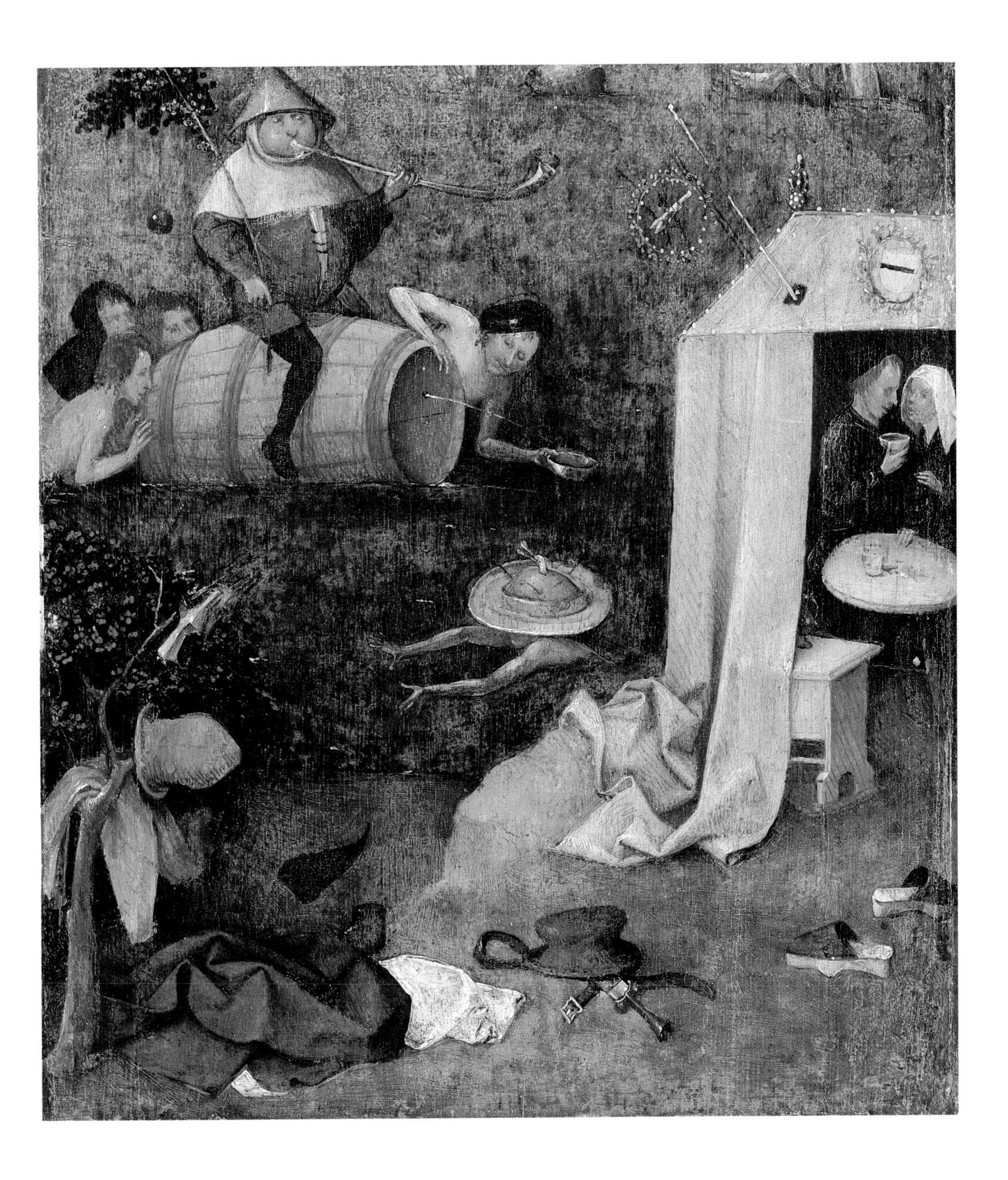

's-Hertogenbosch, given the unusually high proportion of its population in religious orders. It is against this background of hostility that we must view Bosch's frequent condemnation of immorality among monks and nuns, not only in the »Ship of Fools« and the »Stone Operation«, but also in the later »Haywain«.

Allegory of Gluttony and Lust Oil on panel, 35,8 × 32 cm New Haven, Yale University Art Gallery, The Rabinowitz Collection, Gift of Hanna D. and Louis M. Rabinowitz

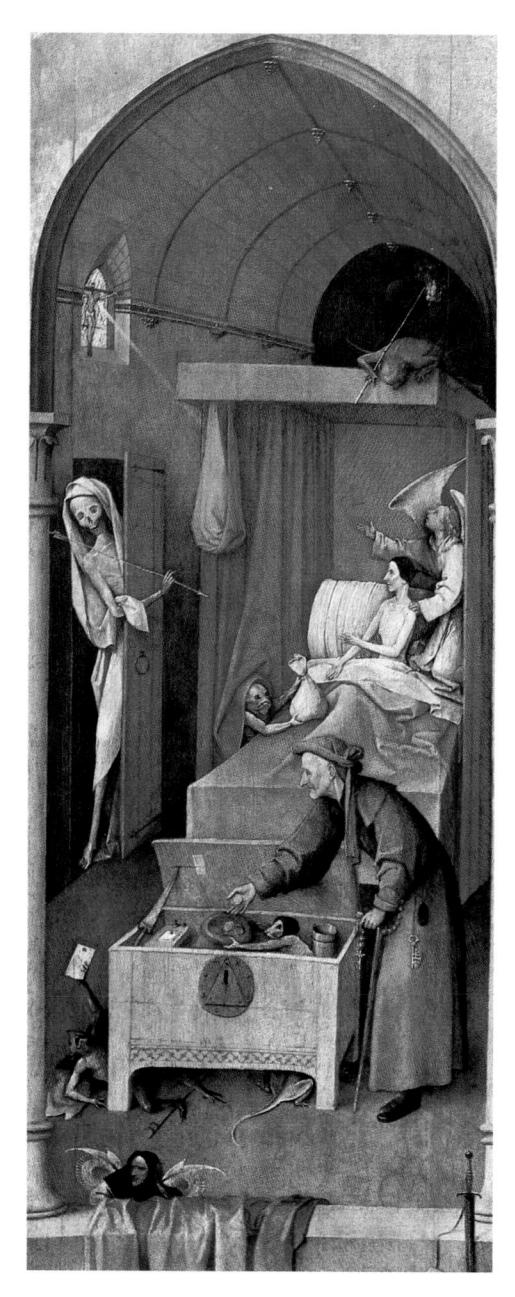

Death of the MiserOil on panel, 92,6 × 30,8 cm
Washington, National Gallery of Art

The intimate association between Gluttony and Lust in the medieval moral system was expressed by Bosch once more, although without a specific reference to monastic life, in a fragment of a painting at Yale University (p. 31). Gluttony is personified by the swimmers at the upper left who have gathered around a large wine barrel straddled by a pot-bellied peasant. Another man swims closer to shore, his vision obscured by the meat pie balanced on his head. This scene is followed, on the right, by a pair of lovers in a tent, another motif reminiscent of the Lust scene in the Prado »Tabletop«. That they should be engaged in drinking wine is entirely appropriate: »Sine Cerere et Libero friget Venus« (Without Ceres and Bacchus, Venus freezes); this tag from Terence was well known to the Middle Ages, and that Gluttony and Drunkenness lead to Lust was a lesson that the moralizers never tired of driving home to their audiences.

That man persists in his folly even at the moment of death, when the eternities of Heaven and Hell hang in the balance, is the subject of the »Death of the Miser« (left). The dying man lies in a high, narrow bedchamber, into which Death has already entered at the left. His quardian angel supports him and attempts to draw his attention to the crucifix in the window above, but he is still distracted by the earthly possessions he must leave behind; one hand reaches out almost automatically to clutch the bag of gold offered by a demon through the curtain. Another demon, delicately winged, leans on the ledge in the foreground, where the rich robes and knightly equipment probably allude to the worldly rank and power which the miser must also abandon. The battle of angels and devils for the soul of the dying man occurs also in the Prado »Tabletop« (where the traditional figure of Death armed with an arrow likewise appears), and both scenes reflect a popular fifteenth-century devotional work, the »Ars Moriendi« or «Craft of Dying«, which was printed many times in Germany and the Netherlands. This curious little handbook describes how the dying man is exposed to a series of temptations by the demons clustered around his bed and how, each time, an angel consoles him and strengthens him in his final agony. In this book, the angel is ultimately successful and the soul is carried victoriously to Heaven as the devils howl in despair below. In Bosch's painting, however, the issue of the struggle is far from certain. An opened money chest can be seen at the foot of the bed, where an elderly man, perhaps the miser shown a second time, places a gold piece into a bag held by a demon. He seems little concerned with the rosary hanging from his waist.

Death, no less than Folly, was a major preoccupation of the waning Middle Ages. The fashionable court poets dwelt upon the dissolution of the flesh and of all fair things in this world. It was also the theme of countless treatises of moral instruction, and the same morbid interest appears in the decaying corpses who seize their victims in scenes of the Dance of Death or recline on sculptured tombs. »I was as you are now, you will be as I am«, they seem to say to the living, repeating a favourite phrase of the period. But this obsession with death was compounded by a still greater horror: the firm conviction that after the physical dissolution of the body, the soul continued to exist, possibly doomed to eternal suffering in Hell. And it is in the depiction of this afterlife of the soul and its torments that Bosch made perhaps his most significant contribution to the history of painting.

The Last Judgement

While sin and folly occupy a prominent place in Bosch's art, their significance can be fully appreciated only within the context of a larger medieval theme, the Last Judgment. The Day of Judgment marks the final act of the long, turbulent history of mankind which began with the Fall of Adam and Eve and their expulsion from Eden. It is the day when the dead shall rise from their graves and Christ shall come a second time to judge all men, rewarding each according to his merits. As Christ himself foretold (Matthew 25:34, 41), the elect will enjoy the eternal bliss prepared for them »from the foundation of the world«, while the damned will be condemned to the »everlasting fire, prepared for the devil and his angels«. Time will cease and eternity begin.

The preparation for this Final Day was one of the chief concerns of the medieval Church. It taught the faithful what conduct would enable them to be numbered among the blessed; it warned backsliders and evildoers of the awful punishment which awaited them if they failed to reform. The majority opinion is represented by Thomas à Kempis who told the readers of the »Imitation of Christ«, »it is good that, if the love of God does not restrain you from sin, the fear of Hell at least should restrain you«. Thus, the unending torments of the damned were described, in lurid details, in countless books and sermons, while meditations on the Last Judgment and Hell played an important part in various spiritual exercises, including those of the »Devotio Moderna«.

The terrors of the Final Reckoning were intensified by a general sense of its imminence. There had always been prophets who insisted that the world was nearing its end, but the feeling of impending doom grew particularly acute in the late fifteenth century. For Sebastian Brant, the sins of mankind had multiplied to such an extent that the Last Judgment must surely be close at hand. Other writers represented the world on the threshold of the final age, in which the prophecies described in the Revelation of St John would soon come to pass. Plagues, floods and other natural disasters were regarded as manifestations of the wrath of God and current political events were searched anxiously for signs of the Last Emperor and of Antichrist.

In 1499, a German astrologer confidently asserted that the world would be destroyed by a second Deluge on 25 February 1524. In 1515, Albrecht Dürer made a watercolour recording his famous dream in which he saw the final catastrophe brought about by huge columns of water crashing to the earth; somewhat earlier, Leonardo da Vinci made drawings of whole cities swept away by raging floods whose dynamic structure was observed with scientific detachment.

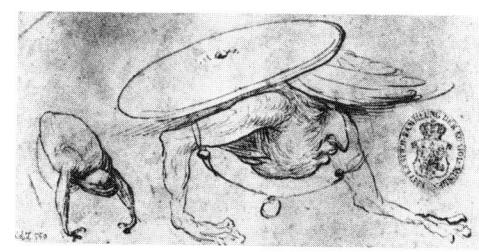

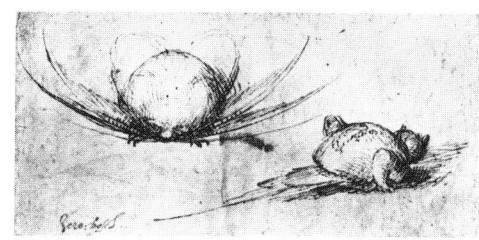

Studies of Monsters Pen, 8,6 × 18,2 cm (each) Berlin, Kupferstichkabinett

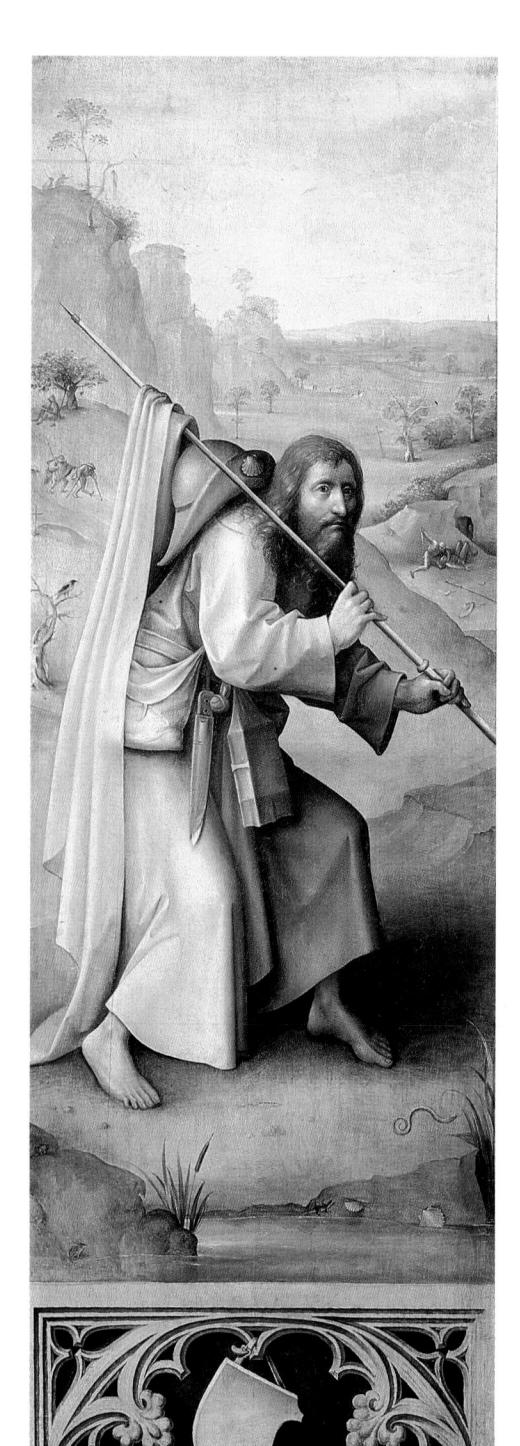

Nowhere, however, was this chronic anxiety of the age given more vivid expression than in Bosch's imposing »Last Judgment« (pp. 37 and 39) triptych in Vienna, executed probably during his middle period. The largest of his surviving works, the »Last Judgment« is prefaced on the outer wings by the figures of St James the Greater and St Bavo, painted in grisaille (left and right). Despite the gloomy and threatening landscape through which St James moves, neither this panel nor its companion prepares us for the apocalyptic scenes which unfold within. Here, across the three inner panels, appear the First and Last Things, beginning with the Fall of Man on the left wing.

The story recounted in the second and third chapters of Genesis has been placed in a lush garden; in the foreground we see the creation of Eve, followed by the temptation of the First Couple. In the middle distance they are driven from the garden by an angel. The expulsion of Adam and Eve from Eden is paralleled above by the expulsion from Heaven of the Rebel Angels, who are transformed into monsters as they descend to earth. Although the revolt of proud Lucifer and his followers is not mentioned in Genesis, it appears in Jewish legends and entered Christian doctrine at an early age. These were the angels who sinned and whose prince, envying Adam, caused him to sin in turn. It was further believed that Adam and Eve had been created by God in order that their offspring might fill the places left vacant by the fallen angels. In this panel, Bosch thus depicted the entrance of sin into the world and accounted for the necessity of the Last Judgment.

The inclusion of the Fall of Adam and Eve in a representation of the Last Judgment is unusual; the other two panels of the Vienna triptych depart even more from traditional iconography. Generally Heaven was allotted the chief role in the eschatological drama. As in the altarpiece by Roger van der Weyden, it is the act of judgment which is stressed; the judged are relegated to positions of secondary importance, and the felicity of the saved is described as fully as the pains of the lost. In Bosch's version, however, the divine court appears small and insignificant at the top of the central panel, and very few souls are numbered among the elect. The majority of mankind has been engulfed in the universal cataclysm which rages throughout the deep, murky landscape below.

This vast panoramic nightmare represents the earth in her final death throes, destroyed not by water as Dürer and Leonardo were to envision it, but by the fire foretold in a thirteenth-century hymn, the sombre »Dies Irae«: »Day of Wrath, that day when the world dissolves in glowing ashes«. Bosch was probably also influenced by the account of the last days given in the Revelation of St John, a book which enjoyed renewed popularity in the late fifteenth century, when it was illustrated by Dürer in his famous »Apocalypse« woodcuts of 1496-97. The wide valley dominating the central panel may represent the Valley of Jehoshaphat, which, on the basis of several Old Testament references (Joel 4:2, 12), was traditionally thought to be the site of the Last Judgment, with the walls of the earthly Jerusalem blazing in the background. In any event, earth has become indistinguishable from Hell, depicted on the right wing, out of which the army of Satan swarms to attack the damned; the eternity of torment has begun.

The mystics claimed that the most grievous pain suffered by the damned in Hell was the knowledge that they were forever deprived of the sight of God. For most people, however, the torments of Hell were chiefly corporeal and so intense that, as one medieval sermon expresses it, the pains of this life will seem but a soothing ointment in comparison. For Bosch, too, the agony of Hell is mainly physical; the pale, naked bodies of the damned are mutilated, gnawed by serpents, consumed in fiery furnaces and imprisoned in diabolic engines of torture. The variety of torments seems infinite. In the central panel, one man is slowly roasted on a spit, basted by an ugly little creature with a bloated belly; nearby, a female demon has sliced up her victim into a frying pan, like a piece of ham, to accompany the eggs at her feet. An infernal concert appears in the right wing, conducted by a black-faced monster.

The Hell scene in the Prado »Tabletop« had paired off each punishment with one of the Deadly Sins; »there is no vice that will not receive its proper retribution«, says Thomas à Kempis, echoing a common belief of the time. Whether or not Bosch consistently followed this formula in the »Last Judgment« would be difficult to determine, although some of the punishments can be identified with specific sins. Thus, the avaricious are boiled in the great cauldron just visible beneath one of the buildings in the central panel. Around the corner, a fat glutton is forced to drink from a barrel held by two devils; the source of his dubious refreshment can be seen squatting in the window overhead. The lascivious woman on the roof above suffers the attentions of a lizard-like monster slithering across her loins, while being serenaded by two musical demons. On the cliffs to the right, across the river, blacksmith-devils hammer other victims on anvils, and one is being shod like a horse; these unfortunate souls are quilty of the sin of anger.

Some of these sins and their punishments can be identified from the inscriptions accompanying the Hell scene of the Prado »Tabletop«. Others occur in the traditional literary descriptions of Hell which flourished during the Middle Ages, generally in the form of visits to the nether regions by persons who returned to tell of their adventures. The best known of these »eyewitness« accounts is, of course, the »Inferno« of Dante, which influenced generations of Italian artists.

Although Bosch followed none of these texts slavishly, he must have been familiar with them. Their influence can be seen not only in his rendering of specific punishments, but also in the general topography of his Hell, including such features as the burning pits and furnaces, and the lakes and rivers in which the damned are immersed. Some of his monsters are also derived from traditional literary and visual sources. The vaguely anthropomorphic devils, such as those in the blacksmith scene of the central panel, occur in many earlier Last Judgement scenes. Traditional, too, are the toads, adders and dragons which crawl over the rocks or gnaw at the vital parts of their victims.

Into this more or less conventional fauna of Hell, however, Bosch introduced new and more frightening species whose complex forms defy precise description. Many display bizarre fusions of animal and human elements, sometimes combined with inanimate objects. To this group belongs the bird-like monster who helps carry a giant knife in the centre

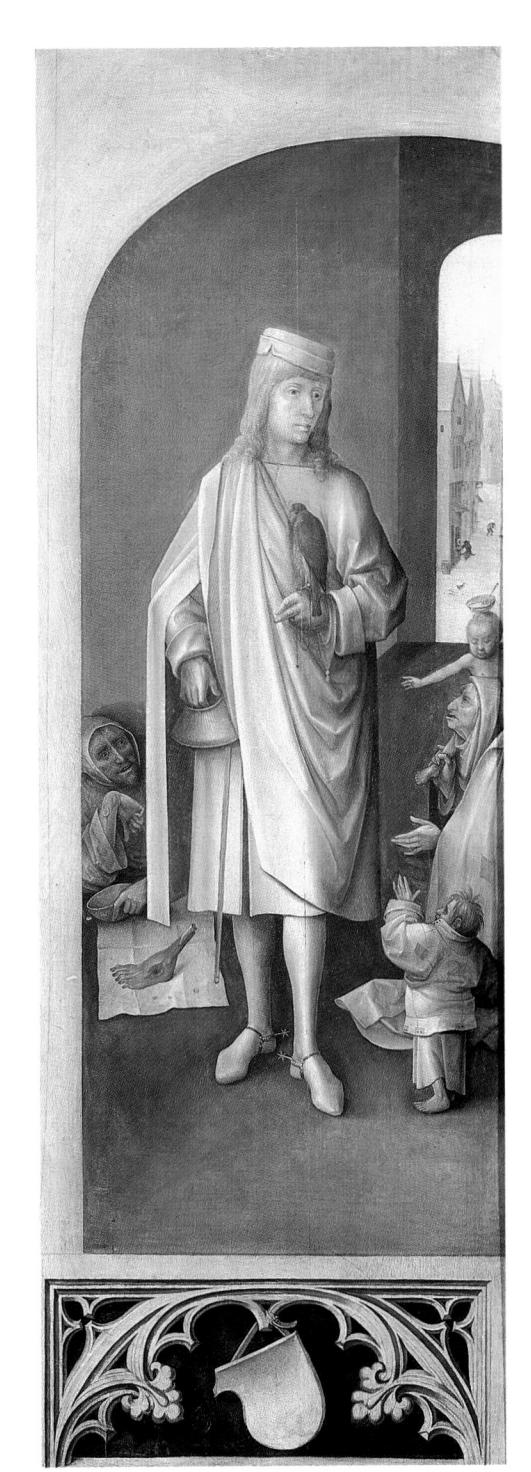

St BavoRight outer wing of the »Last Judgement«
Grisaille on panel, 167 × 60 cm
Vienna, Akademie der bildenden Künste

panel; his torso develops into a fish tail and two humanoid legs, shod in a pair of jars. To the right an upturned basket darts forward on legs, a sword clutched in its mailed fist. Disembodied heads scuttle about on stubby limbs; others possess bodies and limbs which glow in the darkness. Several fiends blow musical instruments thrust into their hind quarters, bringing to mind the farting devil encountered by Dante («Inferno«, XXI, 139).

Not even the dragon which Leonardo da Vinci is reputed to have constructed in the last years of his life could have been as gruesome as Bosch's slithering horrors. And in the way their forms seem to change before our very eyes, Bosch effectively expresses the medieval conception of Hell as a state where the divinely ordained laws of nature have disintegrated into chaos.

In the final analysis, however, it is difficult for us to experience Bosch's Hell as did his contemporaries. Familiar with the conditions of the damned from the »Vision of Tundale« and similar literature, and from innumerable sermons, they would have felt, at least imaginatively, the alternation of extreme heat and cold, and they would have choked on the smoke and the fetid stench arising on every hand. They would have heard the screeching and hissing of the devils and, above all, the cries of the tormented. »Woe, woe, woe to us, the most sinful, wretched sons of Eve!« the damned wail in medieval sermons and books. Some of Bosch's victims clearly express their despair, as, for example, the screaming souls herded together beneath the tent in the right wing. Others, it is true, stare blankly before them, but it must not be assumed that they have become anaesthetized against pain. The Middle Ages thought otherwise. Not only did the agony of the damned persist at its highest intensity, but even the most horribly mutilated souls were perpetually made whole again, to commence their sufferings anew. And this process continued not for a time, but for all eternity.

The Vienna triptych shows the Last Judgment which embraces all men, an event which terminates all human history. In the »Vision of Tundale«, however, and in other sources which influenced Bosch, the torments of the damned are described as if happening in the present, in Purgatory, rather than at some unspecified time in the future. They reflect a belief in a particular judgment, a private reckoning to which each person must submit immediately upon his death; according to his merits, he was then dispatched to a place of torment or bliss, there to await the Last Judgment. Widespread during the later Middle Ages, this doctrine was treated by Denis the Carthusian in his »Dialogue on the Particular Judgment of God«, and, as Albert Châtelet* has shown, it inspired two panels by Dirk Bouts. These, in turn, were the model for four panels by Bosch, the so-called »Paradise« and »Hell« panels, preserved in the Palace of the Doges in Venice (pp. 40/41).

It has been assumed that these panels once formed the wings of a Last Judgment altarpiece; more probably, however, they were originally intended as independent works illustrating the rewards and pains of the Particular Judgment. The pictures have been disfigured by heavy overpainting and darkened varnish, and critics are not unanimous in attributing them to Bosch; nevertheless, it would be difficult to ascribe their compositions to anyone else. In the »Paradise« pair, the left-hand panel depicts the

Paradise

Left wing of the »Last Judgement« triptych Oil on panel, 167,7 × 60 cm Vienna, Akademie der bildenden Künste

Hell

Right wing of the »Last Judgement« triptych Oil on panel, 167 × 60 cm Vienna, Akademie der bildenden Künste

^{*} A. Châtelet: »Sur un Jugement Dernier de Dieric Bouts«. In: »Nederlands Kunsthistorisch Jaarboek«, XVI (1965), 17-42.

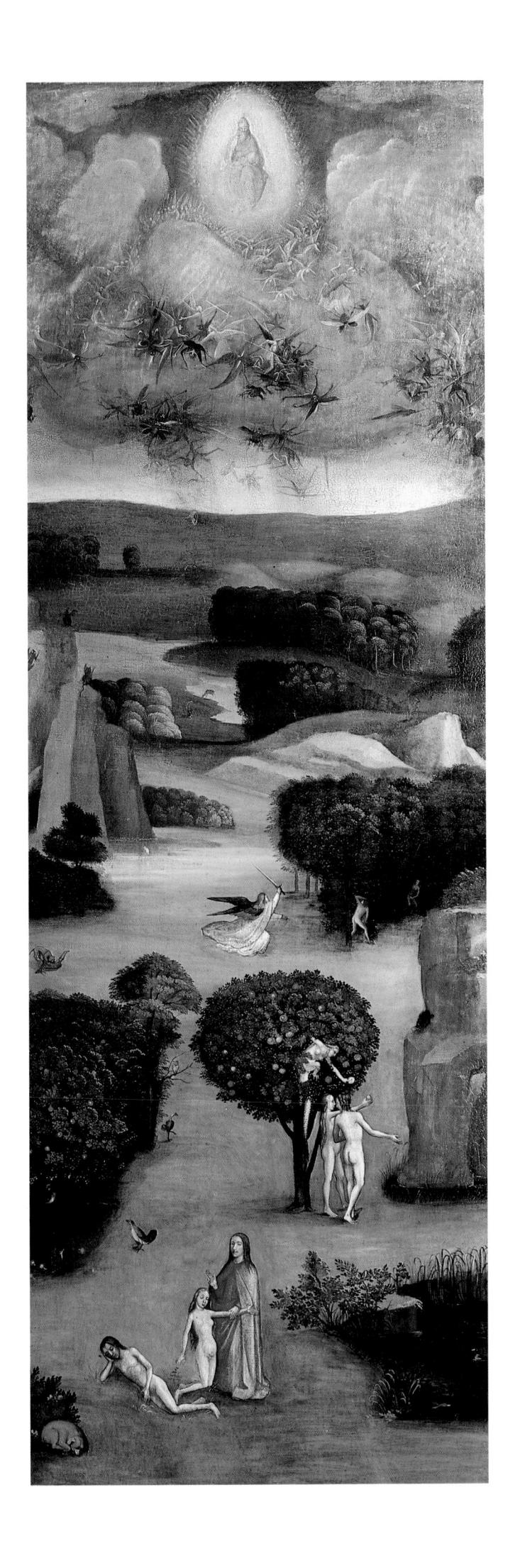

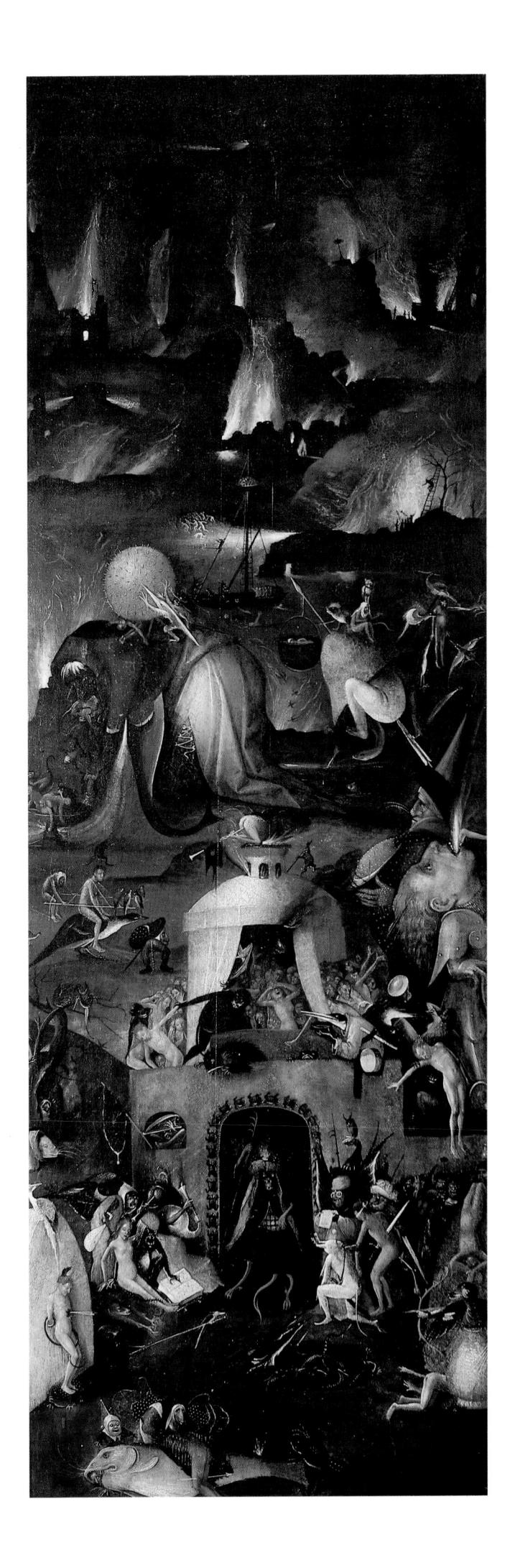

elect shepherded by angels into a rolling landscape from which rises the Fountain of Life; this is the Terrestrial Paradise, a sort of intermediate stage where the saved were cleansed of the last stain of sin before being admitted into the presence of God. Already one group of souls looks expectantly upwards. Several such gardens are described in the »Vision of Tundale«, and the Terrestrial Paradise, placed directly beneath Heaven, is shown in many mystery plays of the period. It was frequently identified with the Garden of Eden, thought to still exist on earth on some remote mountain inacessible to man, a belief which probably influenced the steep terrain to be seen in the Terrestrial Paradise as seen by Bouts and Bosch.

In his composition Bosch followed Bouts's »Terrestrial Paradise « fairly closely, departing from it in only one significant respect. Whereas Bouts depicted the actual entry of the saved into Heaven in the sky above, Bosch reserved this scene for a separate panel presenting a vision of celestial joy that was utterly beyond the powers of the more earthbound Bouts. Shedding the last vestige of their corporeality, the blessed souls float upwards through the night, scarcely supported by their angelic guides. They gaze with ecstatic yearning towards the great light which bursts through the darkness overhead. This funnel-shaped radiance, with its distinct segments, probably owes much to contemporary zodiacal diagrams, but in Bosch's hands it has become a shining corridor through which the blessed approach that final and perpetual union of the soul with God which is experienced on earth only in rare moments of spiritual exaltation. »Here the heart opens itself in joy and in desire«, Ruysbroeck tells us, »and all the veins gape, and all the powers of the soul are in readiness. « Suso describes how the tremulous, enraptured soul is conducted above the ninth heaven. into the »coelum empyreum«, the flaming heaven, there to gaze at the »immeasurable, all-pervading immovable, incorruptible brightness«, and to sink into the »infinite solitude and profound abyss« of the naked Godhead. With such poetic language the medieval mystic sought to express the Beatific Vision, but no artist before Bosch had clothed it with a visual form of comparable power.

The ascent of the blessed into the »coelum empyreum« is balanced in the third panel by the descent of the damned into the pit of Hell. Bosch followed Bouts's version of this subject, but once again he transformed the prosaic images of his model. The damned hurtle past in the darkness, seized upon by devils and scorched by Hellfire spitting through fissures in the rocks. In the final panel, Purgatory, a craggy mountain belches forth flames against a fiery sky, while the souls struggle helplessly in the water below. Not all the torments are physical: oblivious to the bat-winged devil tugging at him, one soul sits on the shore in a pensive attitude, seemingly overwhelmed by remorse. Hell, no less than Heaven, has been interpreted in the spiritual sense of the mystics.

In his use of light to express the most ineffable concepts of the Divine, Bosch approaches Geertgen tot Sint Jans and the great German masters of the early sixteenth century. In Geertgen's enchanting little »Madonna and Child« in Rotterdam, the tiny celestial musicians glow to incandescence in the ardour of their love for the Infant Christ. No less ecstatic are Albrecht Altdorfer's magically lighted »Nativity« of c. 1513 and the angelic jubilation in the Christmas panels of the Isenheim altarpiece,

Last JudgementCentral panel of the triptych
Oil on panel, 163,7 × 127 cm
Vienna, Akademie der bildenden Künste
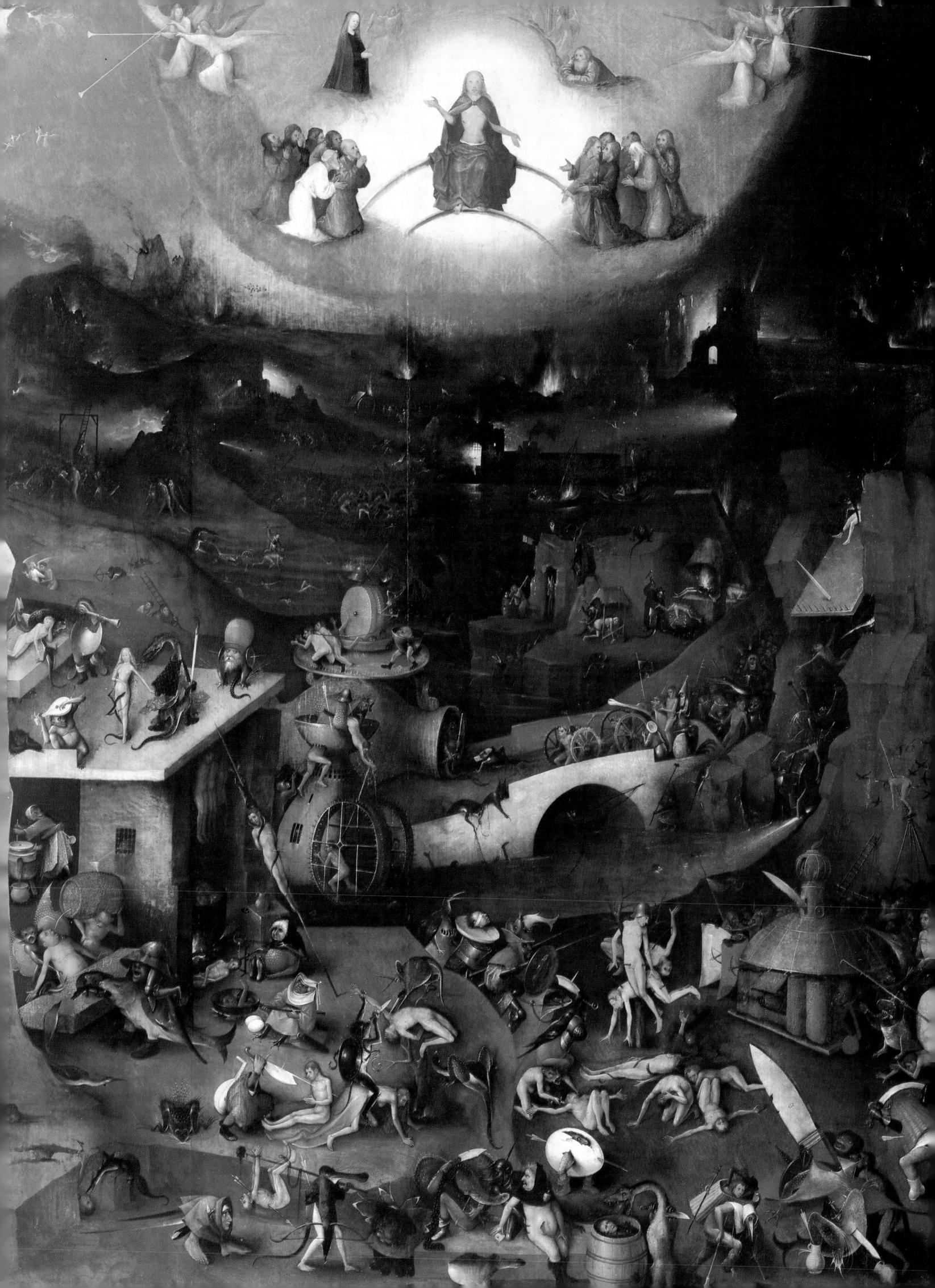

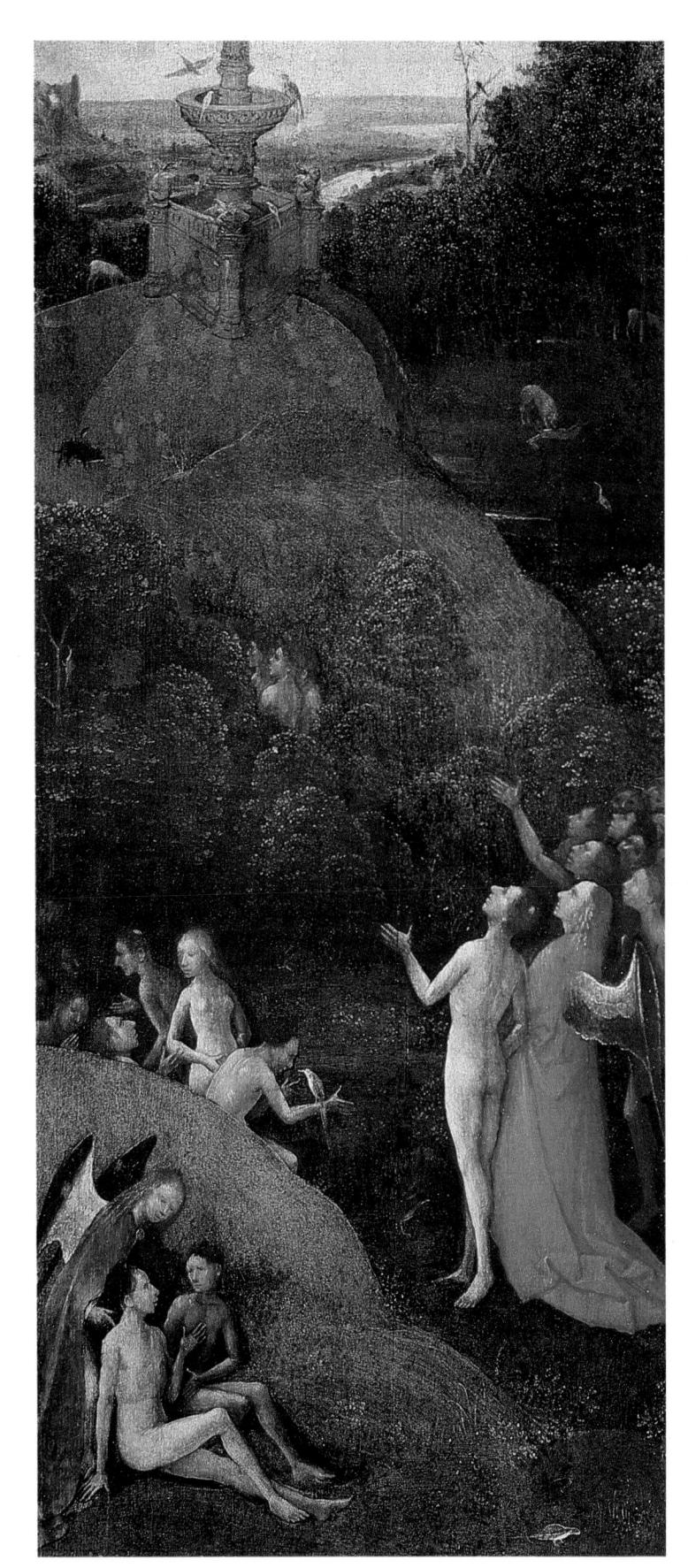

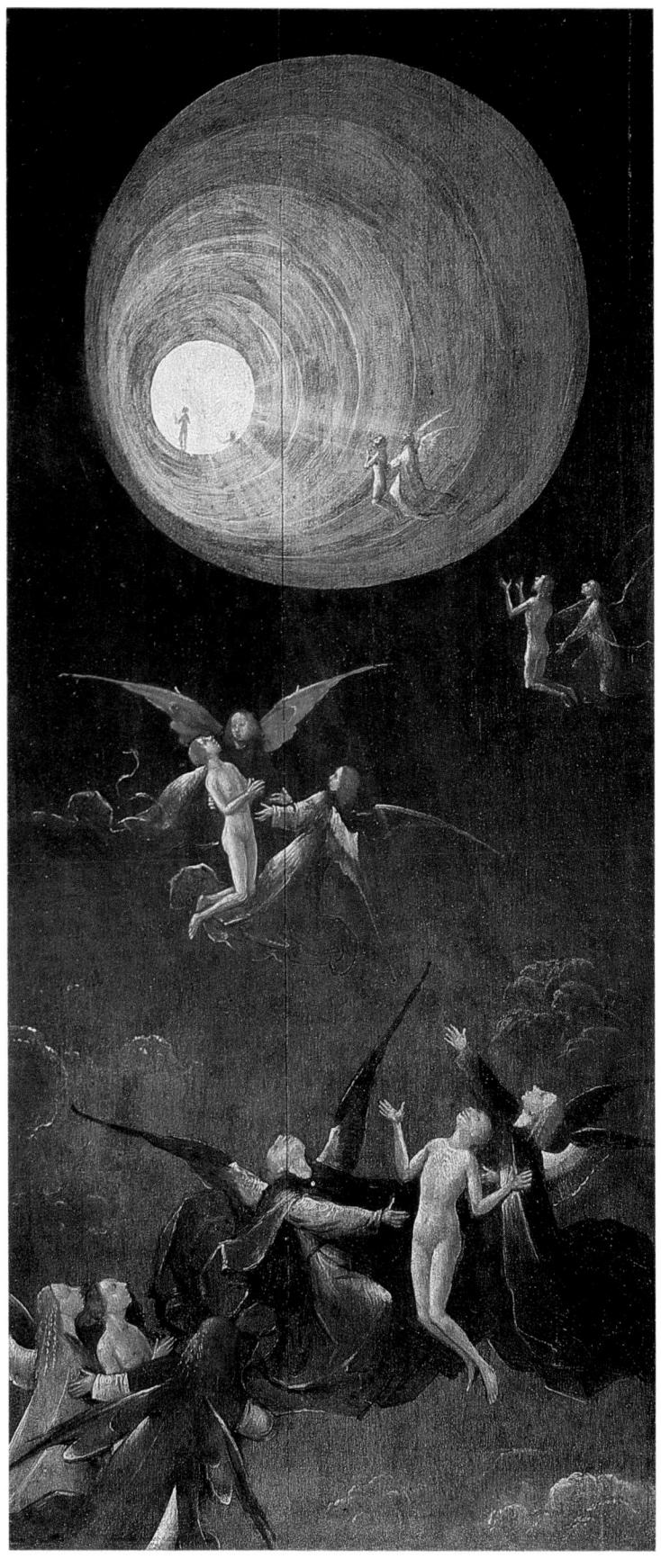

»PARADISE« AND »HELL« PANELS: Oil on panel, 86,5 × 39,5 cm (each) Venice, Palazzo Ducale

Terrestrial Paradise and Ascent of the Blessed

completed by Mathis Grünewald about the time of Bosch's death. In the succinctness and simplicity of their imagery, the two Venice »Hell« panels remain unique in Bosch's work. Elsewhere he portrayed the fauna of Hell in inexhaustible variety. In a group of drawings attributed to Bosch with

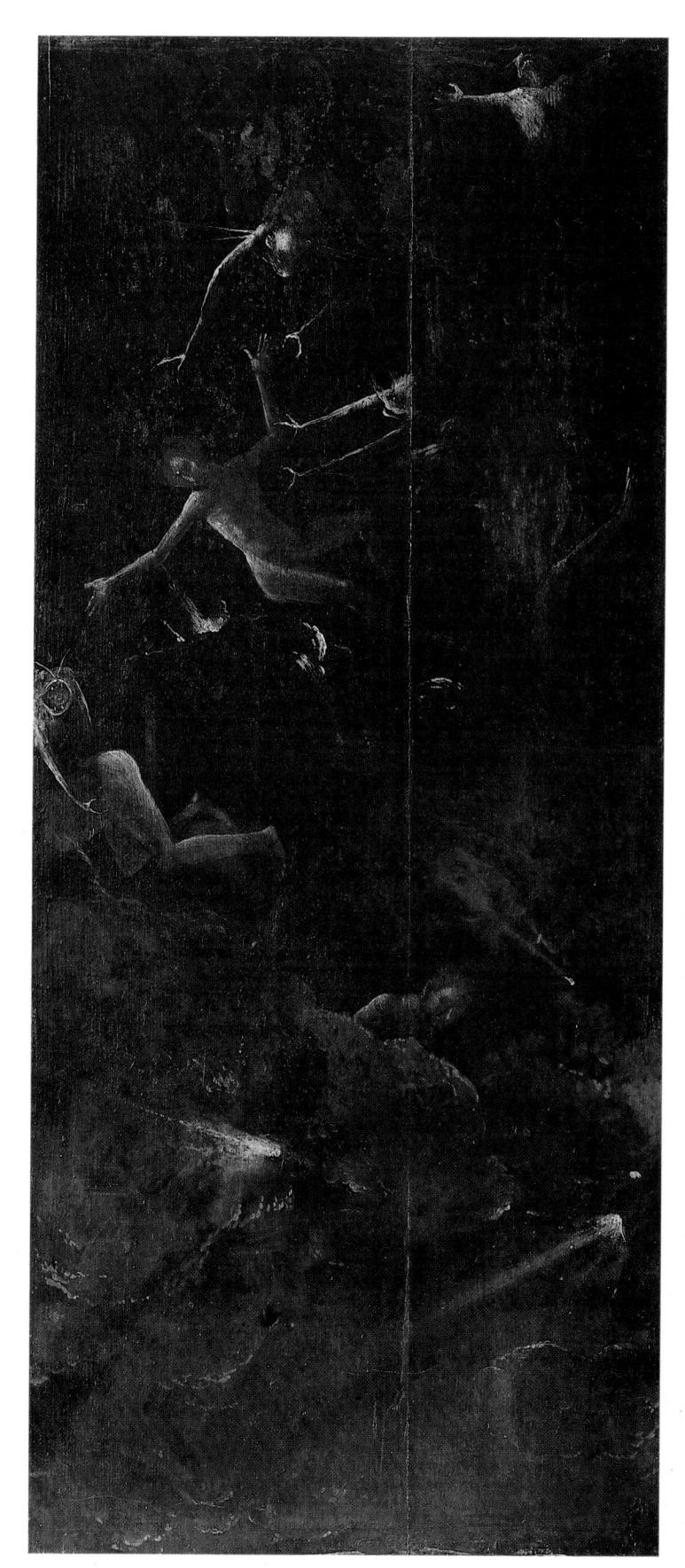

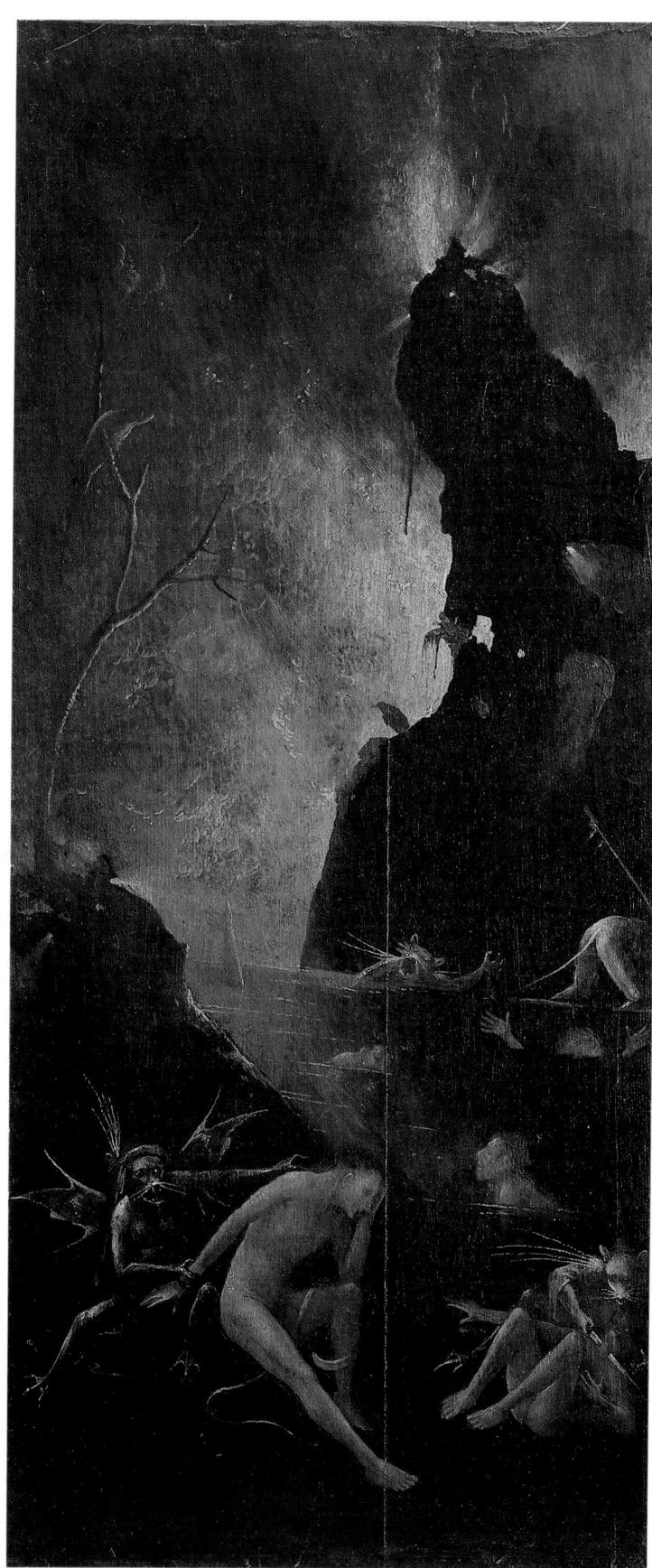

reasonable certainty, monsters proliferate in a multitude of shapes, no two exactly alike (pp. 50/51). Legs sprout from grotesquely grinning heads, obscene bladder-like forms develop snouts and legs; some creatures are all head or rump. This taste for monsters Bosch shared with his age, which

Fall of the Damned and Hell

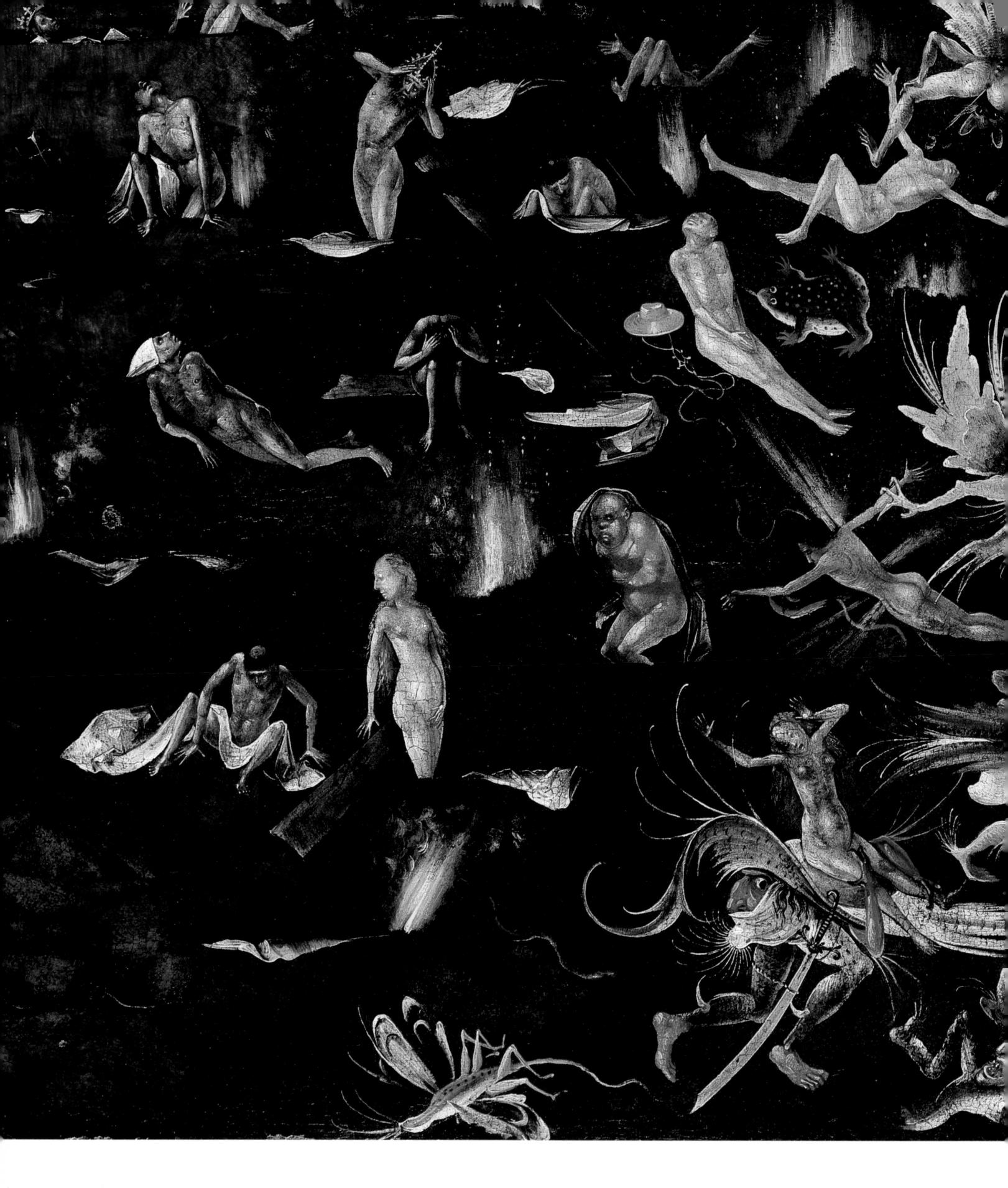

Last Judgement (Fragment) Oil on panel, 60 × 114 cm Munich, Alte Pinakothek

was fascinated by the grotesque and the unnatural. In an engraving, Dürer recorded for posterity the likeness of an eight-legged pig born in 1496, while Sebastian Brant published woodcuts announcing monstrous births and similar prodigies. These were often interpreted as portents of impending disaster sent from God as punishment for sinful mankind. In

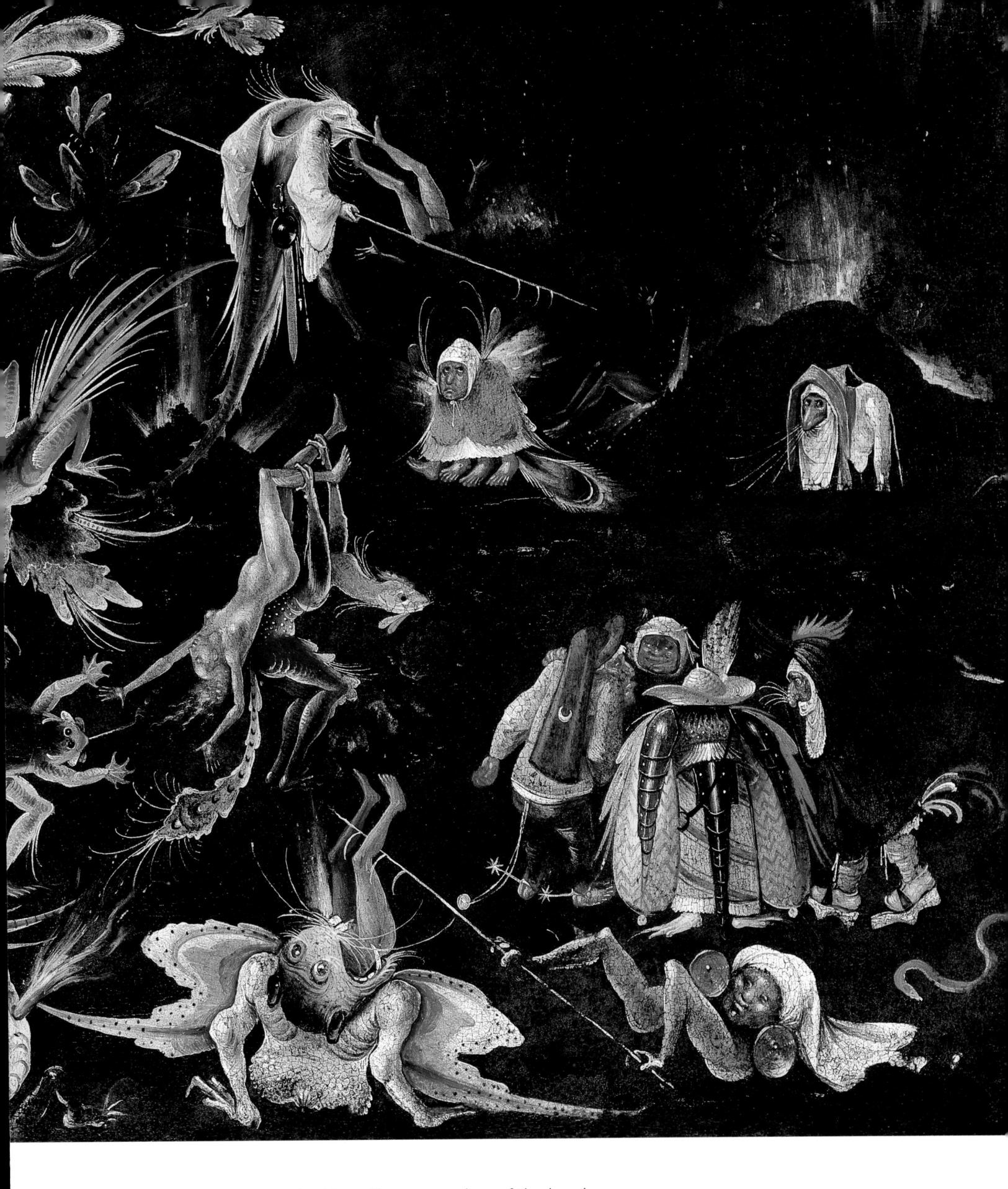

his sketches, however, executed with swift, sure strokes of the brush or pen, Bosch is no longer the medieval moralizer, but the artist vying with the Creator himself in generating new forms »the like of which «, as Dürer would later describe the fruits of artistic genius, »was never seen before nor thought of by any other man «.

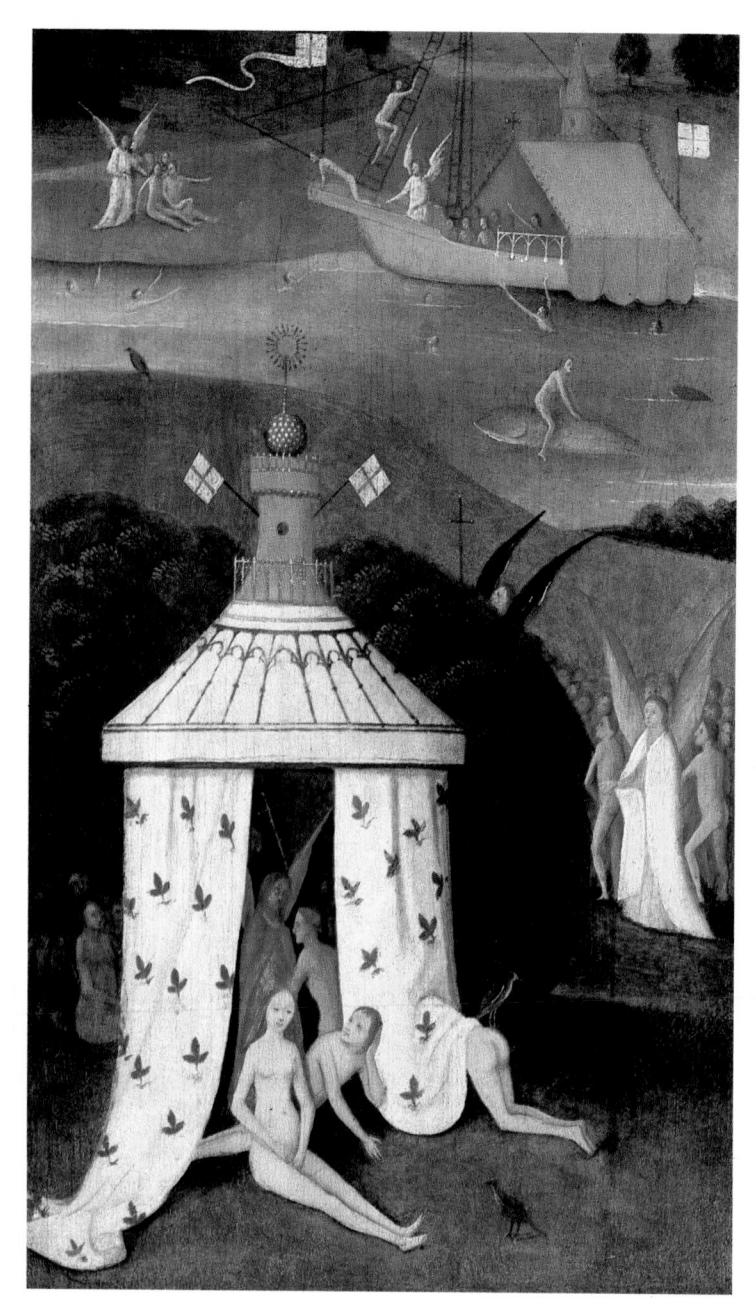

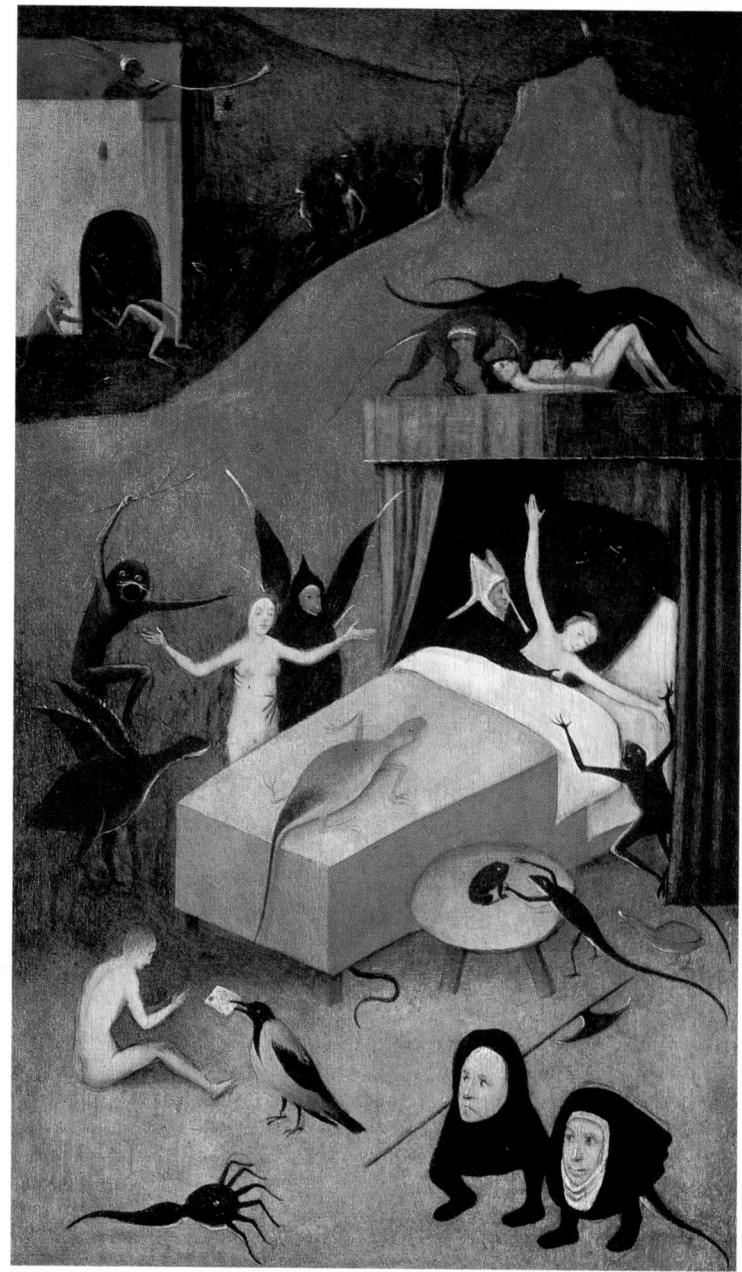

FRAGMENT OF A »LAST JUDGEMENT«:

Paradise

Oil on panel, 33.9×20 cm New York, Private Collection

Death of the ReprobateOil on panel, 34,6 × 21,2 cm
New York, Private Collection

This same attitude is no less apparent in the sadly damaged »Last Judgment« fragment in Munich (pp. 42/43). It is occasionally identified as part of the altarpiece commissioned by Philip the Handsome in 1504, but was probably done somewhat later, towards the end of Bosch's life. A piece of drapery visible in the lower left-hand corner is all that remains of a figure which must have been much larger in scale than the other figures in the fragment. Perhaps it represented an oversized St Michael in the act of weighing souls, such as appears in Roger van der Weyden's triptych at Beaune. Behind and to the right of the drapery, the resurrected slowly climb out of their graves, among others, a king and several ecclesiastics, all distinguished by their headdresses. Around them dart monsters whose gossamer wings and long waving filaments and antennae glow against the dark ground. It is difficult to remember that these jewel-like, delicately luminous creatures are engaged in tormenting the damned. Hell, for once, has become an aesthetic delight.

The Triumph of Sin

Traditional Last Judgement scenes usually represented the resurrected divided into approximately equal numbers of the saved and the damned. This vision of mankind's prospects at the bar of Divine Justice seems almost frivolously optimistic, however, when compared with the grim interpretation of Doomsday presented in the Vienna triptych. For Bosch, sin and folly are the universal conditions of mankind, Hellfire its common destiny. This deeply pessimistic view of human nature was further developed by Bosch in two other triptychs, the »Haywain« and the »Garden of Earthly Delights«, both probably later in date than the Vienna »Last Judgment«, but related to it in format.

The »Haywain« triptych exists in two versions, one in the Escorial (pp. 48/49 and 62), the other in the Prado, Madrid (p. 46). Both are in poor condition and have been heavily restored, and scholars disagree as to which is the original. In each instance, however, the outer wings, to which we will revert, can only have been executed by a rather clumsy workshop hand. As in the Vienna »Last Judgment«, the left inner wing presents the Creation and Fall of Man (reversing, however, the sequence of episodes from foreground to background) and the expulsion of the Rebel Angels, while the right wing is occupied by a view of Hell. The central panel, however, presents a new image: a great haywain lumbering across a vast landscape and followed by the great of this world on horseback, including an emperor and a pope (who has been identified as Alexander VI). The lower classes – peasants, burghers, nuns and clergy – snatch tufts of hay from the waggon or fight for it among themselves. In a variation of the theme of the Prado »Tabletop«, this frantic activity is witnessed by Christ who appears, insignificant and resigned, in a golden glory above. Except for an angel praying on top of the haycart, however, no one notices the Divine Presence; and, above all, no one notices that the waggon is being pulled by devils towards Hell and damnation.

This curious vehicle may remind us of the ship which Brant employs in his »Ship of Fools«, but Bosch's waggonload of hay is not simply an expeditious means of getting to Hell; it illustrates, in fact, one specific aspect of human frailty of which hay was a traditional symbol. A Netherlandish song of about 1470 tells us that God has heaped up good things on the earth like a stack of hay for the benefit of all men, but that each man wants to keep it all to himself. But since hay is of little value, it also symbolizes the worthlessness of all worldly gain. This is certainly the meaning of the allegorical haycarts which appeared in several Flemish engravings after 1550. A haycart also formed part of a religious procession at Antwerp in 1563; according to a contemporary description, it was ridden

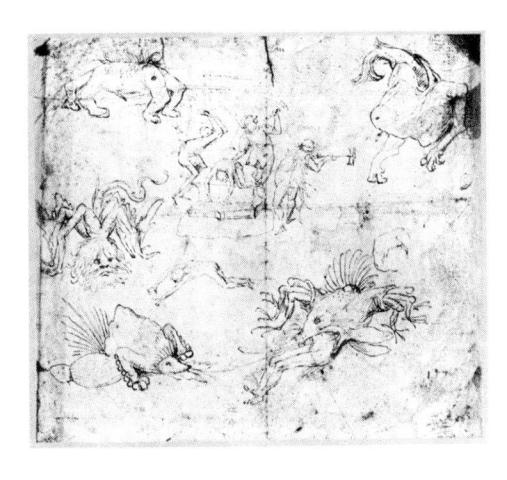

Scenes in HellPen and bistre, 16,3 × 17,6 cm
Berlin, Kupferstichkabinett

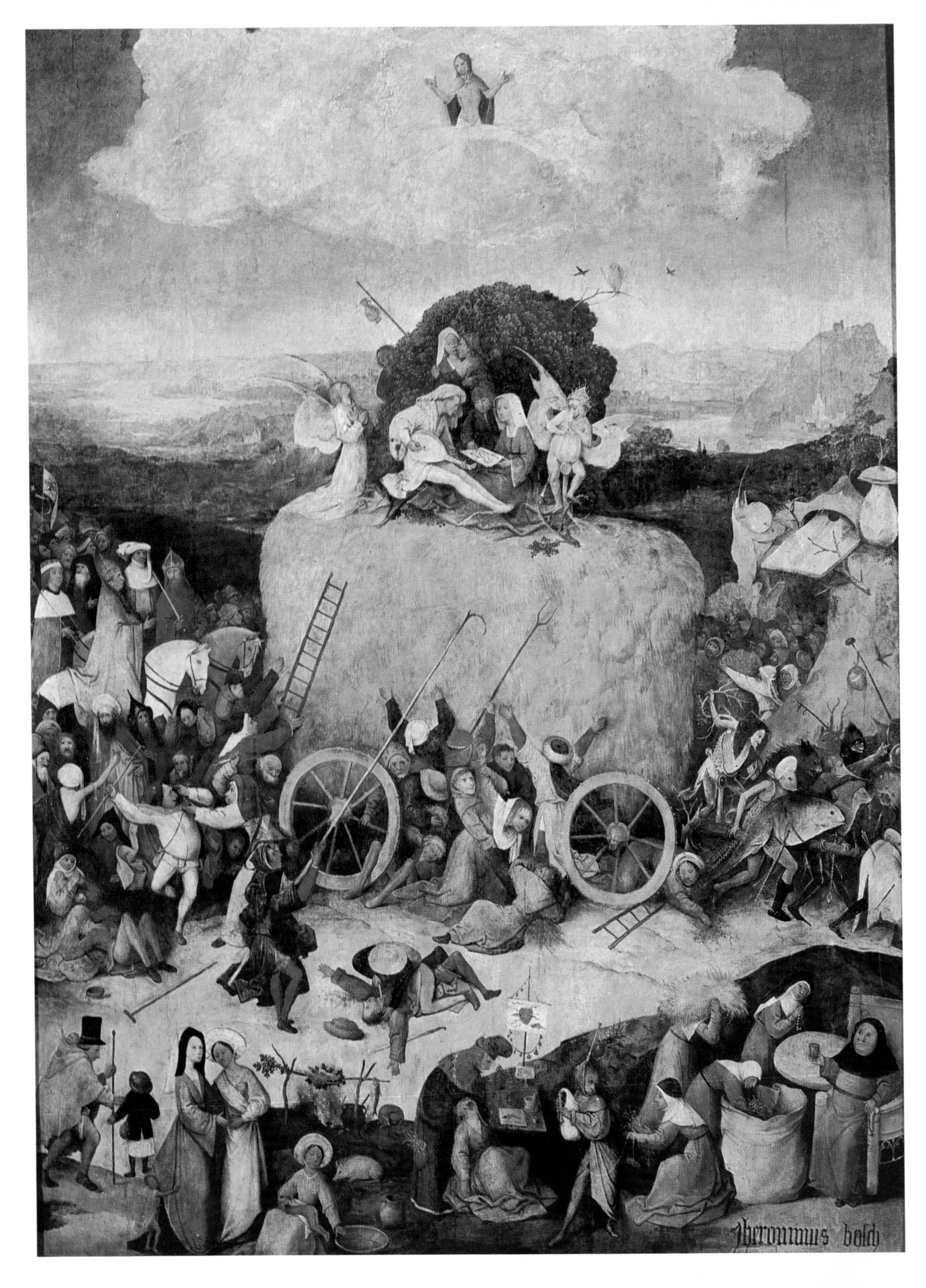

by a devil named Deceitful, and followed by all sorts of men plucking the hay, so as to show that worldly possessions are "al hoy" (all hay). "In the end it is all hoy", echoes a song of the same period.

All these haycarts appeared some years after Bosch's death, most probably inspired by his »Haywain« triptych, but it is reasonable to assume that the latter work possessed the same significance. The fact that the haycart of 1563 was a carnival waggon has led some scholars to suggest that Bosch, in turn, was influenced by similar floats. However this may be, the general arrangement of his haywain with its many attendants recalls the allegorical processions, especially the »Triumphs« of Francesco Petrarch, which appear in so many tapestries and engravings of the fifteenth and sixteenth centuries. Bosch may have had such examples in mind when he composed his own Triumph of Sin.

Like the »Tabletop of the Seven Deadly Sins«, thus, the »Haywain« shows mankind given over to sin, completely unmindful of God's law and oblivious to the fate which he has prepared for them. In this image, however, Bosch focuses on one of the Deadly Sins: the desire for worldly gain, or Avarice, whose sub-categories are elaborated in the adjacent figure groups very much as they are in the old handbooks on the Virtues and Vices. As we are warned in the »King's Dream«, written by Laurent Gallus in 1279. Avarice leads to discord, violence and even murder, all of which are graphically depicted in the open space before the cart. If the princes and prelates complacently jog along behind the cart, holding themselves aloof from this struggle, it is because the haystack is, so to speak, already in their possession; they are guilty of the sin of Pride. Avarice also leads men to cheat and deceive; the man wearing a tall hat and accompanied by a child at lower left is most likely a false beggar, like the ones patronized by Old Avarice in Deguilleville's »Pilgrimage of the Life of Man«. The quack physician in the centre has set up his table with charts und jars designed to impress his victim; the purse at his side stuffed with hay alludes to his ill-gotten gains. Several nuns at lower right push hav into a large bag, supervised by a seated monk whose gluttonous tendencies are revealed by his ample waist.

The meaning of some of the other groups remains unclear, and we may also wonder at the presence of the lovers on top of the haystack. That they illustrate the sin of Lust we know from the appearance of similar figures in the Prado »Tabletop«, but it might be argued that the pursuit of the pleasures of the flesh involves the expenditure rather than the accumulation of earthly goods. A class distinction may perhaps be observed between the rustic couple kissing in the bushes and the more elegantly dressed group making music. Their music is certainly that of the flesh, for the devil near by, piping some lascivious tune through his nose, has already lured their attention from the angel praying at the left.

Such details serve to reinforce Bosch's basic theme of the triumph of Avarice; and the image of the haywain itself has yet another metaphorical function. In the sixteenth century, hay also possessed connotations of falsehood and deceit, and to »drive the haywain« with someone was to mock or cheat him. When we read that the demon who rode on the haywain of 1563 was called »Deceitful«, and note that the musical devil on top of the Prado haywain is blue, the traditional colour of deceit, the full

Haywain

Central panel of the triptych Oil on panel, 135 × 100 cm Madrid, Museo del Prado

PAGE 48/49:

Haywain (Triptych)

Oil on panel, 147 × 232 cm

El Escorial, Monasterio de San Lorenzo

EFT WING:

Paradise

Oil on panel, 147×66 cm

RIGHT WING

Hell

Oil on panel, 147×66 cm

CENTRAL PANEL:

Haywain

Oil on panel, 140×100 cm

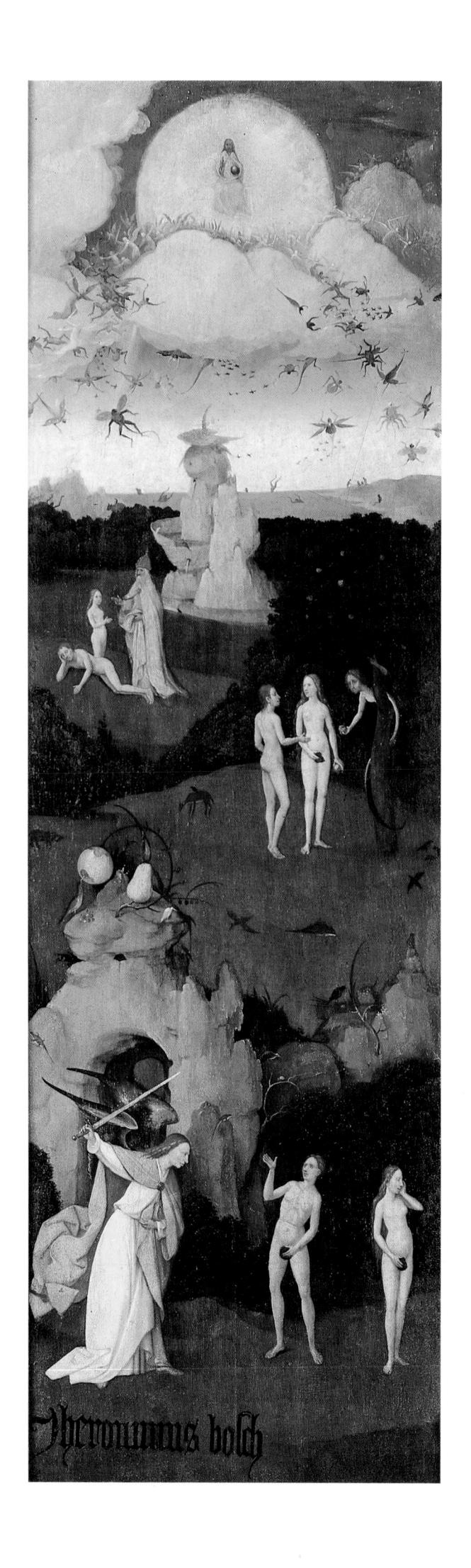

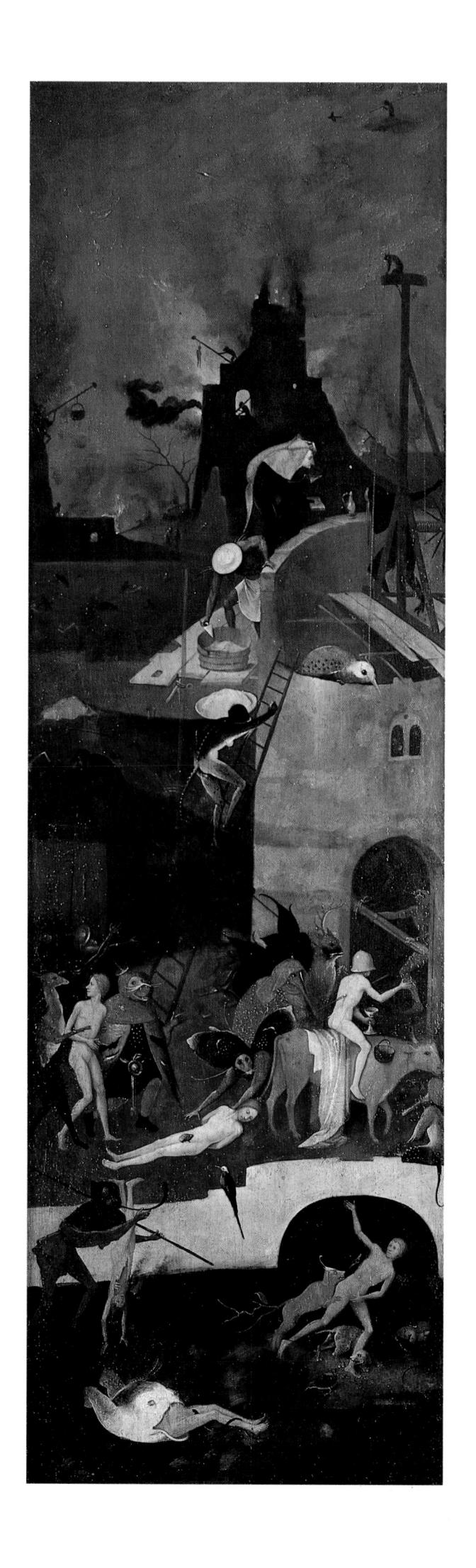

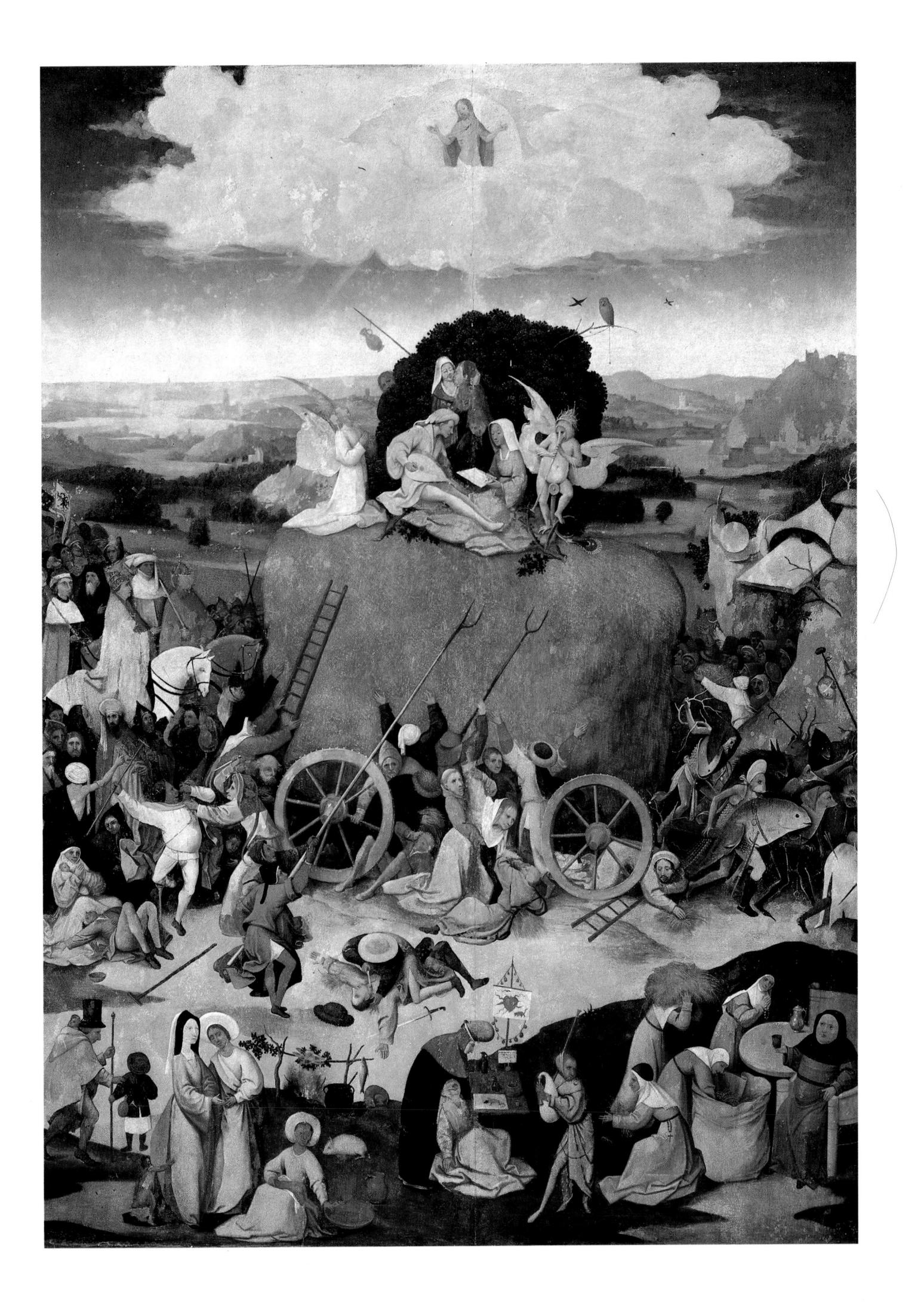

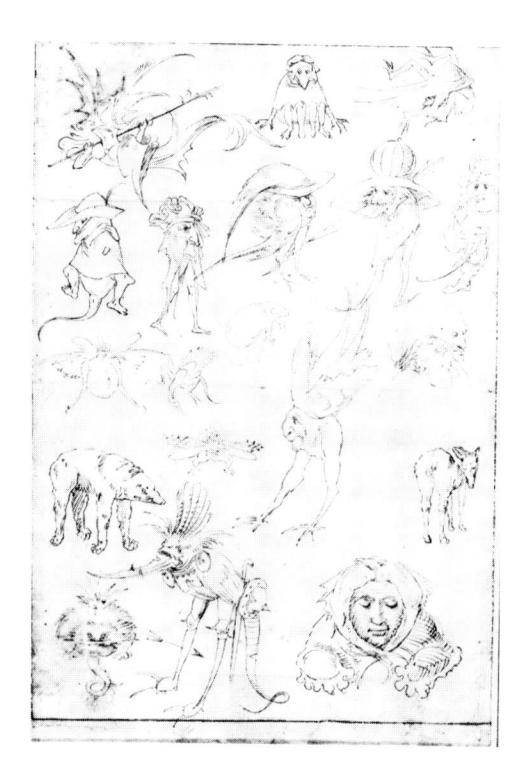

Studies of Monsters Pen and bistre, 31,8 × 21 cm Oxford, Ashmolean Museum

implications of Bosch's load of hay become clear. Not only have wordly goods and honours no intrinsic value, they are also employed by Satan and his army as bait to lure men to destruction.

In composition, the Hellscape of the right wing of the »Havwain« stands between the discursive panorama of the Vienna »Last Judgment« and the monumental simplicity of the »Hell« panel at Venice. Reminiscent of the latter work, too, are the tall blasted ruin silhouetted against the flaming background and the damned souls struggling helplessly in the lake below, although the foreground is dominated by a new motif, a circular tower whose process of construction is shown in circumstantial detail. One demon climbs a ladder with fresh mortar for the devil masons on the scaffolding above, while a black-skinned companion raises a floor beam with a hoist. The significance of this feverish activity is not clear. Towers abound in medieval descriptions of Hell, but the devils are usually too busy ministering to their victims to engage in such architectural enterprises. However, St Gregory reports a vision of Heaven in which houses were constructed of golden bricks, each brick representing an »almsdeed« or charitable act by someone on earth, and were intended to receive the souls of the good. Perhaps Bosch has represented the hellish counterpart of these heavenly mansions, in which avarice, and not almsdeed, supplies the stones. In his account of the »Haywain« triptych in 1605, Sigüenza expresses a similar thought when he describes the tower as being built to accommodate all those entering Hell; the stones are the »souls of the wretched damned«. On the other hand, Bosch's tower may be a parody of the infamous Tower of Babel with which men sought to storm the gates of Heaven itself. In this case it would symbolize Pride, the sin which caused the fall of the Rebel Angels and which is exemplified by the worldly prince and prelate and their retinue behind the haywain.

Other punishments can calso be related to the sins illustrated in the central panel. On the bridge leading to the infernal tower, a squad of devils torments a poor naked soul astride a cow. This hapless figure was probably inspired by the vision of Tundale, who, during his tour of Hell, was forced to lead a cow across a narrow bridge as punishment for stealing one of his neighbour's cattle. On the bridge he encountered those who had robbed churches and committed other acts of sacrilege, a detail which may have suggested the eucharistic chalice clutched by Bosch's figure. The man on the ground with a toad gnawing his genitals suffers the fate of lechers, while greed is appropriately punished by a fish-like monster in the foreground. Above him, a hunterdevil sounds his horn from the left, his human quarry gutted like a rabbit and dangling upside down from a pole. Several dogs rush ahead of their master to bring down a couple beneath the bridge.

Complex though its ramifications may be, the basic meaning of the »Haywain« is relatively simple. Even if we know nothing about the metaphorical use of hay in the sixteenth century, we can easily grasp the fact that Bosch is commenting on an unpleasant aspect of human nature. But this is not true of the triptych known variously as the »Garden of Earthly Delights« or the »Earthly Paradise« (pp. 54-55).

At first sight, the central panel confronts us with an idyll unique in Bosch's work: an extensive park-like landscape teeming with nude men

and women who nibble at giant fruits, consort with birds and animals, frolic in the water and, above all, indulge in a variety of amorous sports overtly and without shame. A circle of male riders revolves like a great carousel around a pool of maidens in the centre and several figures soar about in the sky on delicate wings. This triptych is better preserved than most of Bosch's large altarpieces, and the carefree mood of the central panel is heightened by the clear and even lighting, the absence of shadows, and the bright, high-keyed colours. The pale bodies of the inhabitants, accented by an occasional black-skinned figure, gleam like rare flowers against the grass and foliage. Behind the gaily coloured fountains and pavilions of the background lake, a soft line of hills melts into the distance. The diminutive figures and the large, fanciful vegetable forms seem as harmless as the medieval ornament which undoubtedly inspired them, and when we stand before this picture, it is difficult not to agree with Fraenger's insistence that the nude lovers »are peacefully frolicking about the tranquil garden in vegetative innocence, at one with animals and plants, and the sexuality that inspires them appears to be pure joy, pure bliss«. Indeed, we might be in the presence of the childhood of the world, the Golden Age described by Hesiod, when men and beasts dwelt in peace together and the earth yielded her fruit abundantly and without effort. Or to put it in more contemporary terms, Bosch's garden appears to be a sort of universal love-in.

Nevertheless, it must be denied that this crowd of naked lovers was intended as an apotheosis of innocent sexuality. The sexual act, which the twentieth century has learned to accept as a normal part of the human condition, was most often seen by the Middle Ages as proof of man's fall from the state of angels, at best a necessary evil, at worst a deadly sin. That Bosch and his patrons shared fully in this view we know, of course, from the contexts in which lovers appear in his other works, and is further confirmed by the fact that his garden, like the haywain, is situated between Eden and Hell, the origin of sin and its punishment. Hence, just as the "Haywain" depicts worldly gain or Avarice, so the "Garden of Earthly Delights" depicts the sensual life, more specifically the deadly sin of Lust.

Various aspects of this sin are acted out in a forthright fashion, by the couple enclosed in a bubble at the lower left, for example, or the pair near by concealed in a mussel shell; other figures seem to display perverted acts of love, such as the man plunged head first into the water and shielding his privy parts with his hands or, at lower right, the youth who thrusts some flowers into the rectum of his companion. Along with these fairly obvious representations, however, the carnal life is also alluded to in metaphorical or symbolic terms. The strawberries which figure so prominently in the landscape, for instance, probably symbolize the unsubstantial quality of fleshly pleasure; this was the conclusion of Sigüenza who speaks of the »vanity and glory and transient taste of strawberries or the strawberry plant [whose] fragrance one can hardly smell when it passes«. The strawberry is thus analogous to the hay in the »Haywain«.

The »Garden of Earthly Delights« triptych has been carefully studied by Dirk Bax*, whose extensive knowledge of older Dutch literature has led him to identify many of the forms in the central panel – fruit, animals, the exotic mineral structures in the background – as erotic symbols inspired by

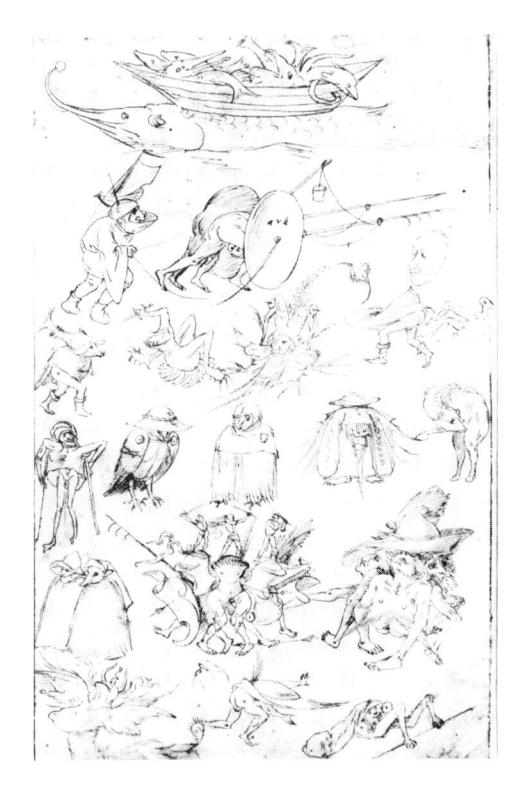

Studies of Monsters Pen and bistre, 31,8 × 21 cm Oxford, Ashmolean Museum

^{*} Dirk Bax: »Beschrijving en poging tot verklaring van het Tuin der onkuisheiddrieluik van Jeroen Bosch, gevolgd door kritiek op Fraenger«, Amsterdam 1956.

Creation of the WorldOuter wings of the triptych »Garden of Earthly Delights«
Grisaille on panel, 220 × 195 cm
Madrid, Museo del Prado

the popular songs, sayings and slang expressions of Bosch's time. For example, many of the fruits nibbled and held by the lovers in the garden serve as metaphors of the sexual organs; the fish which appear twice in the foreground occur as phallic symbols in Old Netherlandish proverbs. The group of youths and maidens picking fruit in the right middleground also possesses erotic connotations: »to pluck fruit« (or flowers) was a euphemism for the sexual act. Most interesting, perhaps, are the large,

hollow fruits and fruit peelings into which some of the figures have crept. Bax sees them as a play on the medieval Dutch word »schel« or »schil«, which signified both the »rind« of a fruit and »quarrel« or »controversy«. Thus, to be in a »schel« was to engage in a struggle with an opponent, and this included the more pleasant strife of love. Moreover, the empty rind itself signified worthlessness. Bosch could have chosen no more appropriate a symbol for sin, for it was, after all, a fruit that brought about the fall of Adam.

In the first place, it is significant that Bosch conceived his image of carnal delight as a great park or garden-like landscape. The garden had functioned for centuries as a setting for lovers and love-making. The most famous medieval love garden was the one described in the »Romance of the Rose«, a long allegorical poem of the thirteenth century; translated into many languages including Dutch, it also inspired numerous imitations in later literature and art. These love gardens invariably contain beautiful flowers, sweetly singing birds and a fountain in the centre around which the lovers gather to stroll or sing, as can be seen in many tapestries and engravings of Bosch's day. That Bosch was familiar with this tradition cannot be doubted. An abbreviated love garden appears in an engraving by his associate Alart du Hameel, and Bosch himself employed similar elements in one of his earlier images of Lust, on the Prado »Tabletop«. In the »Garden of Earthly Delights«, of course, he incorporated much more of its traditional iconography, including the fountain and pavilions which dominate the lake in the background. These curiously wrought, glittering forms are, in fact, hardly more fantastic than the fountains and buildings, constructed of gold, coral, crystal and other precious materials, which are described in many literary »Gardens of Love«.

Although the »Garden of Earthly Delights« thus owes much to the conventional love gardens, the inhabitants of the latter generally behave much more discreetly; very seldom do they frisk about naked or make love in the water. Nevertheless, the association of love and love-making with water was firmly established by Bosch's day. In scenes of the »labours of the months«, May, the time of love, was illustrated by lovers embracing in a tub of water. Even representations of the Fountain (or Pool) of Youth frequently received an erotic twist. While Bosch does not, strictly speaking, show a Fountain of Youth, as no one is being rejuvenated, this or similar prints may have inspired the outdoor water sports of the »Garden of Earthly Delights«.

To the Garden of Love and the Bath of Venus can be added a third major theme in the »Garden of Earthly Delights«. The background lake is given over to mixed bathing, but in the middle section the sexes are carefully segregated. The circular pool is occupied only by women, while the men ride around it on the backs of animals of different species. The antics of the acrobatic riders, one somersaulting on the back of his mount, suggest that they are excited by the presence of the women, one of whom is already climbing out of the water. By this means, of course, Bosch shows the sexual attraction between men and women, and it is not without significance that the pool and cavalcade occupy the centre of the garden, as the source and initial stage of the activity elsewhere. To the medieval moralists, who were not very chivalrous about such matters, it was woman

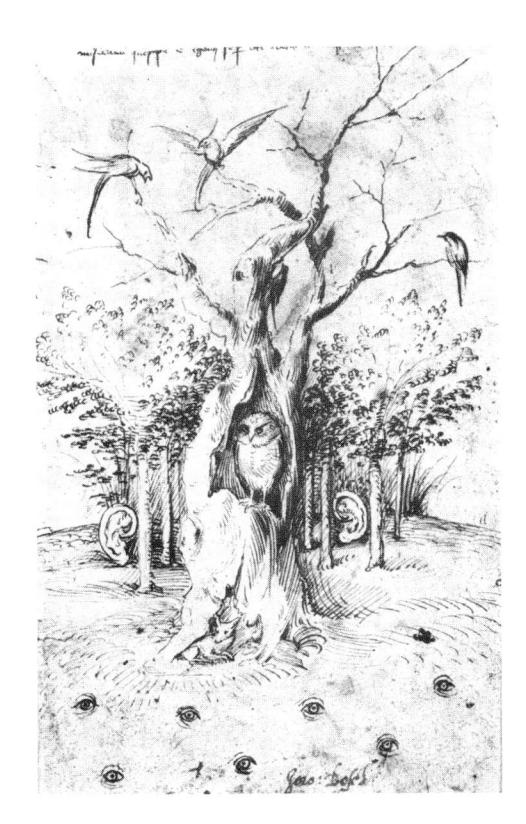

The Hearing Forest and the Seeing Field Pen and bistre, 20,2 × 12,7 cm Berlin, Kupferstichkabinett

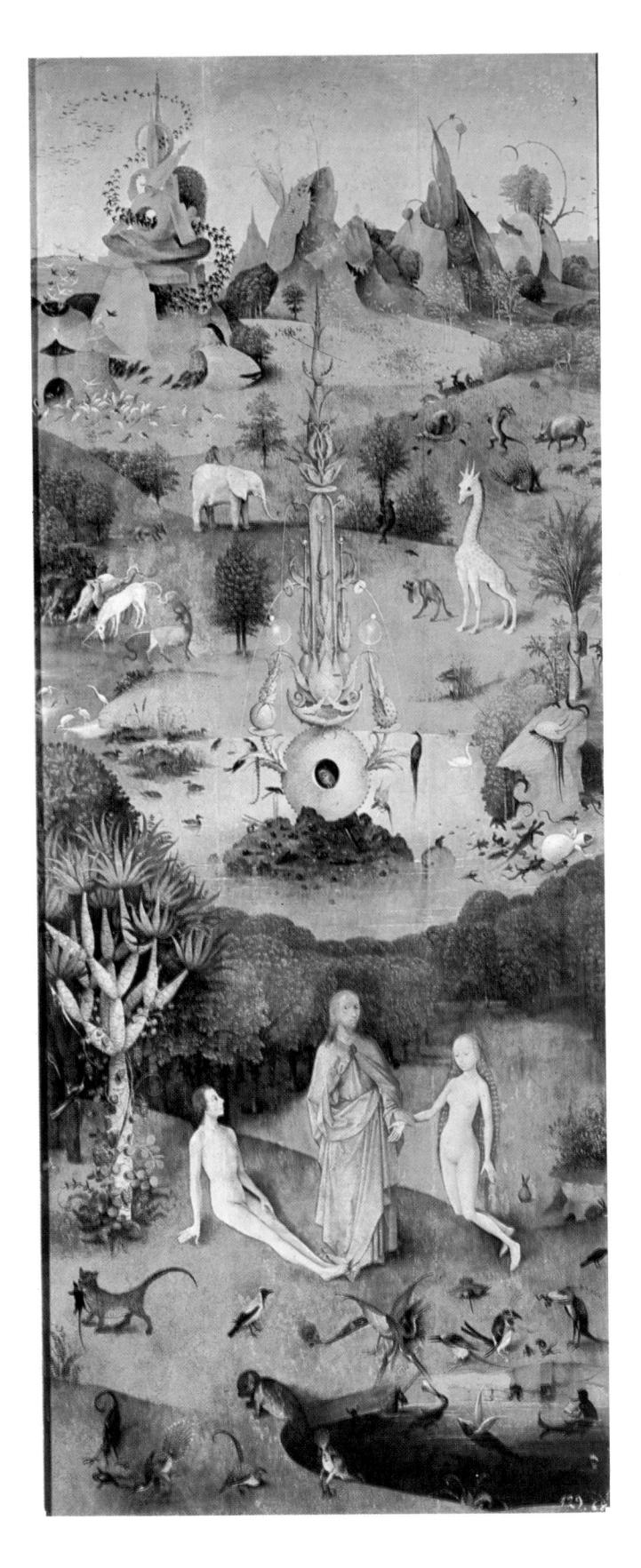

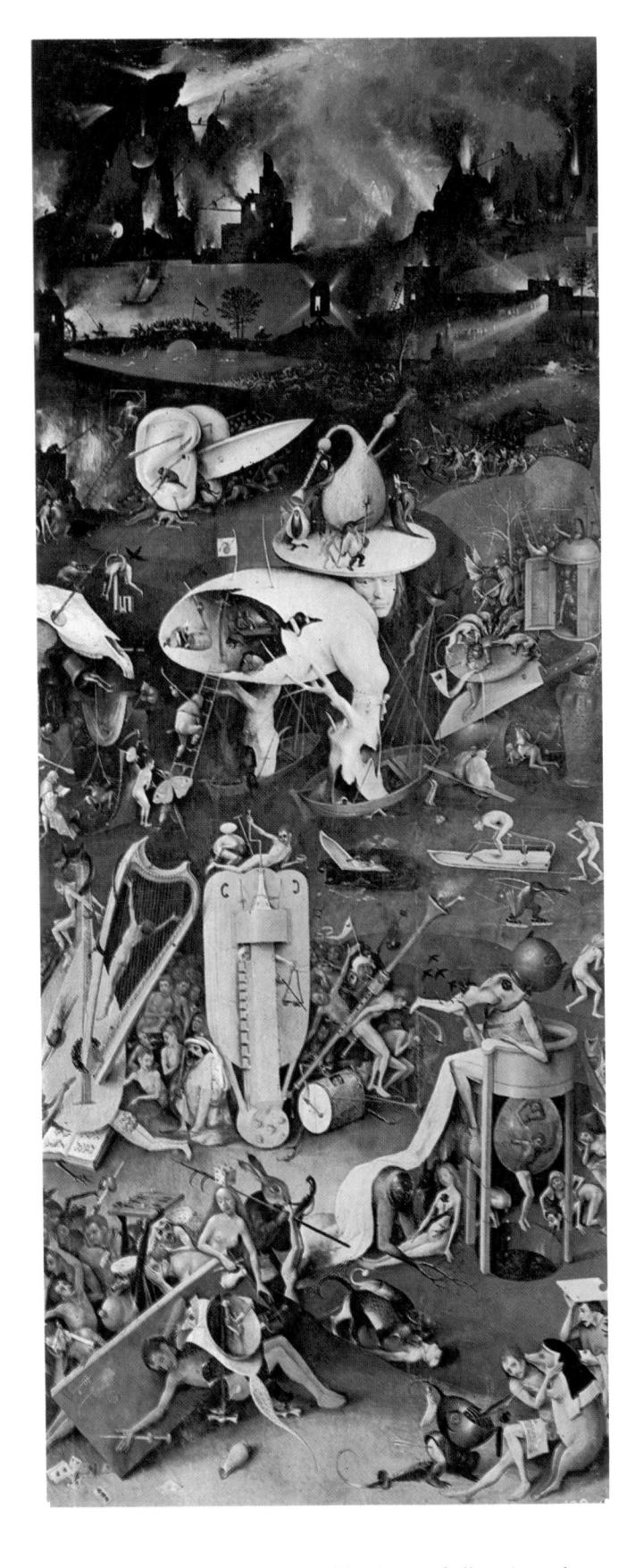

Garden of Earthly Delights (Triptych)
Oil on panel 220 × 389 cm

Oil on panel, 220 × 389 cm Madrid, Museo del Prado

LEFT WING

Paradise (Garden of Eden)

Oil on panel, 220 × 97 cm

RIGHT WING:

Hell

Oil on panel, 220 × 97 cm

who took the initiative in leading man into sin and lechery, following the precedent set by Eve. The power of woman was often represented by placing her within a circle of male admirers. But on Bosch's painting men are riding instead of dancing. Animals traditionally symbolized the lower or animal appetites of mankind and personifications of the Sins were often depicted on the backs of various beasts: the act of riding, finally, was commonly employed as a metaphor for the sexual act.

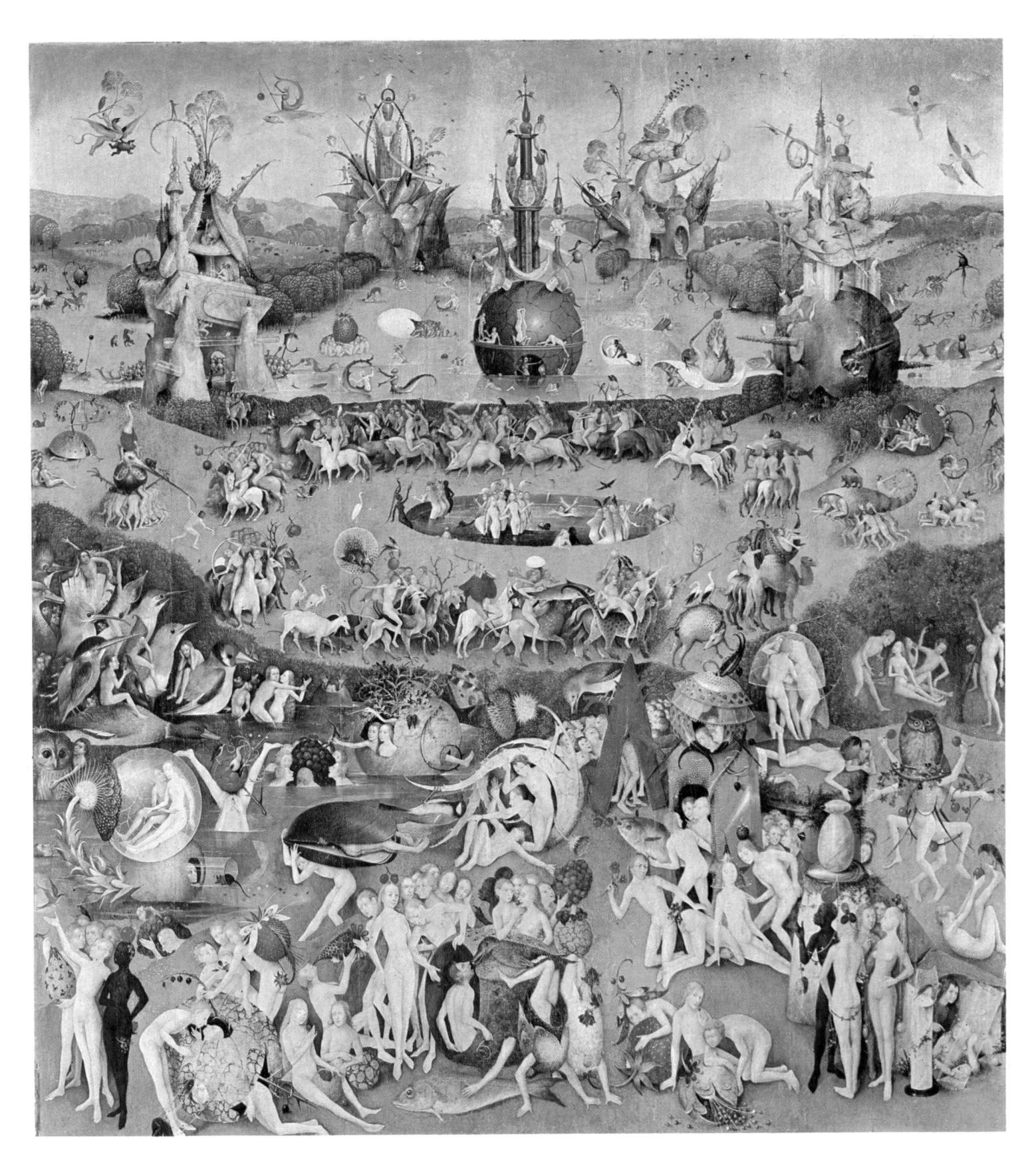

For his image of sensual pleasure, Bosch thus fused together several erotic themes of the Middle Ages within the framework of the Garden of Love, just as Brant employed the ship to unify his diatribes on human folly. Bosch was not the only artist, however, to use the traditional love garden to symbolize Lust. In a manuscript of St Augustine's »City of God«, the saint's condemnation of the lascivious customs of ancient Rome was often illustrated with pictures of nudes dancing in a garden.

CENTRAL PANEL: **Garden of Earthly Delights**Oil on panel, 220 × 195 cm

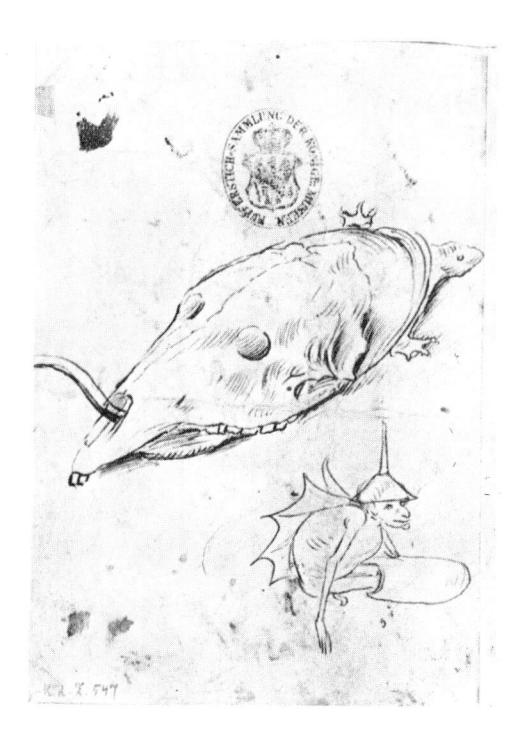

Tortoise with Death's Head on its Carapace and winged DemonPen and bistre, 16,4 × 11,6 cm
Berlin, Kupferstichkabinett

In the final analysis, the meaning of the »Garden of Earthly Delights« is not inconsistent with Bosch's other moralizing subjects. Like the »Ship of Fools«, the »Death of the Miser« and the »Haywain«, it, too, provides a mirror wherein we may see reflected the folly of man. Nevertheless, we may still find it difficult to accept the fact that these carefree lovers are quilty of the deadly sin of Lust. Like Fraenger, we may object that Bosch can hardly have intended to condemn what he painted with such visually enchanting forms and colours. Medieval man, however, was more suspicious of material beauty. He was taught that sin presents itself under the most alluring aspects, and that behind physical loveliness and agreeable sensations often lurked death and damnation. The visible world, in short, was not unlike those little ivory carvings popular in Bosch's day which display a pair of embracing lovers or a voluptuous female nude, but when turned around reveal a rotting corpse. What Bosch shows us, in other words, is a false paradise whose transient beauty leads men to ruin and damnation, a motif common in medieval literature. We encounter it, for example, in the legend of the Venusberg, the underground kindgdom of love where Tannhäuser was detained at the peril of his soul. In the second part added by Jean de Meun to the »Romance of the Rose«, the garden of the rose is explicitly and unfavourably compared with the true garden of Heaven. The garden of Heaven is everlasting, but in the garden of the lovers, the »dances will reach their end and dancers fail«; everything will crumble and decay, for Death lies in wait for all. A similar thought was frequently expressed in sixteenth-century representations of pleasant gardens where lovers enjoy themselves, unaware that Death stalks them from behind.

To return to Bosch's version of this venerable theme, Bax has plausibly suggested that the hairy couple visible in the mouth of the cave in the lower right-hand corner of the garden represent Adam and Eve after their expulsion from Eden, when, according to apocryphal accounts, they took refuge in a cave and dressed in animal skins. The head of the man behind Adam is that of Noah, who re-founded the human race after the Flood. Indeed, the full implications of the »Garden of Earthly Delights« are understood only when we turn to the Garden of Eden and the other scenes of the triptych.

The Creation of the world unfolds on the outer wings in subdued tonalities of grey and grey-green (p. 52). The Creator appears in a rift in the clouds in the upper left-hand corner. In the approximately contemporary frescoes of the Sistine ceiling, Michelangelo represented God as a sort of superhuman sculptor imposing form on the primordial chaos with his own hands. Bosch, on the other hand, followed the more traditional Christian concept in showing God creating through his Word; he is passively enthroned and holds a book, while the divine »fiat« is recorded in an inscription near the upper edge from Psalms 33:9: »For he spake and it was done; he commanded, and it stood fast.« Light has been separated from darkness in the centre of the wing, and within the sphere of light, the waters have been divided above and below the firmament. Dark rain clouds gather over the dry land emerging slowly from the misty waters beneath. Already trees are sprouting from its humid surface, as well as curious growths, half-vegetable, half-mineral, which anticipate the

exotic flora of the inner panels. This is the earth as it stood on the third day of creation.

On the reverse of the left wing, the greyness gives way to brilliant colour and the last three days of Creation are accomplished. The earth and water have brought forth their swarms of living creatures, including a giraffe, an elephant, and some wholly fabulous animals, like the unicorn. In the centre rises the Fountain of Life, a tall, slender roseate structure resembling a delicately carved Gothic tabernacle. The precious gems glittering in the mud at its base and some of the more fanciful animals probably reflect the medieval descriptions of India, whose marvels had fascinated the West since the days of Alexander the Great and where popular belief situated the lost Paradise of Eden.

In the foreground of this antediluvian landscape, we see not the Temptation and Expulsion of Adam and Eve, as in the »Haywain«, but their union by God. Taking Eve by the hand, he presents her to the newly awakened Adam who gazes at this creation from his rib with a mixture, it seems, of surprise and anticipation. God himself is much more youthful than his white-bearded counterpart on the outer wings, and represents the Deity in the guise of Christ, the second person of the Trinity and the Word of God made incarnate (John 1:14). The marriage of Adam and Eve by a youthful Deity occurs frequently in Dutch manuscripts of the fifteenth century, and illustrates the moment when he blessed them, saying in the words of Genesis 1:28: »Be fruitful and multiply, and replenish the earth and subdue it; and have dominion over the fish of the sea, and over the fowl of the air, and over every living thing that moveth upon the earth.« God's injunction to »be fruitful and multiply«, which he later gave also to Noah, could perhaps be construed as a mandate to indulge in the sort of licentious activity taking place in the middle panel; but, as we might guess, the Middle Ages thought otherwise. Instead, it was assumed that previous to the Fall, Adam and Eve would have copulated without lust, solely for the purpose of producing children. After the Fall, however, all this was changed; many people believed, in fact, that the first sin committed after the eating of the forbidden fruit had been carnal lust, an interpretation which is reflected in certain erotic representations of the Fall in the early sixteenth century.

In this respect, it is significant that no children can be found in the garden of the central panel, and that inhabitants, far from subduing the earth, are in fact overshadowed by the giant birds and fruit. The garden thus shows not the fulfilment of God's injunction to Adam and Eve, but its perversion. Man has abandoned the true paradise for the false; he has turned from the Fountain of Life to drink from the fountain of the flesh which, like the fountain in the garden of the »Rose«, intoxicates and brings death.

The erotic dream of the garden of delights gives way to the night-mare reality of the right wing. It is Bosch's most violent vision of Hell. Buildings do not simply burn, they explode into the murky background, their fiery reflections turning the water below into blood. In the foreground a rabbit carries his bleeding victim on a pole, a motif found elsewhere in Bosch's Hell scenes, but this time the blood spurts forth from the belly as if propelled by gunpowder. The hunted-become-hunter well

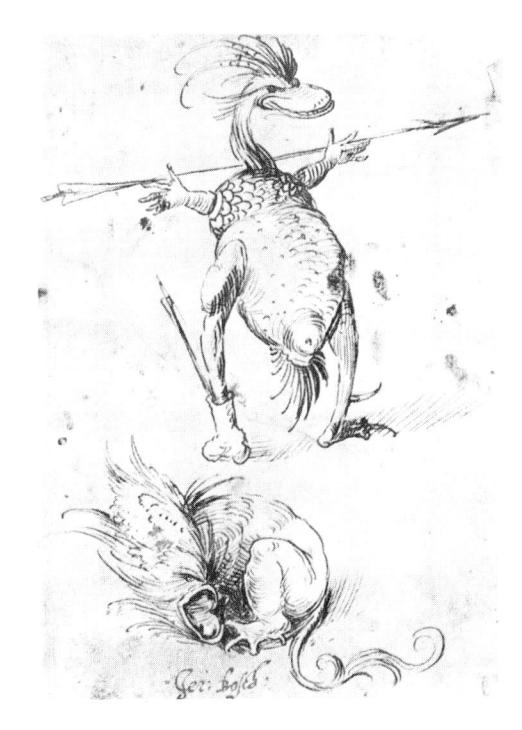

Two Monsters Pen and bistre, 16,4 × 11,6 cm Berlin, Kupferstichkabinett

Nest of OwlsPen and bistre, 14 × 19,6 cm
Rotterdam, Museum Boymans-van Beuningen

expresses the chaos of Hell, where the normal relationships of the world are turned upside down. This is even more dramatically conveyed in the innocuous everyday objects which have swollen to monstrous proportions and serve as instruments of torture; they are comparable to the oversized fruits and birds of the central panel. One nude figure is attached by devils to the neck of a lute; another is helplessly entangled in the strings of a harp, while a third soul has been stuffed down the neck of a great horn. On the frozen lake in the middleground, a man balances uncertainly on an oversized skate, and heads straight for the hole in the ice before him, where a companion already struggles in the freezing water. This episode echoes old Dutch expressions similar in meaning to our »to skate on thin ice«, illustrating a precarious situation indeed. Somewhat above, a group of victims have been thrust into a burning lantern which will consume them like moths, while on the opposite side, another soul dangles through the handle of a door key. Behind, a huge pair of ears advances like some infernal army tank, immolating its victims by means of a great knife. The letter M engraved on the knife, which also appears on other knives in Bosch's paintings, has been thought to represent the hallmark of some cutler whom the artist particularly disliked, but it more likely refers to »Mundus« (World), or possibly Antichrist, whose name, according to some medieval prophecies, would begin with this letter.

The focal point of Hell, occupying a position analogous to that of the Fountain of Life in the Eden wing, is the so-called Tree-Man, whose egg-shaped torso rests on a pair of rotting tree trunks that end in boats for shoes. His hind quarters have fallen away, revealing a hellish tavern scene within, while his head supports a large disc on which devils and their victims promenade around a large bagpipe. The face looks over one shoulder to regard, half wistfully, the dissolution of his own body. A similar, though less forcefully conceived, tree-man was sketched by Bosch in a drawing now in the Albertina, Vienna (p. 6). The meaning of this enigmatic, even tragic figure has yet to be explained satisfactorily, but Bosch never created another image that more successfully evoked the shifting, insubstantial quality of a dream.

Much more solid, in contrast, is the bird-headed monster at lower right, who gobbles up the damned souls only to defecate them into a transparent chamber pot from which they plunge into a pit below. He recalls a monster in the »Vision of Tundale« who digested the souls of lecherous clergy in a similar manner. Other sins can be identified in the area around the pit. The slothful man is visited in his bed by demons, and the glutton is forced to disgorge his food, while the proud lady is compelled to admire her charms reflected in the backside of a devil. Lust, like Avarice, was thought to give rise to other deadly vices: indeed, as the first sin committed in the garden of Eden, it was often considered the gueen and origin of all the rest. Therefore we should not be surprised, as some scholars are, to see other sins, besides Lust, punished in the Hell of the »Garden of Earthly Delights«. The knight brought down by a pack of hounds to the right of the Tree-Man is most likely guilty of the sin of Anger, and perhaps also of Sacrilege, for he clutches a chalice in one mailed fist, as does the nude astride a cow in the »Haywain«. The tumultuous group at right suffers for the excesses associated with gambling and taverns.

Bird-headed MonsterDetail of the left wing of the »Garden of Earthly Delights« Madrid, Museo del Prado

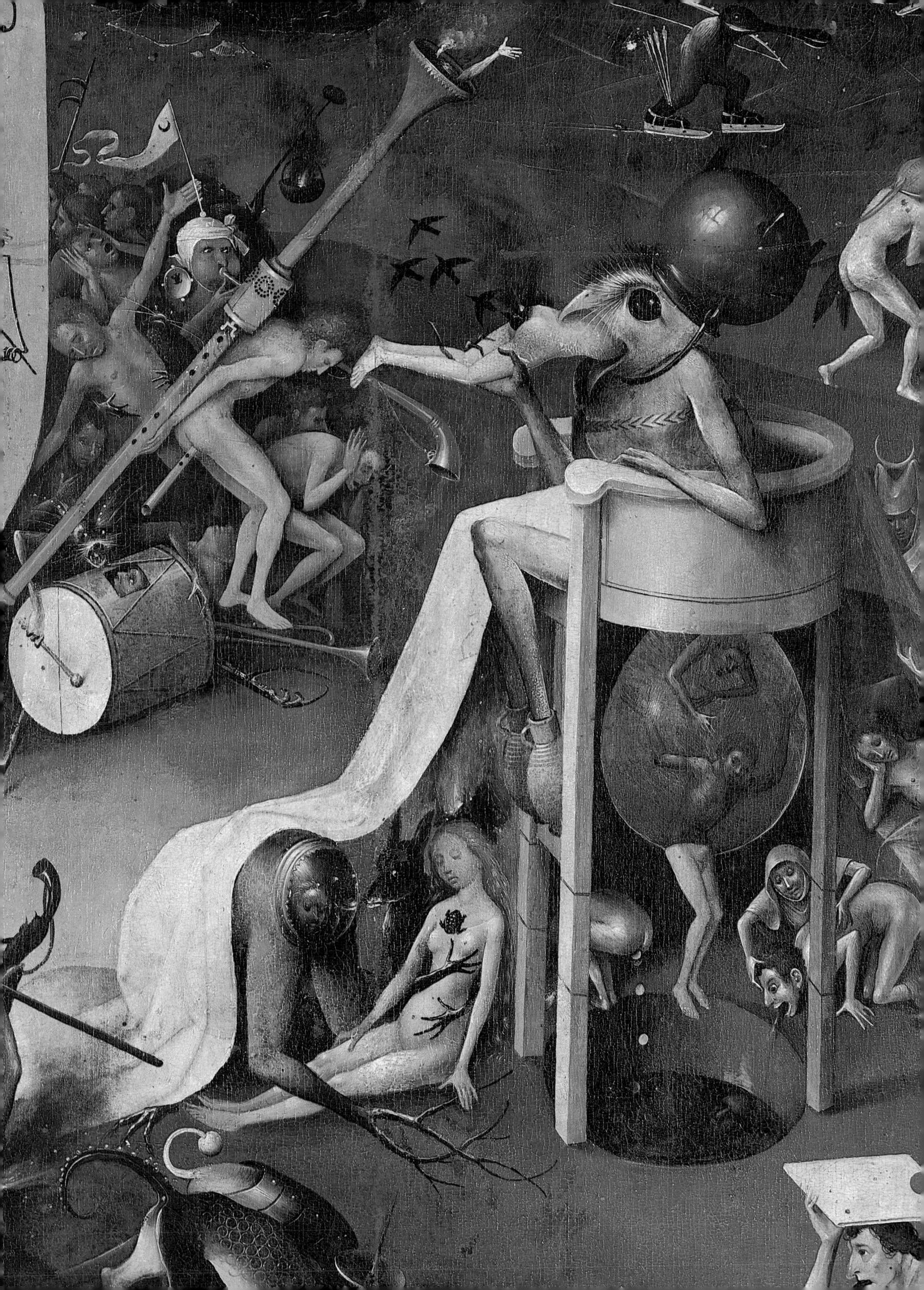

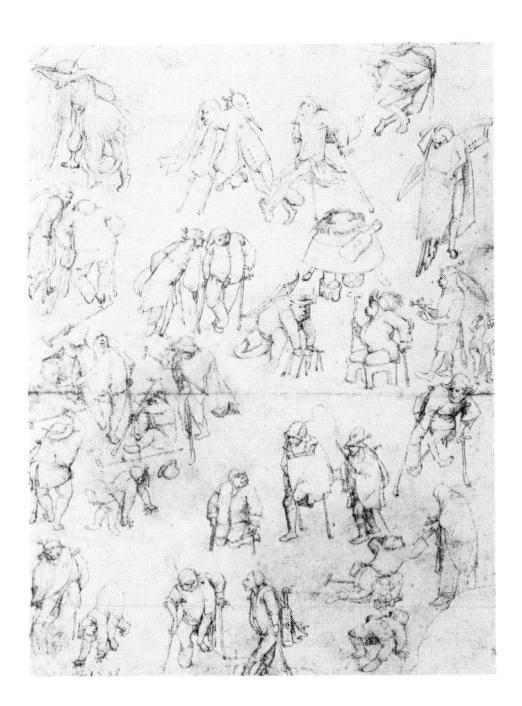

BeggarsPen and bistre, 28,5 × 20,5 cm
Vienna, Albertina
(also attributed to Pieter Bruegel the Elder)

References to Lust, however, are not absent; it is punished in the lower right-hand corner, where an amorous sow tries to persuade her companion to sign the legal document in his lap. Perhaps he is a monk, for the sow wears the headdress of a nun. An armoured monster waits near by with an inkwell dangling from his beak. Lust is also the subject of the oversized musical instruments and choral singing in the left foreground. These scenes, as well as the bagpipe on the head of the Tree-Man, have been interpreted as a blast against travelling players who frequented the taverns and whose lewd songs stirred others to lechery. But the musical instruments themselves often possessed erotic connotations. The bagpipe, which Brant calls the instrument of dunces, also figured as an emblem of the male organ of generation, while to play the lute signified making love. Moreover, Lust was frequently termed the »music of the flesh« by medieval moralizers, a concept also reflected in the long-snouted musician who serenades the lovers in the Prado »Haywain«. It is a discordant music, contrasted to the harmonies of the divine order. How different from Geertgen's angelic concert is the harsh cacophony of Bosch's music, where the instruments which gave only passing pleasure in life are now made to give perpetual pain.

The »Garden of Earthly Delights« shows Bosch at the height of his powers as a moralizing artist. No other work painted by him displays the same complexity of thought in such vivid images. It is for this reason, more than any other, that we are justified in placing this triptych fairly late in Bosch's career, certainly well after 1500. In its didactic message, in its depiction of mankind as given over to sin, the »Garden of Earthly Delights« unquestionably belongs to the Middle Ages. Likewise, its iconographical programme, encompassing the whole of history, betrays the same urge for universality that we encounter in the façade sculptures of a Gothic cathedral or in the contemporary cycles of mystery plays. Nevertheless, it also reflects the Renaissance taste for highly original, intricate allegories whose full meaning is apparent only to a limited audience. In this respect, the »Garden of Earthly Delights« may be compared to Botticelli's »Primavera« (Florence, Galleria degli Uffizi), for example, or to the »Melencolia I« of Albrecht Dürer.

The subjects of the »Garden of Earthly Delights« and the »Haywain« make it unlikely that they were destined for a church or monastery, even though their triptych format had long been traditional for Netherlandish altarpieces. We may rather suspect that Bosch's allegories, like those of Botticelli, were painted for lay patrons. There is good evidence, in fact, that the »Garden of Earthly Delights« was owned by Hendrick III of Nassau, an enthusiastic collector of art; in 1517, just after Bosch's death, the Italian Antonio de Beatis visited Hendrick's palace in Brussels where he saw and described a painting which must be the triptych now under discussion. Even before this, however, a number of Bosch's works had been acquired by members of the Burgundian nobility. The Flemish rhetoricians and the courtly circles in Brussels and Malines possessed a taste for abstruse, erudite allegories, mostly of a moralizing nature, as can be seen in many Flemish tapestries of the early sixteenth century. It is not difficult to understand why this milieu would have been so receptive to Bosch's art.

The Pilgrimage of Life

The »Haywain« and the »Garden of Earthly Delights« show mankind trapped by its age-old enemies, the World, the Flesh and the Devil. The precarious situation of the human soul in this life was represented again, although in somewhat different terms, on the outer panels of the »Haywain« triptych (p. 62). These panels are inferior in quality to the rest of the triptych and were probably completed by workshop assistants, but Bosch must have designed the composition.

The foreground is dominated by an emaciated, shabbily dressed man who is no longer young, carrying a wicker basket strapped to his back; he travels through a menacing landscape. A skull and several bones lie scattered at lower left; an ugly cur snaps at his heels, while the footbridge on which he is about to step appears very fragile indeed. In the background, bandits have robbed another traveller and are binding him to a tree, and peasants dance at the right to the skirl of a bagpipe. A crowd of people gather around an enormous gallows in the distance, not far from a tall pole surmounted by a wheel, used for displaying the bodies of executed criminals.

A countryside similarly filled with violence can be seen behind St James on the exterior of the Vienna »Last Judgment«, serving to remind us that James was the patron saint of pilgrims who invoked his protection against the dangers of the road. In the Middle Ages, however, every man was a pilgrim in a more spiritual sense. He was but a stranger on earth, an exile searching for his lost homeland. This poignant image of the human condition is almost as old as Christianity itself, for St Peter had already described Christians in similar terms, and these were repeated with countless variations by later writers. The German mystic Henry Suso, for example, saw men as »miserable beggars who still wander so verry wretchedly in our sorrowful exile«. In Deguilleville's »Pilgrimage of the Life of Man«, the pilgrimage is employed as a framework for the life and spiritual temptations of a monk.

Bosch's pilgrim makes his way through the treacherous world whose vicissitudes are represented in the landscape. Some of the dangers are physical, such as the robbers or the snarling dog, although the latter may also symbolize detractors and slanderers, whose evil tongues were often compared to barking dogs. The dancing peasants, however, connote a moral danger; like the lovers on top of the haywain, they have succumbed to the music of the flesh. In expressing the spiritual predicament of all mankind, the pilgrim thus resembles Everyman and his Dutch and German counterparts Elckerlijc and Jedermann, whose spiritual pilgrimages form the subjects of contemporary morality plays.

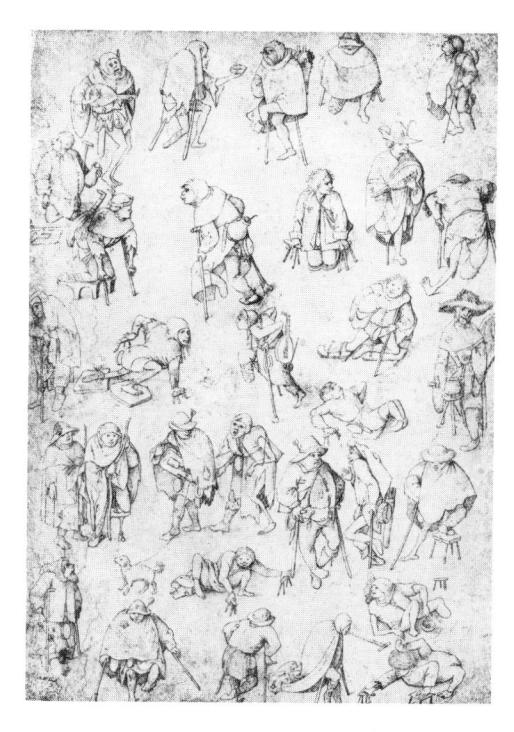

Beggars and CripplesPen and bistre, 26,4 × 19,8 cm
Brussels, Bibliothèque Royale Albert I,
Cabinet des Estampes
(also attributed to Pieter Bruegel the Elder)

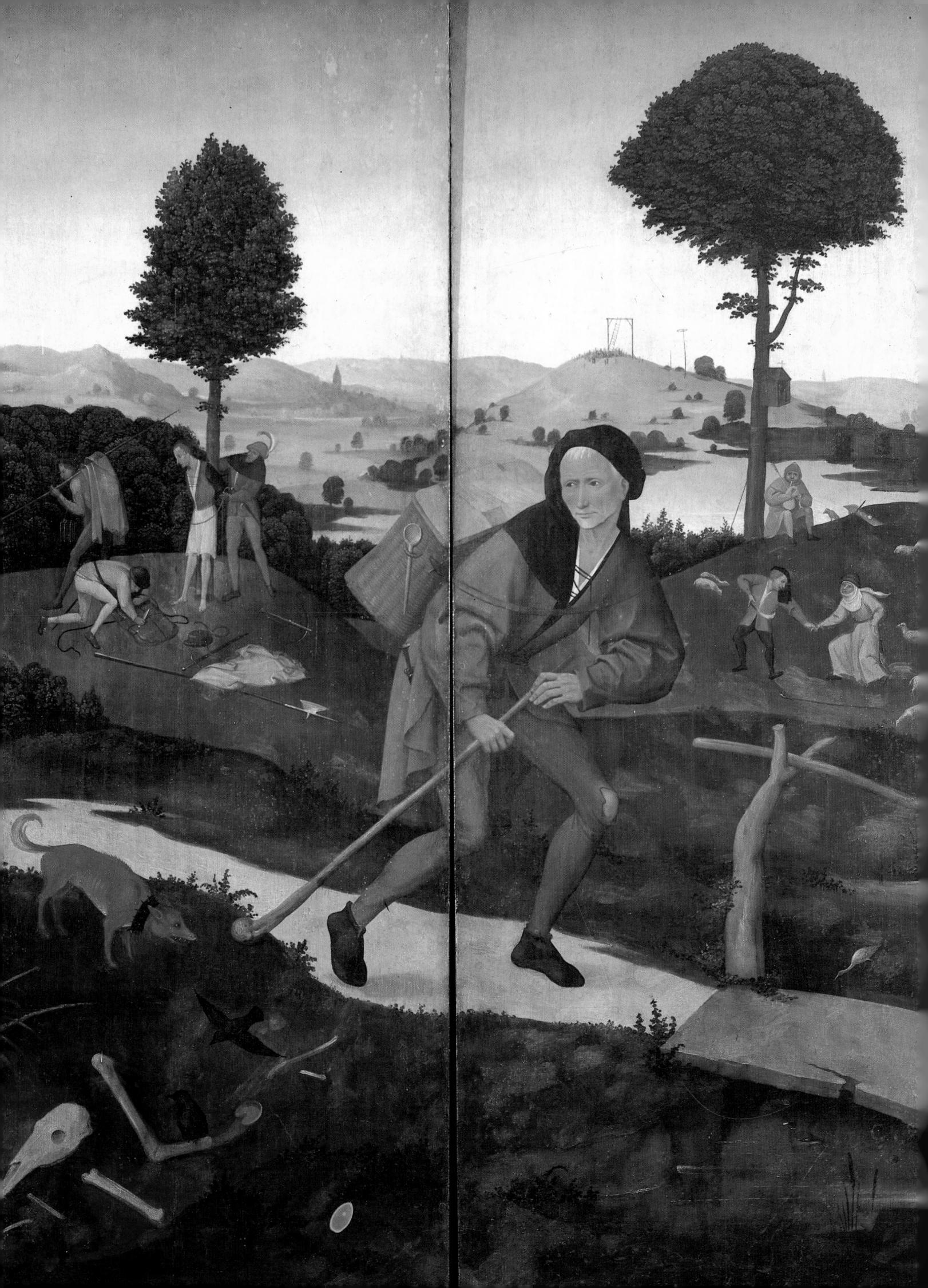

In a circular painting now in Rotterdam (p. 65), Bosch reworked the figure of the Prado wayfarer a decade or so later, this time placing him against one of his most delicately conceived landscapes. The rolling sand dunes at the right and the subdued tonalities of grey und yellow are sensitive transcriptions into paint of the rain-drenched Dutch countryside. There is little reason to believe, as some scholars do, that the picture represents an episode from the parable of the Prodigal Son. The large foreground figure closely recalls the »Haywain« pilgrim, except that he appears even more haggard and poorly dressed. There are, however, some subtle differences. Except for the snarling dog, with its possible allusion to slander, the dangers of the world are here chiefly spiritual. They are embodied first of all in the tavern at the left, whose ruinous condition echoes the ragged clothes of the wayfarer. As in Bosch's earlier »Marriage Feast at Cana«, the tavern symbolizes the World and the Devil in general, its dubious nature revealed by the man urinating at the right, and by the couple embracing in the doorway. Another inmate of the house peers curiously through one of the dilapidated windows.

The customer for whom the second woman waits may very well be the traveller himself. As Bax has perceptively observed, he has not just emerged from the tavern, but has passed it in his journey and now halts on the road, as if allured by its promise of pleasure. Bax further suggests that the garments of the traveller and the various articles he carries are a symbolic commentary on his poverty, the sinful tendencies which led to his present condition, and his readiness to succumb to temptation once more. However this may be, the spiritual state of the wayfarer is also conveyed in less symbolic terms. Bosch has transformed the defensive movement of the »Haywain« pilgrim into an attitude of hesitation, while the wayfarer's head is turned towards the tavern with an almost wistful expression.

In the Rotterdam panel Bosch does not make the moral alternatives quite so explicit, but they can be discerned nonetheless. If the wayfarer looks back in the direction of the tavern, his path leads towards a gate and the tranquil Dutch countryside beyond. Unlike the violencefilled landscape of the »Haywain« wings, the background contains no suspicious incidents, and, except for the owl perched on a dead branch directly above the wayfarer's head, no overt symbols of evil. We are probably justified in seeing in the gate and fields a reference to Christ who, in John 10:9, speaks of himself as the door through which those who enter »shall be saved, and shall go in and out, and find pasture«.

In the »Haywain«, the pilgrim appears as a neutral figure, neither good nor bad. In the Rotterdam panel, Bosch made the image more profound by showing the pilgrim in the grip of a spiritual crisis. But whether the pilgrim will turn away from the tavern to pass through the gate is as doubtful as the issue of the struggle between angel and devils in the »Death of the Miser«.

This ambiguity of the Rotterdam »Wayfarer« exemplifies perfectly the pessimism of Bosch's age concerning the human condition. The same attitude predominates in a pair of small panels, perhaps altar wings, also at Rotterdam (pp. 66/67). On the reverse, Bosch painted four little monochrome scenes showing mankind beset by devils. They possess a farm and

The Wayfarer

Outer wings of the »Haywain« triptych Oil on panel, 135 × 90 cm El Escorial. Monasterio de San Lorenzo

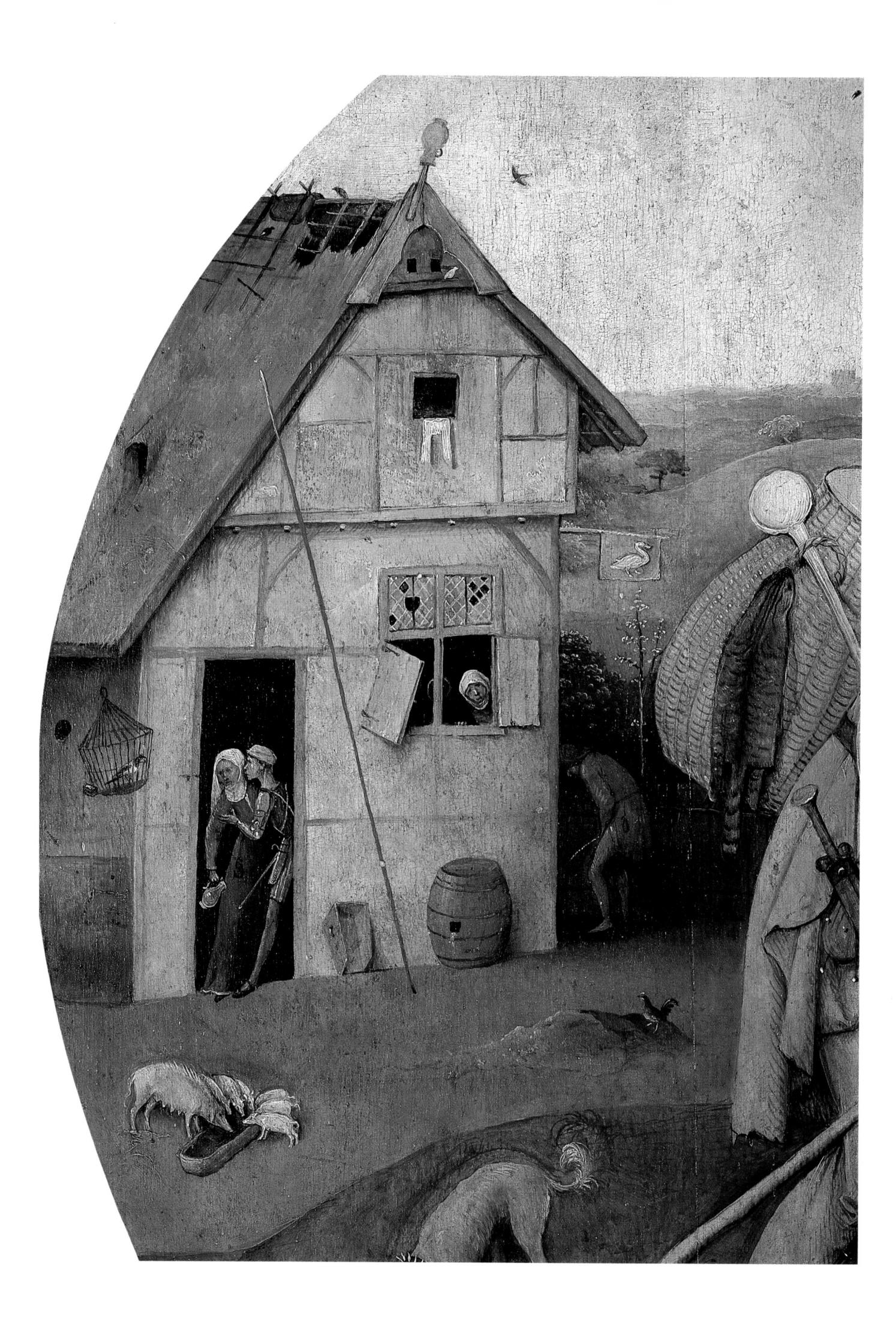

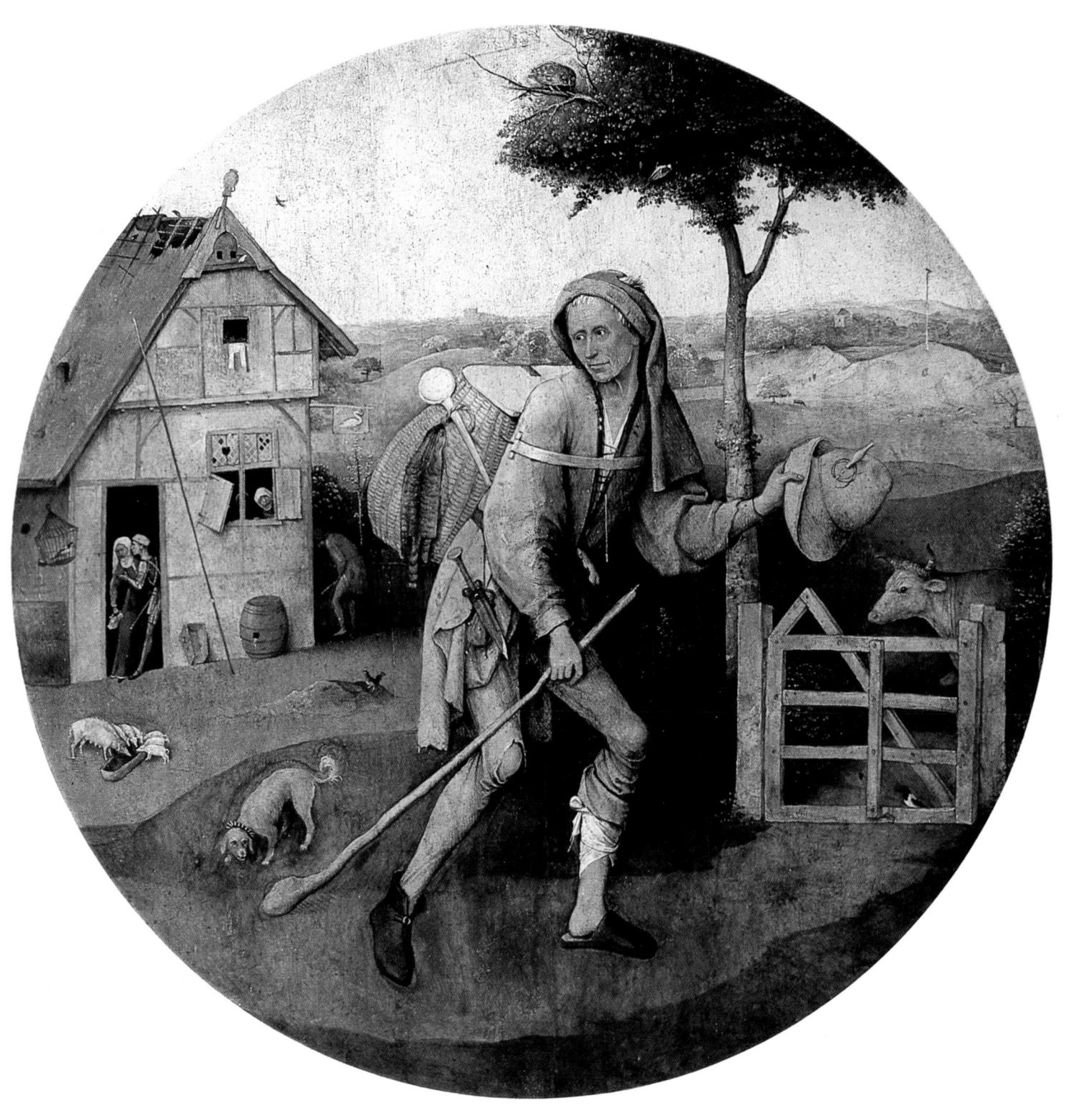

drive away the inhabitants, throw a ploughman from his horse and fall upon an unwary traveller. In the fourth scene, however, the Christian soul finds asylum: he kneels before Christ while a companion, like the just souls described in Revelation 6:11, receives a white robe from an angel.

It was during Bosch's lifetime that belief in devils reached a new height. Erasmus could scoff at the demons of hell as mere bogeymen and empty illusions, but most of Bosch's contemporaries believed that devils actively and maliciously intervened in human affairs, both directly and through their agents, the witches and sorcerers. These beliefs were codified in the infamous »Malleus Maleficarum«, or »Witches' Hammer«, of Jacob Sprenger and Heinrich Kramer, published at Nuremberg in 1494. In

The Wayfarer

Oil on panel; diameter of roundel: 71,5 cm Rotterdam, Museum Boymans-van Beuningen

The House of Ill Fame Detail from »The Wayfarer«

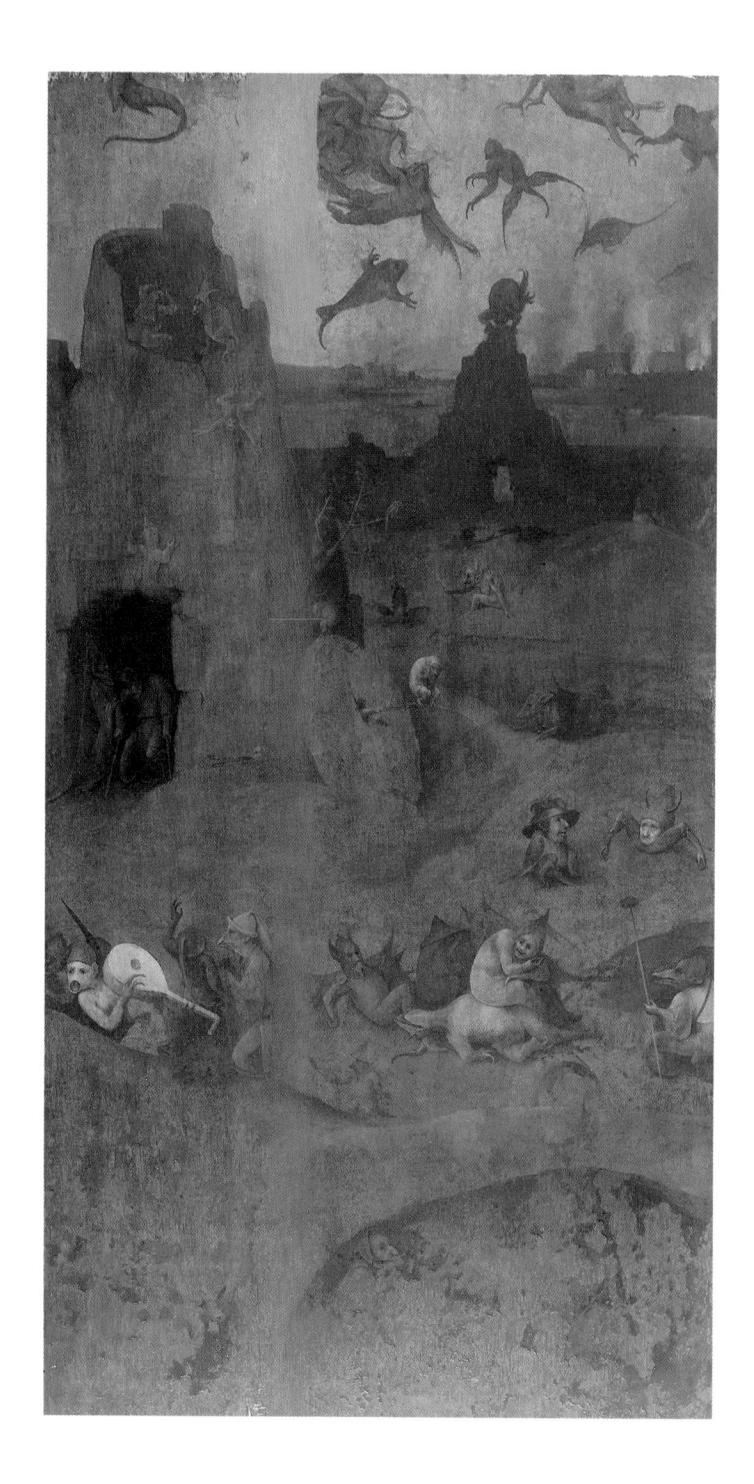

TWO WINGS OF A TRIPTYCH WITH SCENES OF THE HELL AND THE FLOOD (on the reverses scenes of the Passion) Rotterdam, Museum Boymans-van Beuningen

LEFT WING:

Fall of the Rebel Angels Oil on panel, 69 × 35 cm

REVERSE:

Mankind Beset by Devils
Oil on panel, diameter of roundels:
32,4 cm (each)

scholastically precise terminology, the »Malleus Maleficarum« examines the nature of witches and their relationships with the Devil, as well as the means by which they were to be recognized and punished.

This immensely popular book influenced a great many witch trials of the sixteenth and seventeenth centuries and may also have inspired the pictures on the obverse of the two panels at Rotterdam just discussed. Here we see the Rebel Angels, already transformed into monsters, tumbling into a desolate landscape; and the landing of Noah's Ark on Mount Ararat, from which animals descend by pairs among the corpses of the drowned. These two curious scenes may allude to a medieval interpretation of Genesis 6:1-6, describing the corruption of the earth which resulted in the Flood. In those days, we are told, the sons of God took to wife the daughters of men who bore a mighty race of giants. The sons of God were frequently identified with the Fallen Angels, and the »Malleus Malefi-

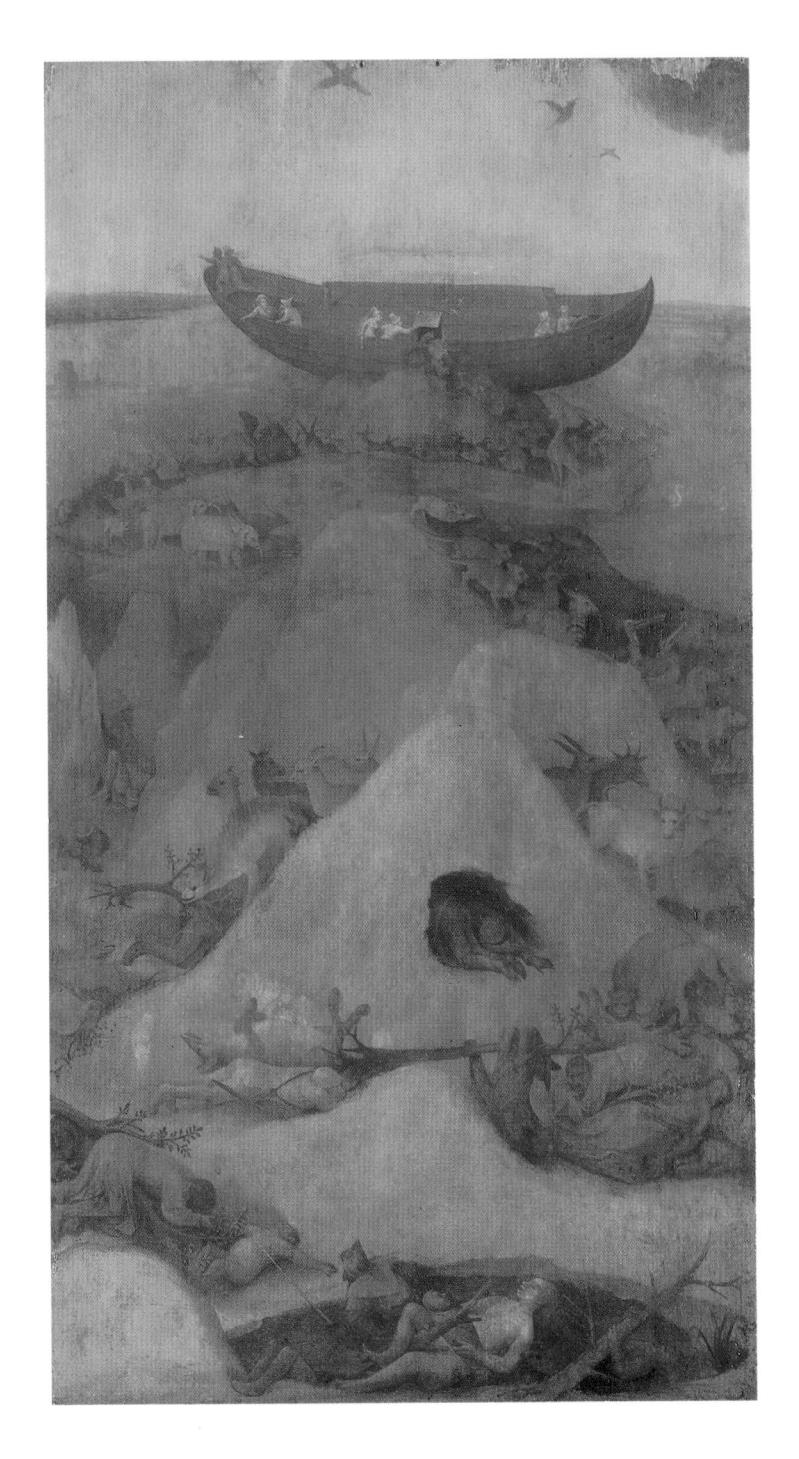

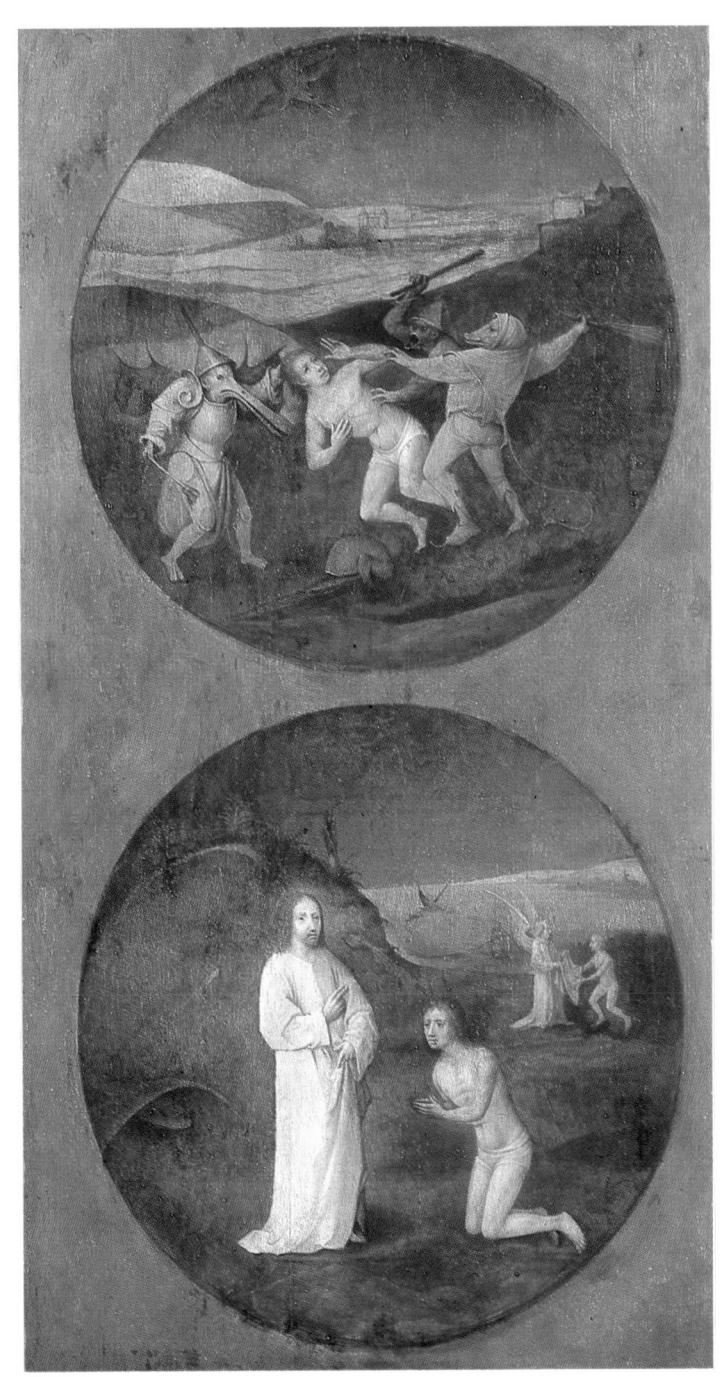

carum«, following an opinion of St Thomas Aquinas, asks if their mighty progeny were not, in fact, the first witches, born of the »pestilent mutual association« of men with devils.

To Bosch's contemporaries, the melancholy spectacle of sin and folly could be explained only in terms of the Devil and his followers seeking to drag mankind into perdition. Against such overwhelming odds, what chance did the pilgrim have to reach his homeland? The answer of the medieval Church may be summed up in the title of Thomas à Kempis's book, the »Imitation of Christ«. By renouncing the world and following the examples set by Christ and his saints, the pilgrim could hope to pass through the dark night of this world into Paradise. And although Bosch painted many pictures mirroring the tragic condition of humanity, he produced almost as many others which illuminated this path to salvation.

RIGHT WING:
Noah's Ark on Mount Ararat

Oil on panel, 69,5 × 38 cm

REVERSE

Mankind Beset by Devils
Oil on panel, diameter of roundels:
32,4 cm (each)

The Imitation of Christ

Although Bosch contributed many new themes to Netherlandish painting, it must be remembered that well over half of his pictures are devoted to traditional Christian subjects: the lives of the saints and the life of Christ, especially episodes of the Passion. As might be expected, many of his Christological scenes are fairly conventional, conforming to types which had been current in Northern Europe for several generations. They offer nothing new beyond, perhaps, an increased intensity of expression. This is true, as we have seen, of such early works as the Philadelphia »Epiphany« and the Frankfurt »Ecce Homo«. In representing Christ carrying the Cross, he occasionally depicted the good thief confessing to a friar or priest, but this anachronism was only a natural development of the late medieval tendency to clothe sacred history in contemporary modes and manners. Several paintings show his knowledge of the Flemish schools to the south. His »Nativity«, now lost but represented by a good copy in Cologne, reflects the compositions of Hugo van der Goes, whose influence is to be seen also in several Passion scenes discussed below. Likewise, the influence of Dirk Bouts and his followers can be discerned in a votive picture in Brussels, the »Christ on the Cross with Donors and Saints« (left), although Bosch has characteristically transformed the conventional distant view of Jerusalem into the homely forms of a simple Dutch town, perhaps 's-Hertogenbosch itself, veiled in atmospheric greys and lavenders.

In a number of important instances, however, Bosch transcended the limits of the biblical narrative to present a more universal image of the conflict between good and evil. This has already been observed in the devil-haunted tavern which serves as a setting for the early »Marriage Feast at Cana«, and Van Mander describes a »Flight into Egypt«, now lost, whose landscape contained an inn similarly possessed by demons. This idea also inspired one of Bosch's most enigmatic works, the »Epiphany« triptych in the Prado (pp. 70/71).

The inner wings of this altarpiece are occupied by the kneeling figures of the donors, husband and wife, attended by their patron saints Peter and Agnes. The coats of arms behind them identify the couple as members of the Bronckhorst and Bosshuyse families, but nothing is known of these names which would help determine the date of the work or its original destination.

The central panel displays the adoration of the Christ Child by the three Kings or Magi. Many details of the composition, including the ruined stable and the sumptuous dress of the Magi, bring to mind Bosch's »Epiphany« in Philadelphia, but the casual mood of the earlier version has

Christ Carrying the Cross
Pen, 23,6 × 19,8 cm
Rotterdam, Museum Boymans-van Beuningen

Christ on Cross with Donors and Saints Oil on panel, 73,5 × 61,3 cm Brussels, Musées Royaux des Beaux-Arts completely disappeard. Instead of reaching out impulsively towards the Magi, the Infant Christ now sits solemnly enthroned on his mother's lap. The Virgin, too, has acquired a new dignity and amplitude of form. perhaps inspired by Jan van Eyck's »Madonna of Chancellor Rolin« (Paris. Louvre). Set apart from the other figures by the projecting roof of the stable, the Virgin and Child resemble a cult statue beneath its baldachin. and the Magi approach with all the gravity of priests in a religious ceremony. The splendid crimson mantle of the kneeling King echoes the monumental figure of the Virgin. That Bosch intended to show a parallel between the homage of the Magi and the celebration of the Mass is clearly indicated by the gift which the oldest King has placed at the feet of the Virgin: it is a small sculptured image of the Sacrifice of Isaac, a prefiguration of Christ's sacrifice on the Cross. Other Old Testament episodes appear on the elaborate collar of the second King, representing the visit of the Queen of Sheba to Solomon, and on the Moorish King's silver orb, depicting Abner offering homage to David (not David's reception of the three heroes, as commonly assumed). In the »Biblia Pauperum«, a popular religious picture book of the period, both scenes prefigure the Epiphany.

A group of peasants have gathered around the stable at the right. They peer from behind the wall with lively curiosity and scramble up to the roof in order to get a better view of the exotic strangers. The Shepherds had seen Christ on Christmas Eve, but they frequently reappear as spectators in fifteenth-century Epiphany scenes. Generally, however, they display much more reverence than do Bosch's peasants, whose boisterous behaviour contrasts strongly witht the dignified bearing of the Magi. This difference is significant, for the Shepherds were frequently identified with the Jews who rejected Christ, while the Magi represent the Gentiles who accepted him as the true Messiah.

The most curious detail of Bosch's »Epiphany« is the man standing just inside the stable behind the Magi. Naked except for a thin shirt and a crimson robe gathered around his loins, he wears a bulbous crown; a gold bracelet encircles one arm, and a transparent cylinder covers a sore on his ankle. He regards the Christ Child with an ambiguous smile, but the faces of several of his companions appear distinctly hostile.

Because they stand within the dilapidated stable, time-honoured symbol of the Synagogue, these grotesque figures have been identified as Herod and his spies, or Antichrist and his counsellors. Although neither identification is quite convincing, the association of the chief figure with the powers of darkness is clearly suggested by the demons embroidered on the strip of cloth hanging between his legs. A row of similar forms can be seen on the large object which he holds in one hand; surprisingly, this can only be the helmet of the second King, and still other monsters decorate the robes of the Moorish King and his servant. These demonic elements undoubtedly refer to the pagan past of the Magi, recalling the medieval belief, echoed in the »Golden Legend«, that they had practised sorcery before their conversion to Christ.

In an unpublished paper, Charles Scillia has plausibly suggested that the mysterious figure in the stable represents still another pagan sorcerer, Balaam, who was instructed by God to announce: »I shall see him, but not now: I shall behold him, but not nigh: there shall come a Star out of Jacob

Epiphany (Triptych)Oil on panel, 138 × 138 cm
Madrid, Museo del Prado

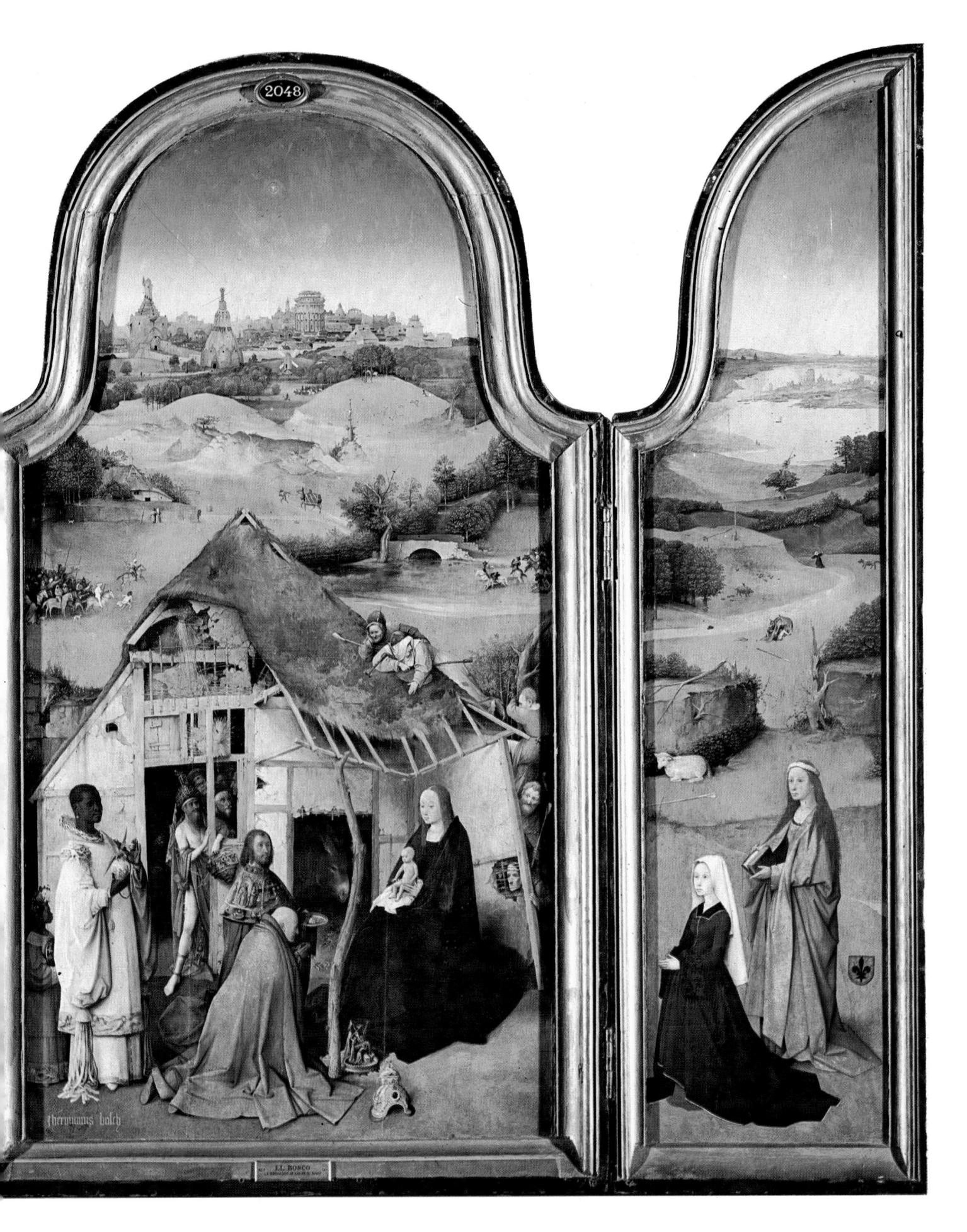

LEFT WING: **The Donor with St Peter and St Joseph** Oil on panel, 138 × 33 cm CENTRAL PANEL: **The Virgin and Child and the Three Magi**Oil on panel, 138 × 72 cm

RIGHT WING: **The Donor with St Agnes** Oil on panel, 138 × 33 cm

The Mass of St Gregory Outer wings of the »Epiphany« triptych Grisaille on panel, 138 × 66 cm Madrid, Museo del Prado

and a Sceptre shall rise out of Israel. « (Numbers 24: 17.) Traditionally interpreted as referring to the Star of Bethlehem and the coming of Christ, this prophecy was thought to have inspired the perpetual watch for the Star which centuries later resulted in the journey of the Magi. If this identification is correct, the crystal-encased wound on the leg of Bosch-'s figure may allude to the injured foot which Balaam suffered in the Old Testament episode, and his companions are perhaps the Moabite ambassadors sent to him by King Balak.

But if Balaam thus appears as a precursor of the Magi, he also possesses a more unfavourable significance in the Prado »Epiphany«. Although he refused Balak's request to curse the Israelites, he seems later to have conspired with the Moabites to seduce them away from the Lord into idolatry (Numbers 31:16). To the Middle Ages, therefore, he was not only a prophet but also typified the false preacher, the teacher of heresy. This latter aspect would account for his presence within the stable, whose sinister nature is indicated by the owl and lizard half hidden in the caves; and it is surely no accident that this thorny crown closely resembles the headdress of the blue devil serenading the lovers in the »Haywain«. Through Balaam, perverter of the Jews, Bosch once more reminds us of the antithesis between Church and the Synagogue.

The stable and its inhabitants seem to be the source of the malevolent influences contaminating almost every part of the majestic landscape which unfolds in the background of all three panels. Demons haunt the ruined portal in the left wing, where Joseph sits hunched over a fire. The crumbling walls around him are the remains of King David's palace, near which the Nativity was popularly supposed to have occurred; like the stable, it represents the Synagogue, the Old Law collapsing at the advent of the New. In the field beyond, peasants dance to the sound of bagpipes, a familiar symbol of the carnal life. On the right wing, wolves attack a man and a woman on a desolate road. Behind the stable in the centre, the followers of two of the Magi rush towards each other like opposing armies: the host of the third King appears beyond the sand dunes. The gently rolling countryside contains, in addition, an abandoned tavern and a pagan idol. Even the distant grey-blue walls of Jerusalem, one of Bosch's most evocative renderings of the Holy City, appear vaguely sinister. A little roadside cross leans precariously to one side at the left, and the two watchtowers are architecturally similar to the demonic city which Bosch depicted in the »St Anthony« triptych in Lisbon.

The Epiphany had for centuries been closely associated with the Mass. Just as the incarnate Christ appeared to the Shepherds and the Magi, so does he continue to appear to the faithful in the form of the bread and wine. In the Philadelphia »Epiphany«, Bosch had alluded to the Eucharist by depicting the Gathering of Manna, a prefiguration of the Last Supper, on the sleeve of the Moorish King. The relationship between Epiphany and Eucharist, however, is more explicitly stated on the outer wings of the Prado triptych, which, when closed, display the Mass of St Gregory (left). The tall, narrow panels are painted in a greyish-brown monochrome, except for the two male donors who appear in natural colour. They may represent father and son, but neither can be identified

with the husband on the left inner wing.

Christ Carrying the Cross Oil on panel, 150×94 cm Madrid, Palacio Real

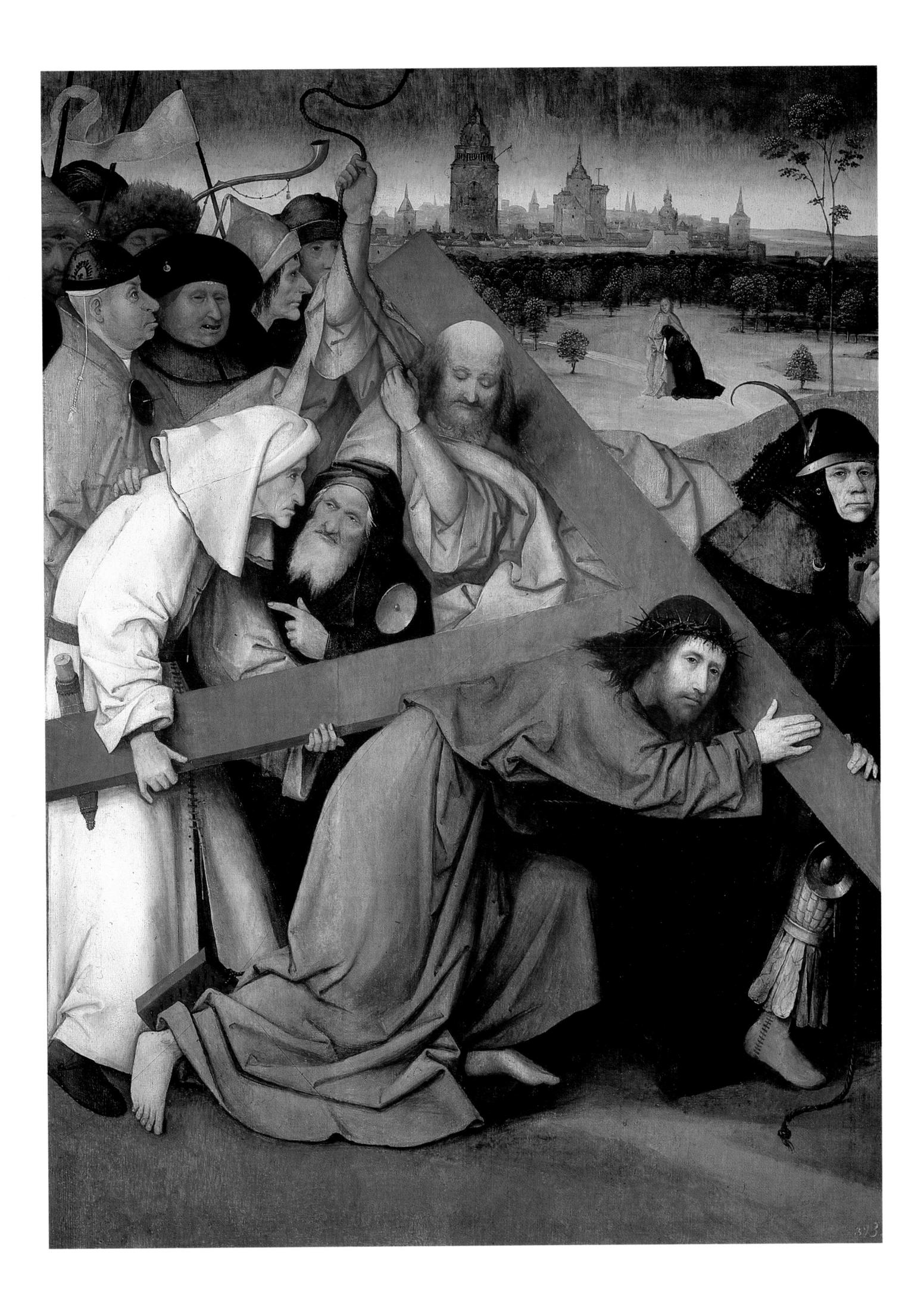

The legend of the Mass of St Gregory concerns a eucharistic miracle which attached itself rather late in the Middle Ages to the name of Pope Gregory the Great (c. 540-604). One day, when Gregory was celebrating Mass, an assistant doubted the true presence of Christ in the host. At the earnest prayer of the Pope for some sign from Heaven to refute the unbeliever, Christ himself appeared suddenly on the altar, displaying his wounds and surrounded by the instruments of his Passion. Bosch represents this miracle in the form of a spiritual dialogue between the kneeling Pope and the Man of Sorrows emerging from the sarcophagus above, unnoticed by the spectators behind the altar, and sensed, but not actually seen, by the acolyte and the two donors.

The basic elements of this composition, the frontal placement of the altar and the prominence of the sarcophagus and the great arch behind, were probably inspired by an engraving which Israhel van Meckenem made in the 1480s. Bosch, however, achieved a monumentality absent in his model by lowering the viewpoint and by increasing the distance between Gregory and his vision; in addition, he exchanged the usual instruments of the Passion for the biblical episodes which they symbolize. Beginning with the Agony in the Garden and the Betraval, these scenes are presented as pictures painted on the lower part of the arch whose upper part becomes a mountain from which the Crucifixion emerges into the space of the church itself. Gregory's vision, in fact, fills the entire church; instead of vaults, we see a cloudy night sky from which an angel descends to receive the soul of the good thief. The crucifixion of the bad thief, however, has been replaced by the suicide of Judas Iscariot whose limp figure dangles from a tree on the right-hand slope, his soul borne away by a black devil. In this detail, Bosch alludes once again to the conflict between Church and Synagogue, reminding us that it was Judas's treachery which precipitated the events of the Passion and death of Christ.

By comparison with the Prado »Epiphany«, whose iconographical complexities are exceeded only by the »Garden of Earthly Delights« and the Lisbon »St Anthony«, the Passion scenes which Bosch painted during his middle and later years are simpler, their imagery more easily grasped by the viewer. One such work is the »Christ Carrying the Cross« in the Palacio Real, Madrid. Christ dominates the foreground, almost crushed beneath the heavy Cross which the elderly Simon of Cyrene struggles to lift from his back. The ugly heads of his executioners rise steeply in a mass towards the left; in the distance, the sorrowing Virgin collapses into the arms of John the Evangelist. Whereas Bosch's earlier composition of this subject in Vienna (p. 19) had been diffuse and primarily narrative, the Madrid version is concentrated, and the way that Christ ignores his captors to look directly at the spectator gives it the quality of a timeless devotional image.

Perhaps, as some critics claim, Bosch equated the historical tormentors of Christ with mankind at large, whose daily wickedness continues to torture Christ even after his Resurrection. This notion of the »Perpetual Passion« was not uncommon in Bosch's day. In the Madrid picture, however, Christ's gaze is not so much an accusation as an appeal, as if to say, in the words of Matthew 16:24: »If any man will come after me, let him deny himself, and take up his cross, and follow me.«

Christ Crowned with ThornsOil on panel, 73 × 59 cm
London, National Gallery
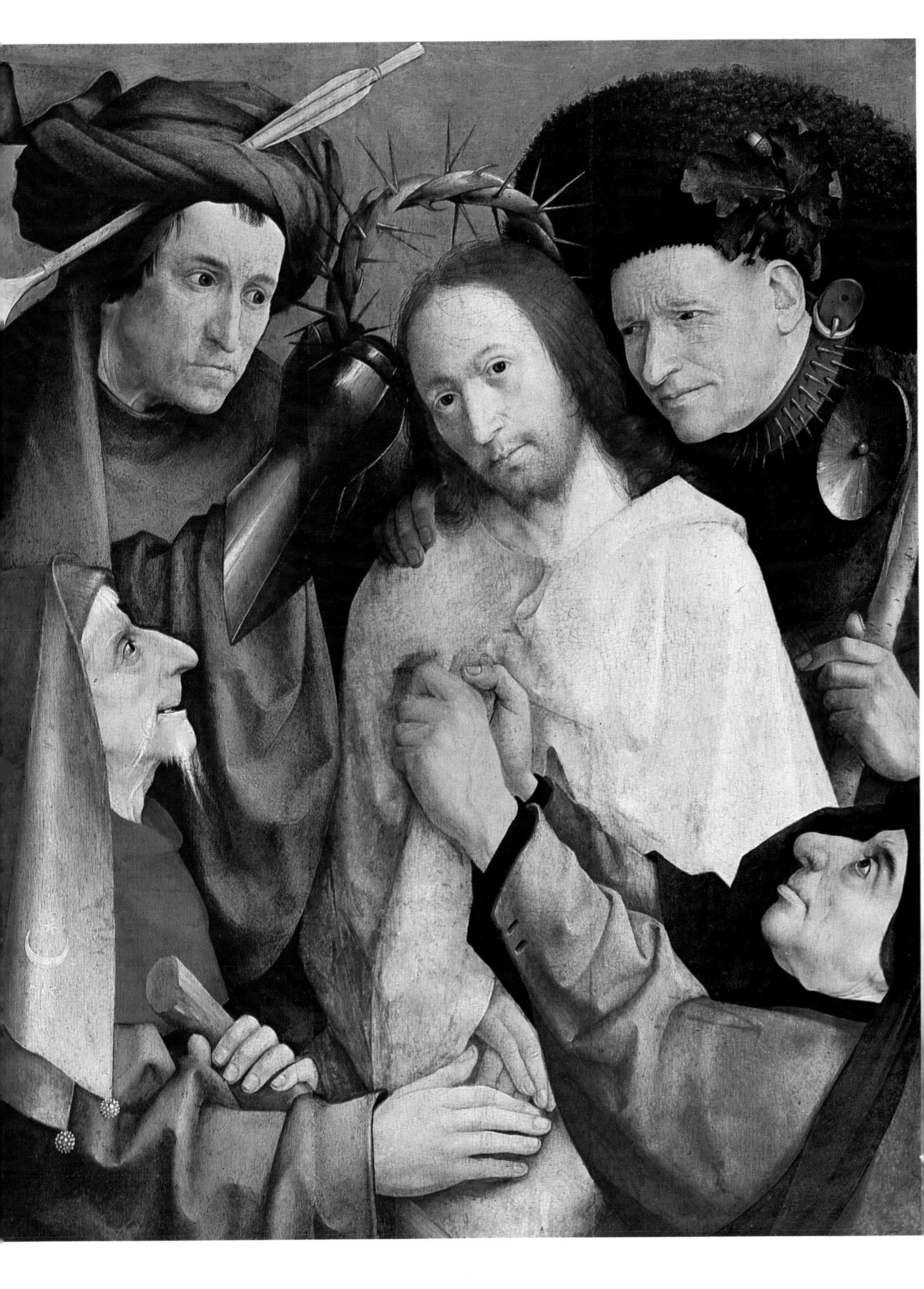

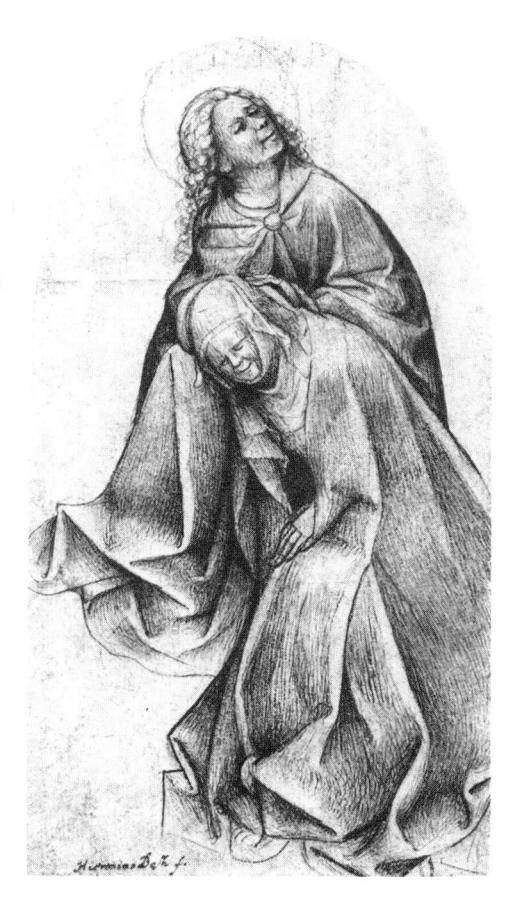

Mary and John at the Foot of the Cross Brush, 30,2 × 17,2 cm Dresden, Kupferstichkabinett

Simon of Cyrene had been compelled by the soldiers to take up the Cross of Christ, but for centuries the Cross had been willingly embraced by pious Christians who sought to emulate the Saviour in their own lives. To imitate Christ was to submit to the assaults of this world with the same patience and humility displayed by Christ himself during his Passion; for temporal affliction, as the mystics and moralizers never tired of telling their audience, purifies the soul just as fire tempers steel and refines gold. This religious ideal is well known to us through Thomas à Kempis's famous book, but a more succinct expression of it can be found in a prayer attached to a fifteenth-century German woodcut representing Christ Carrying the Cross: »O dear Lod Jesus Christ, as thou hast carried thy cross, so grant me, dear Lord, that I also patiently bear all adversity and sorrows which may befall me, that I therewith lay low all villainy and temptation of the body and of the battle over the evil spirit.«

The concept of the Way of the Cross, the Imitation of Christ, was further developed by Bosch in a group of half-length Passion scenes. The earliest example most probably is the »Christ Crowned with Thorns« (London, National Gallery; p. 75). The large, firmly modelled figures are composed against the plain, grey-blue background with the utmost simplicity, the white-robed Christ surrounded by his four tormentors. One soldier holds a crown of thorns above his head, another tugs at his robe, and a third touches his hand with a mocking gesture. Their actions, however, seem curiously ineffectual and, as in the Madrid »Christ Carrying the Cross«, Christ ignores his persecutors to look calmly, even gently, at the spectator.

The half-length format and the tendency to crowd the figures against the picture plane with little indication of space, are characteristics which reflect a Flemish devotional type popularized by Hugo van der Goes and Hans Memling. Like its Flemish models, the London »Christ Crowned with Thorns« presents the sacred scene not in its historical actuality but in its timeless aspect, in this instance, as a prototype for the Christian virtues in the midst of adversity.

Bosch's interpretation of the Imitation of Christ must have appealed to his contemporaries, for he reworked the London composition into a second version of the subject. Although the original painting is lost, it survives in no less than seven copies, a testimony to its popularity.

This second composition, in turn, seems to have inspired the large, imposing »Christ Crowned with Thorns« in the Escorial, in which the figures have been adjusted to a circular field and placed against a gold ground (right). Christ sits on a ledge in the immediate foreground, and, as before, his eyes engage the viewer. This time, however, his furrowed brow clearly expresses his suffering, and the static gestures of his captors in the earlier versions have been transformed into violent actions. A snarling rat-faced man rips off Christ's robe with a mailed fist; his smirking companion has placed one foot on the ledge in order to push the crown of thorns more tightly on his head, while a third man watches intently from behind the other two. In contrast, the two spectators on the left look on with cool detachment. This torment of Christ is given cosmic meaning in the grisaille border, where angels and devils are locked in unending conflict.

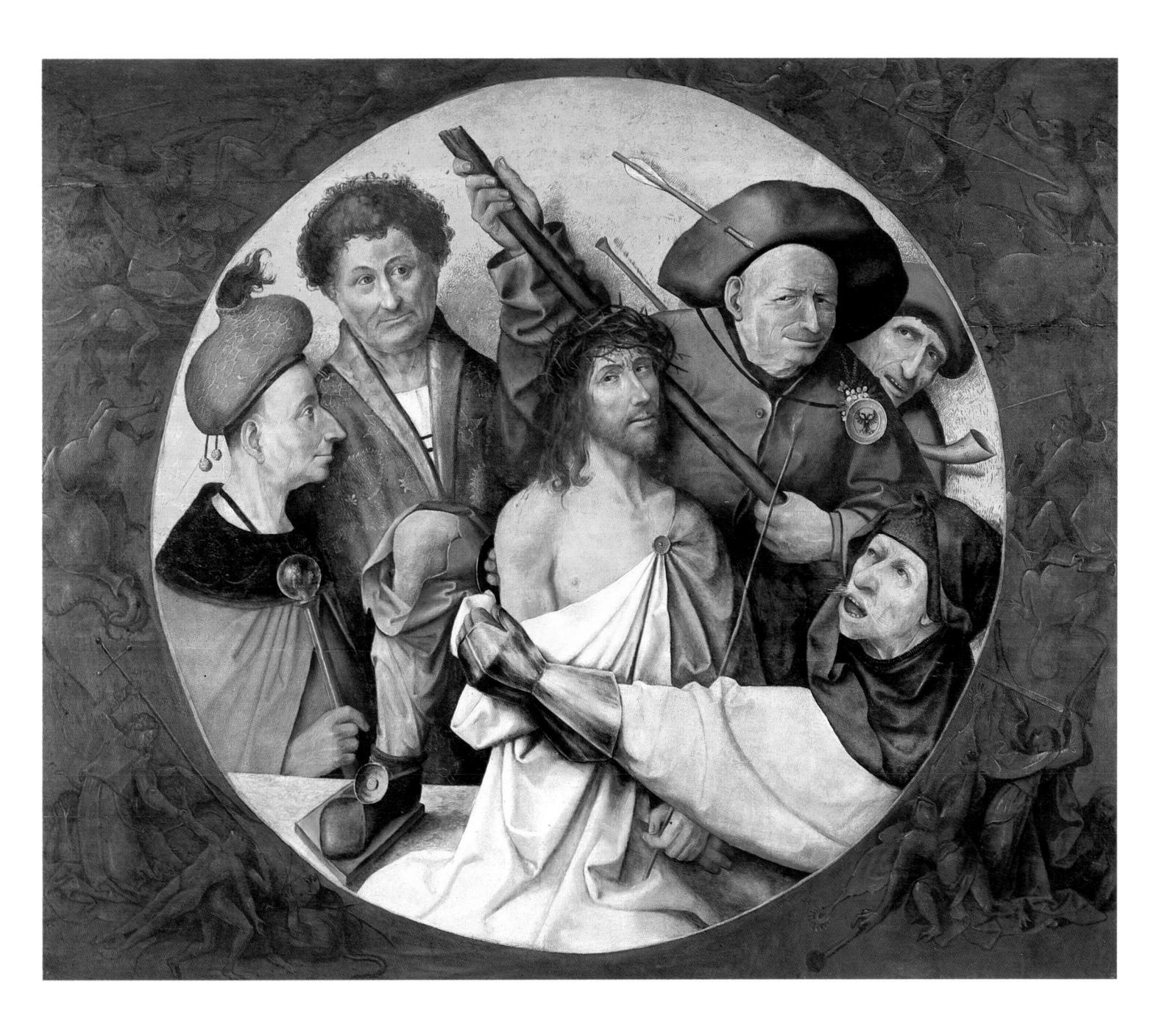

The malice of Christ's enemies reaches a hysterical pitch in Bosch's last Passion scene, the »Christ Carrying the Cross« in Ghent (p. 78). This time Christ is accompanied by St Veronica, an apocryphal figure not mentioned in the Bible, who supposedly wiped the sweat from her Saviour's face as he struggled beneath the Cross and thereby obtained a miraculous image of his features on her handkerchief. The two thieves appear at the right. Around these four figures surge a howling mob who scowl, leer and roll their eyes at their victims, their twisted and deformed faces glowing with an unearthly light against the dark ground. These are not men but demons, perfect incarnations of all the lusts and passions that ever stained the soul. Bosch never rendered human physiognomies with a more intense ugliness, and it has been thought that he was inspired here by Leonardo's drawings of grotesque heads. It is just as likely, however, that he turned to the German artists who for generations had endowed the tormentors of Christ with monstrously deformed features.

Christ Crowned with ThornsOil on panel, 165 × 195 cm
El Escorial, Monasterio de San Lorenzo

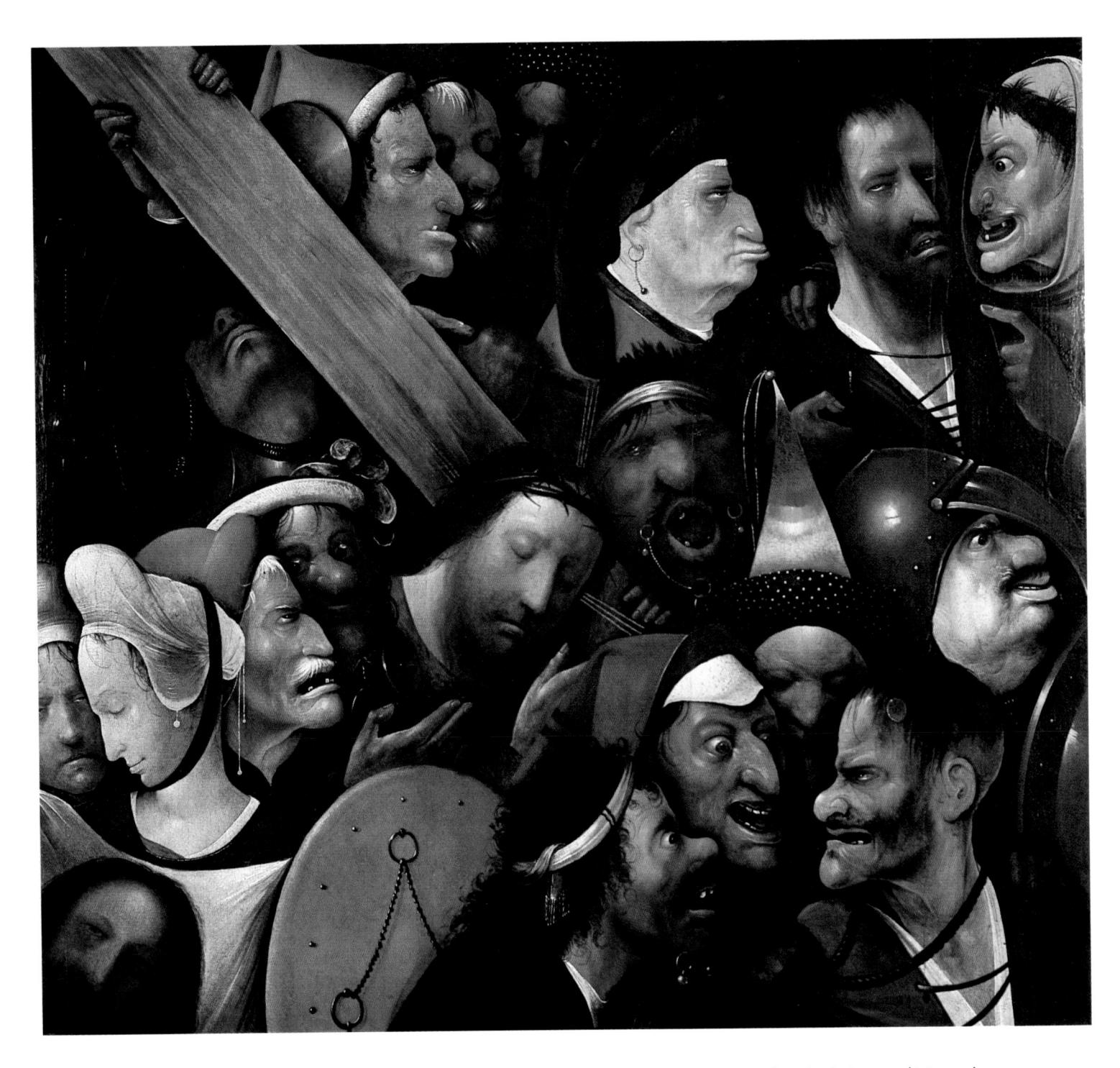

Christ Carrying the Cross Oil on panel, 76,7 × 83,5 cm Ghent, Musée des Beaux-Arts

In this maelstrom of evil, the heads of Christ and Veronica appear oddly calm and aloof. Eyes closed, they appear to respond to some inner vision rather than to the tumult around them; Veronica's lips even curve in a slight smile. Paradoxically, it is Christ's image imprinted on her veil which looks out to us beseechingly. The contrast between Christ himself and the two thieves could not be greater. The bad thief, at lower right, snarls back at his taunting captors; the good thief above appears about to collapse in terror at the words of his diabolic confessor. They are carnal men, still immersed in the troubles of this world, but Christ has withdrawn to a higher sphere where his persecutors cannot reach him. In the midst of suffering he is victorious. And to all who take up his Cross and follow him, Christ promises the same victory over the World and the Flesh: this was the message which Bosch's half-length Passion scenes presented to his contemporaries.

The Triumph of the Saint

In his pictures of the saints, Bosch seldom depicted those miraculous exploits and spectacular martyrdoms which so fascinated the later Middle Ages. Except for the early »Crucifixion of St Julia« (p. 84), he showed the more passive virtues of the contemplative life: no soldier saints, no tender virgins frantically defending their chastity, but hermits meditating quietly in a landscape.

Three variations of this theme appear in the sadly damaged triptych of the »Hermit Saints« in Venice, painted towards the middle of his career. In the centre (p. 80) St Jerome fastens his gaze on a crucifix, secure against the evil world symbolized by the remains of a pagan temple scattered around him on the ground and by two monstrous animals engaged in a death struggle below. On the left, St Anthony the Hermit resists the amorous advances of the Devil-Queen, an episode to which we shall return. Snugly ensconced in a cave chapel on the right wing, St Giles prays before an altar, the arrow piercing his breast commemorating the time when he was shot accidentally by a passing hunter.

All three saints reflect the monastic ideal as set forth, for example, in the »Imitation of Christ«: a life spent in mortification of the flesh and in continuous prayer and meditation. »How strict and self-denying was the life of the holy Fathers in the desert!« exclaims Thomas à Kempis, »How long and grievous the temptations they endured! How often they were assaulted by the Devil! How frequent and fervent their prayers to God! ...How great their zeal and ardour for spiritual progress! How valiant the battles they fought to overcome their vices!«

In the »St Jerome at Prayer« (p. 83), Bosch gave an even more telling image of this ideal. Jerome has cast himself down, a crucifix cradled in his arms; his splendid red cardinal's robe lies abandoned on the ground. Absent are the dramatic gestures — the breast-beating and the eyes raised adoringly to the Cross — with which other artists represented the penitent saint, but in this still, intent figure, Bosch has nonetheless poignantly expressed Jerome's spiritual anguish. The peaceful background panorama contains no hint of evil, but the swampy grotto in which the saint lies is rank with corruption and decay. In his autobiography, Jerome describes how his meditations in the wilderness were interrupted by visions of beautiful courtesans. These lustful thoughts are undoubtedly symbolized by the large decomposing fruits near the saint's cave, reminiscent of the flora in the «Garden of Earthly Delights«. Only by surrendering completely to the will of God could Jerome subdue his rebellious flesh.

In another picture (Madrid, Museo Lázaro-Galdiano), Bosch shows St John the Baptist seated in a humid summer landscape (p. 85). The

Temptation of St Anthony Pen and bistre, 25,7 × 17,5 cm Berlin, Kupferstichkabinett

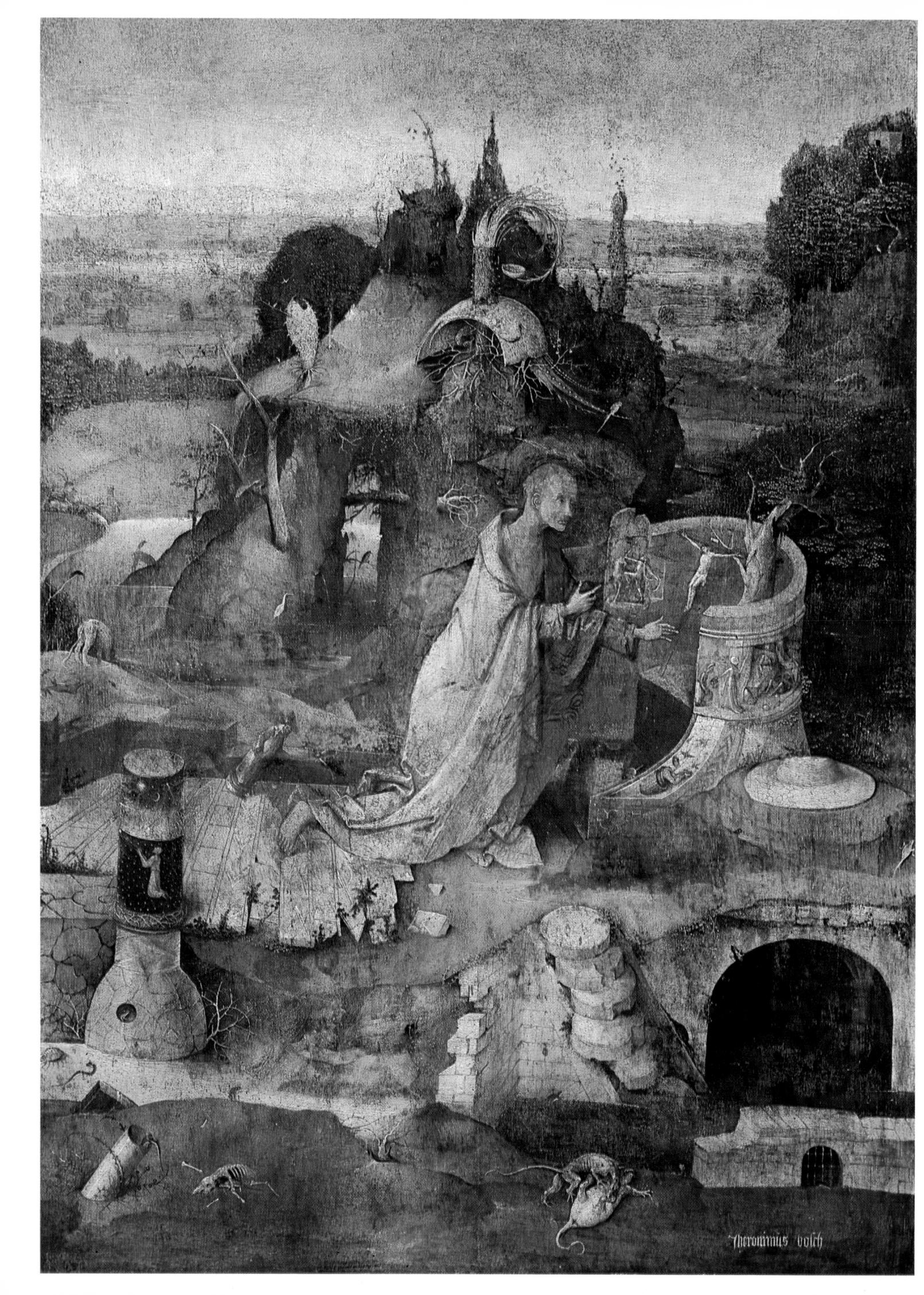

composition may well have been influenced by a painting done some years earlier by Geertgen tot Sint Jans. Geertgen represented the thoughtful prophet staring abstractedly into space, rubbing one foot against the other, but Bosch shows him pointing purposefully towards the Lamb of God crouching at lower right. This gesture traditionally identifies John as the forerunner of Christ, the »precursor Christi«. In this instance however, it also indicates a spiritual alternative to the life of the flesh symbolized in the great pulpy fruits hanging near him on gracefully curving stems, and in the equally ominous forms rising in the background.

In a painting in Rotterdam, St Christopher appears in a landscape similarly charged with evil (p. 87). His red cloak bunched up behind him, the giant Christopher staggers across the river, with the Christ Child on his back. According to legend, Christopher had served a king and the Devil himself in a search for a powerful and worthy master, a search which ended only when a hermit converted him to Christianity. The hermit stands at the edge of the water at lower right, but his treehouse has been transformed into a broken jug which houses a devilish tavern; above, a naked figure scrambles up a branch towards a beehive, a symbol of drunkenness. Across the river, a dragon emerges from a ruin, frightening a swimmer, while a town blazes in the shadowy distance. These and other sinister details recall the landscape on the exterior of the »Haywain« triptych, but unlike the »Haywain« pilgrim, Christopher is well protected by the passenger he bears.

No less secure against the wiles of the Devil is St John the Evangelist in a picture in Berlin (p. 89). The youthful apostle is depicted on the island of Patmos, where he had been banished by the Emperor Domitian and where he composed the Book of Revelation, presumably the volume on his lap. His mild gaze is lifted towards an apparition of the Virgin enthroned on a crescent moon, the Apocalyptic woman described in Revelation 12:1-16. She is pointed out to him by an angel whose slender figure and delicately plumed wings appear scarcely more substantial than the misty Dutch panorama behind. Perhaps influenced by earlier representations of this subject, Bosch for once restrained his predilection for demonic spectacles. There are, to be sure, several ships burning in the water at lower left, and a little monster can be seen at lower right, both details probably suggested by St John's Apocalypse, but neither seriously disturbs the idyllic landscape in which the saint enjoys his vision.

But the evil thus suppressed in the Berlin »St John« bursts out on the reverse of the panel, painted in grisaille, where monsters swarm like luminous deep-sea fish around a great double circle (p. 88). As in the Prado »Tabletop«, Bosch employs the mirror motif, this time, however, showing a mirror of salvation: the Passion of Christ unfolds within the outer circle, culminating visually in the Crucifixion at the top. The Mount of Golgotha is repeated symbolically in the inner circle, in the form of a high rock surmounted by a pelican in her nest. The pelican, who supposedly fed her young with blood pricked from her own breast, was a traditional symbol of Christ's sacrifice. She appears very appropriately on the back of this picture devoted to St John, the beloved disciple who had rested his head, as Dante tells us (»Paradiso«, XXV), on the breast of the Divine Pelican himself.

St Anthony
St Giles
Left and right wings of the
»Hermit Saints« triptych
Oil on panel, 86×20 cm (each panel)
Venice, Palazzo Ducale

St Jerome

Central panel of the »Hermit Saints« triptych Oil on panel, 86 × 60 cm Venice, Palazzo Ducale

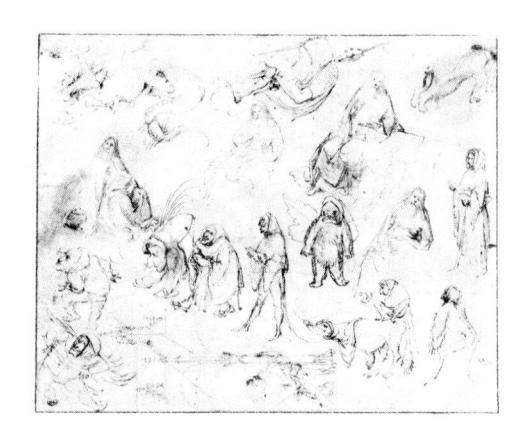

Studies for the »Tempation of St Anthony«Pen and bistre, 20,5 × 26,3 cm
Paris, Louvre, Cabinet des Dessins

It is likely that these little pictures of the saints were intended to be contemplated in the quiet of the cloister or private chapel. They present, in terms of the monastic ideal, the arduous path which the Christian pilgrim must climb to regain his lost homeland and achieve union with God. Nowhere, however, were the vicissitudes of the spiritual life more vividly and circumstantially detailed than in the legend of St Anthony the Hermit, founder of Christian monasticism, which Bosch painted on an altarpiece now preserved in Lisbon.

St Anthony is a recurrent figure in Bosch's work. In addition to the left wing of the »Hermit Saints« triptych, his figure appears several times on a drawing in the Louvre (left). A small panel in the Prado, showing the saint meditating in a sunny landscape (p. 90), is also generally attributed to him although many details deviate from his usual style. Nevertheless, the Lisbon triptych (pp. 91-95) remains his most comprehensive statement of the theme, the particulars of which he drew from the »Lives of the Fathers« and the »Golden Legend«, both of which were available in contemporary Dutch translations.

As we learn from these medieval compendia of saints' lives, St Anthony passed most of his long life (c. 251-356) in the Egyptian desert, where his extraordinary piety made him an object of special attention for Satan. Once while praying in the shelter of an old tomb, Anthony was overwhelmed by a horde of devils who beat him so relentlessly that he was left for dead. After several fellow hermits had rescued and revived him, however, he returned to the tomb, where the devils caught him a second time and tossed him high into the air. This time his torments ended only when a Divine light illuminated the tomb and dispersed the devils. Satan then appeared in the guise of a beautiful and saintly queen whom Anthony encountered bathing in a river. Taking the hermit into her city, the Devil-Queen showed him all her supposed works of charity, and it was only when she sought to seduce the bedazzled Anthony that he recognized her true nature and intentions.

Two of these episodes are represented on the left inner wing of the Lisbon altarpiece. In the foreground, the unconscious Anthony is carried across a bridge by two companions dressed in the habit of the Antonite Order, accompanied by a secular figure who has been identified with some plausibility as a self-portrait of Bosch. Anthony appears again in the sky, borne aloft by demons, while other monsters buzz around him like angry insects. These scenes conform fairly closely to the written sources but as in so many other instances, Bosch enriched the original accounts with a wealth of inventive and dramatic detail. Three monsters confer beneath the bridge as an equally grotesque messenger skates towards them on the ice. A bird gulps down its newly hatched young at lower left. On the road ahead of Anthony and his companions, another group of demons approach a kneeling male figure whose body forms the roof and entrance of a brothel; a false beacon lures ships to their destruction in the sea beyond; and the shore is littered with corpses.

This powerful evocation of a corrupt and stinking world is no less apparent in the right wing, where Bosch used as his starting point the story of the Devil-Queen, a subject he had already depicted in the »Hermit Saints« altarpiece. The Devil-Queen appears in the river before Anthony,

St Jerome at Prayer Oil on panel, 77 × 59 cm Ghent, Musée des Beaux-Arts

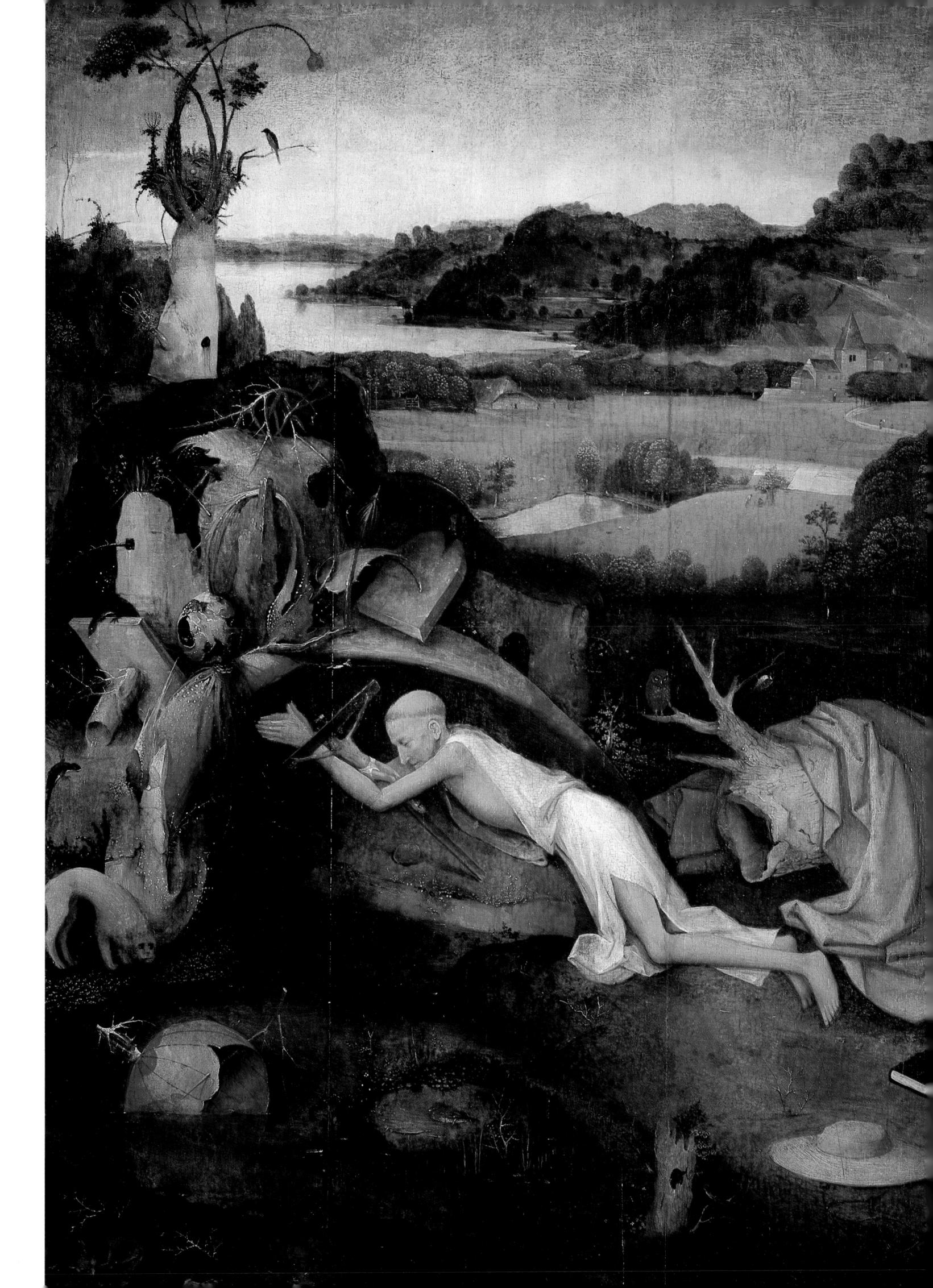

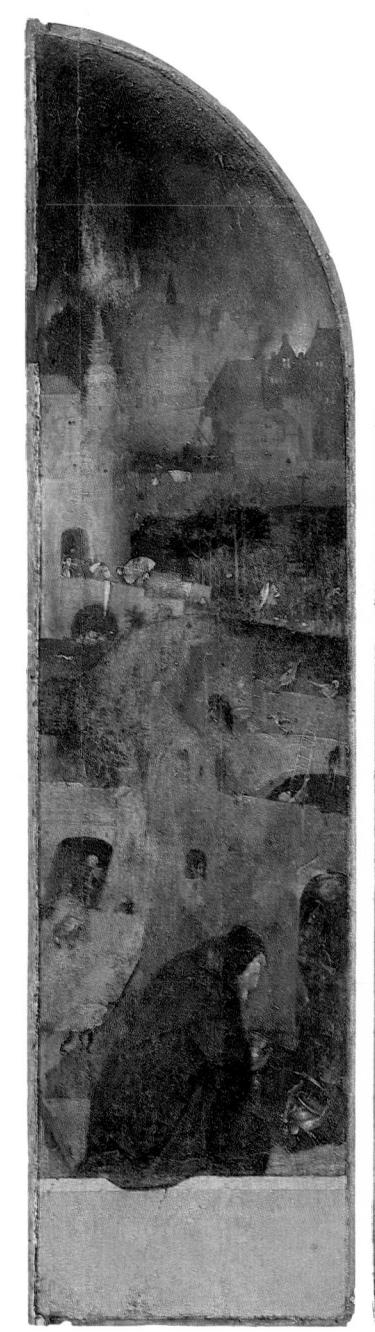

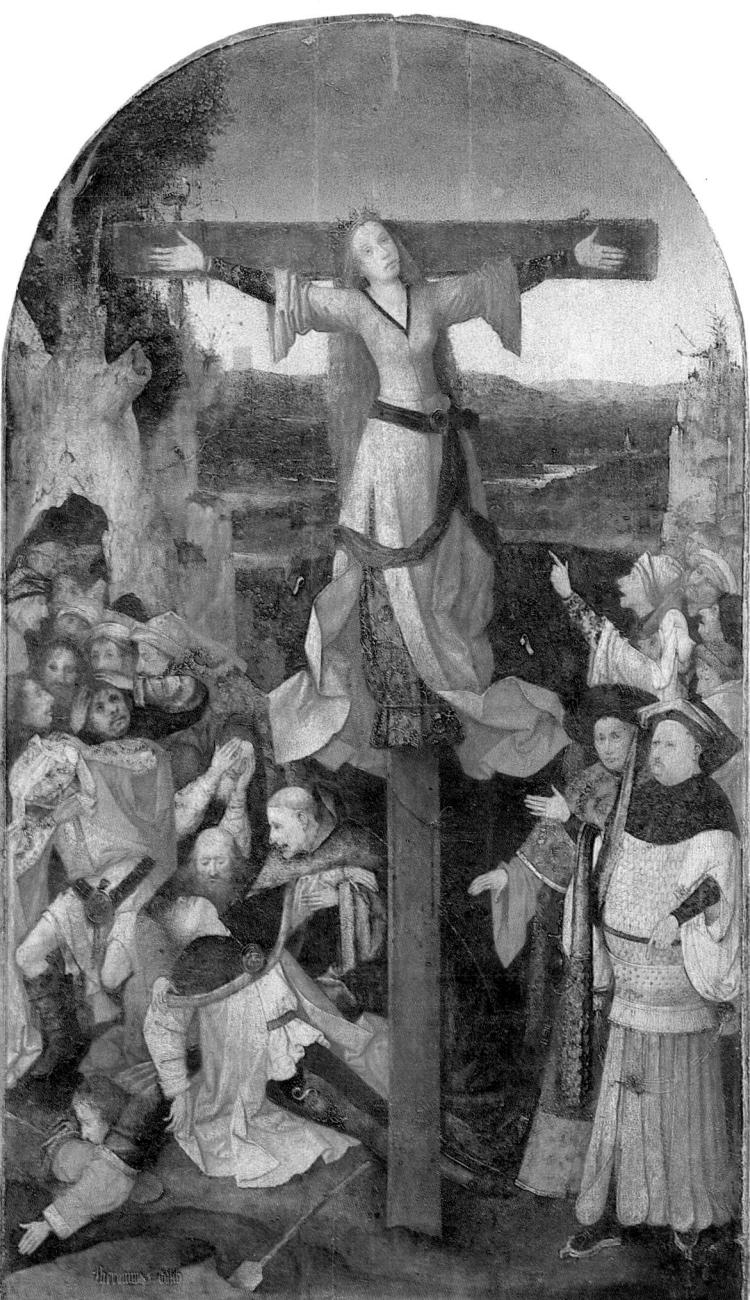

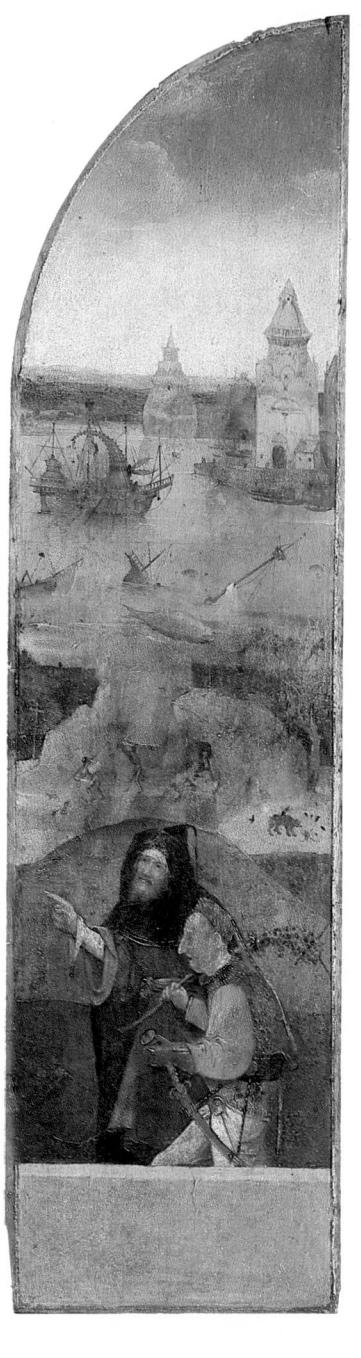

Crucifixion of St Julia (Triptych)Oil on panel, 104 × 119 cm

Venice, Palazzo Ducale

LEFT WING:

St Anthony in Meditation Oil on panel, 104 × 28 cm

CENTRAL PANEL:

Crucifixion of St Julia or Liberata Oil on panel, 104 × 63 cm

RIGHT WING:

Two Slave-Dealers Oil on panel, 104×28 cm

RIGHT:

St John the Baptist in the Wilderness Oil on panel, $48.5 \times 40 \text{ cm}$ Madrid, Museo Lázaro Galdiano

shielding her private parts with a false modesty and surrounded by her infernal court. Anthony averts his eyes from this obscene group only to be summoned by a demon-herald to the devilish feast in the foreground. The open-air table, the cloth slung tent-like over the tree stump beside the temptress, and the servants pouring wine seem like a grotesque parody of the traditional Garden of Love. In the background looms the city of the Devil-Queen, its demonic nature betrayed by the dragon swimming in the moat and by the flames erupting from the top of the main gate.

These diabolic enterprises reach a climax in the middle panel. Devils of all species, human and grotesque, arrive from all directions by land, water and air, to converge upon a ruined tomb in the centre. On a platform before the tomb, an elegantly dressed pair have set up a table from which they dispense drink to their companions. Near by, a woman wearing a large headdress and a gown with an extravagantly long train kneels at a parapet to offer a bowl to a figure opposite. Kneeling beside her, almost

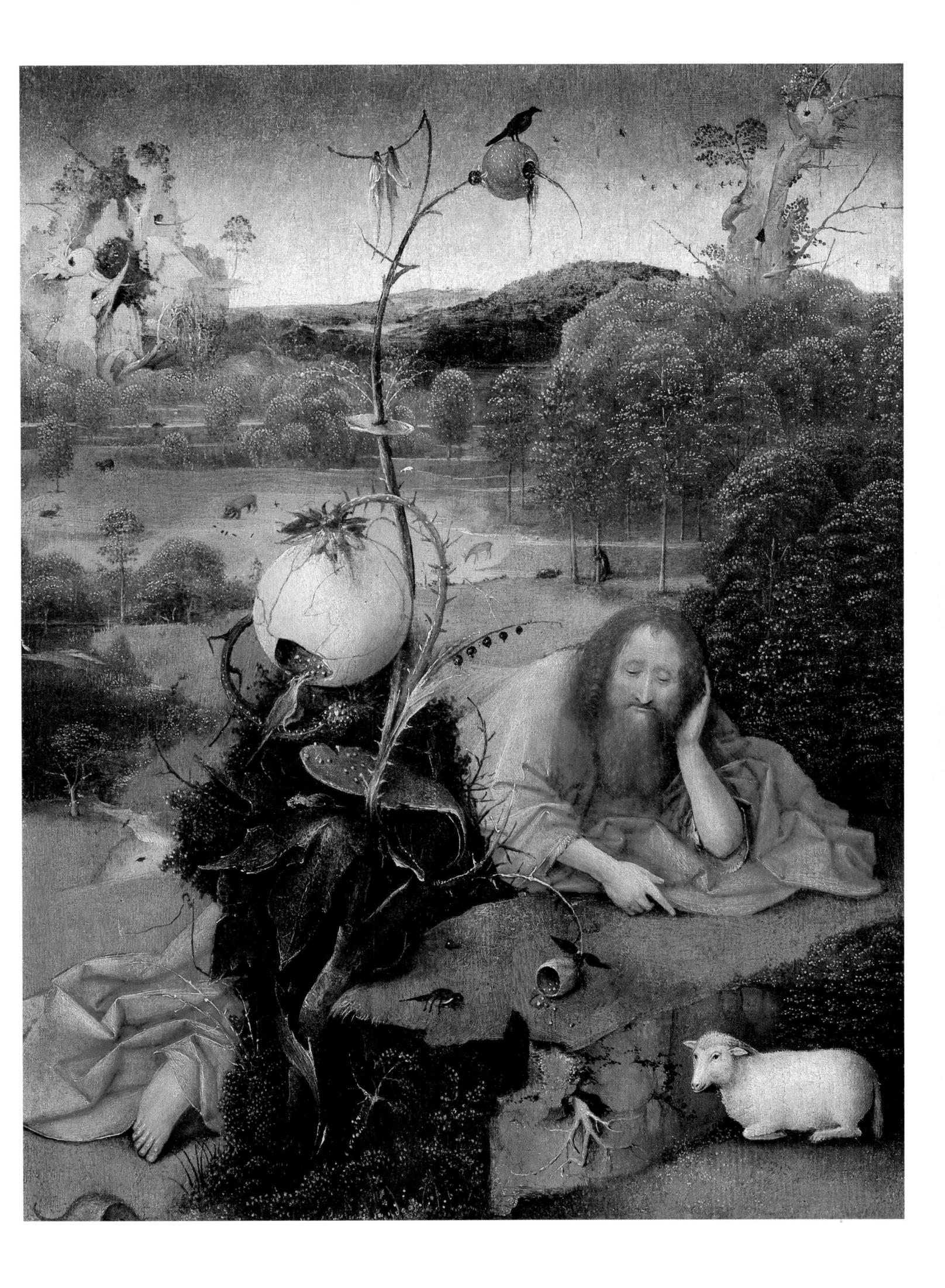

Two WitchesPen and bistre, 12,5 × 8,5 cm
Rotterdam, Museum Boymans-van Beuningen

unnoticed in the midst of this hellish activity, is St Anthony himself; he turns towards the viewer, his right hand raised in blessing. His gesture is echoed by Christ halfhidden in the depths of the tomb, which Anthony has converted into a chapel. The right wall of the sanctuary ends in a decaying tower covered with monochrome scenes. Two of them, the Adoration of the Golden Calf and a group of men making offerings to an enthroned ape, are images of idolatry, while the third, the Israelites returning from Canaan with a bunch of grapes, prefigures Christ carrying the Cross on the outer wings of the triptych.

A burning village illuminates the dusky background, probably a reference to the disease of ergotism or »St Anthony's Fire«, whose victims invoked the name of St Anthony for relief. The ancient association of ergotism with the devil-plagued saint may have been influenced by the fact that one phase of the disease is characterized by hallucinations in which the sufferer believes that he is attacked by wild beasts or demons.

The devils who have gathered around St Anthony display a complexity of form unusual even for Bosch. In the group far right, for example, a blasted tree trunk becomes the bonnet, torso and arms of a woman whose body terminates in a scaly lizard tail; she holds a baby and is mounted on a giant rat (p. 95). Near by, a jug has been transformed into another beast of burden whose wholly unsubstantial rider bears a thistle for a head. In the water below, a man has been absorbed into the interior of a gondola-fish, his hands thrust helplessly through its sides. An armoured demon with a horse's skull for a head plays a lute at lower left; he sits astride a plucked goose who wears shoes and whose neck ends in a sheep's muzzle. All these shifting forms, moreover, display a richness of colour that confers a visual beauty on even the most disgusting shape. A recent, careful cleaning of the triptych, among Bosch's best preserved works, reveals brilliant reds and greens alternating with subtly modulated passages of blue-greys and browns.

This convocation of fiends ostensibly illustrates the second attack on Anthony described in the literary accounts; the miraculous light which dispersed the devils on this occasion can be seen shining through one of the chapel windows. But the devils do not seem about to scatter »like dust in the wind«, as one version has it, nor are they physically attacking Anthony. Instead, their torments must be understood in a spiritual sense. Like the monstrous creatures who confront Dequilleville's pilgrim, they are incarnations of the sinful urges with which Anthony wrestled in his desert solitude. In a drawing made around 1500, Albrecht Dürer similarly illustrated the evil thoughts of a group of people at Mass by means of little devils fluttering about their heads. Bax has identified a number of sins symbolized by Bosch's monsters, chief among which is Lust. Lust is also represented more overtly in the group of buildings at extreme right, where a monk and a prostitute drink together within a tent; there may be a further reference in the dark-skinned devil in the central group: the demon of unchastity, we are told, once appeared to Anthony in the form of a black boy. It should not be surprising that even the most ascetic saints were susceptible to this particular vice: as the »Malleus Maleficarum« informs us, it was through the carnal act that the Devil could most easily assail mankind.

St Christopher Carrying the Christ ChildOil on panel, 113 × 71,5 cm
Rotterdam, Museum Boymans-van Beuningen

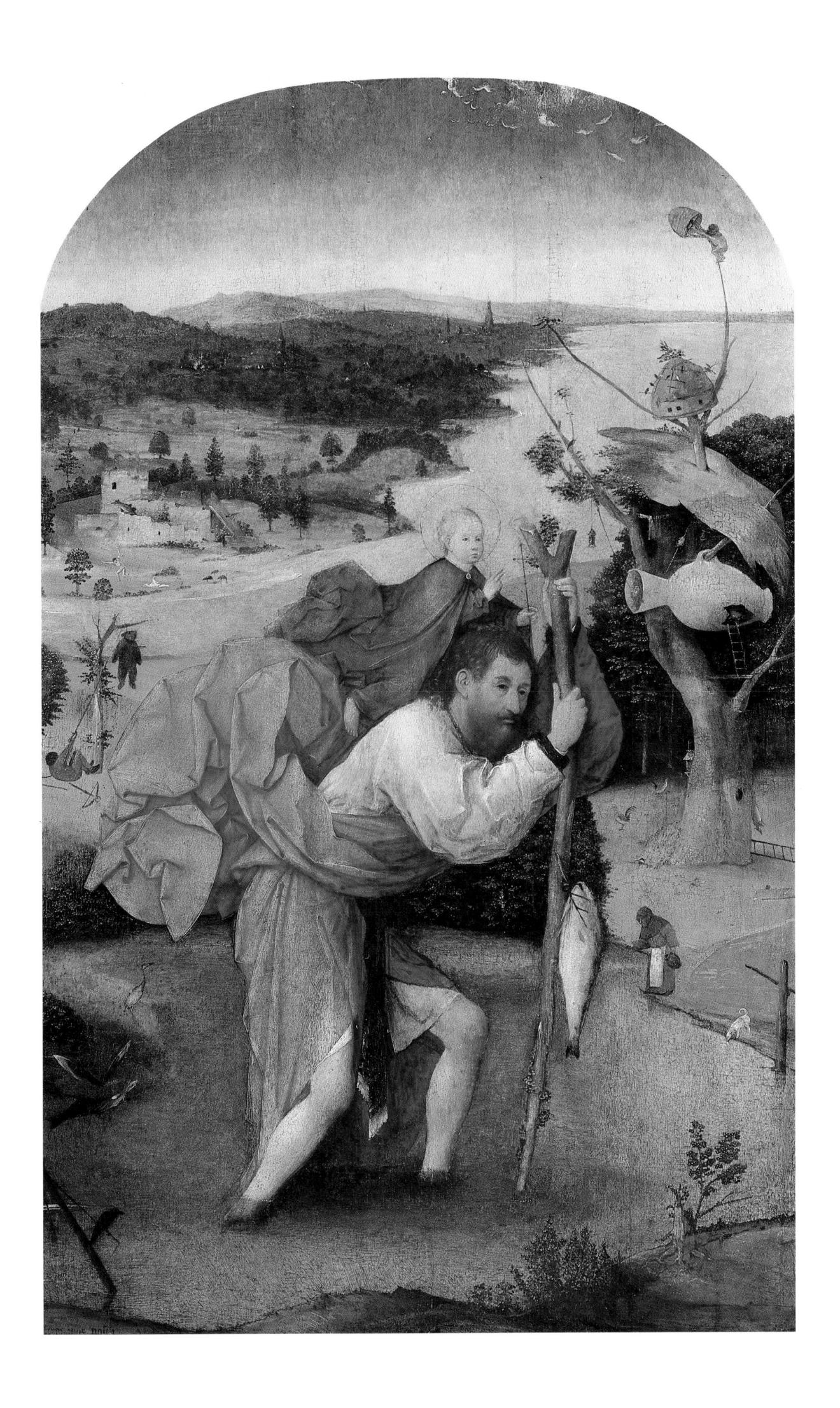

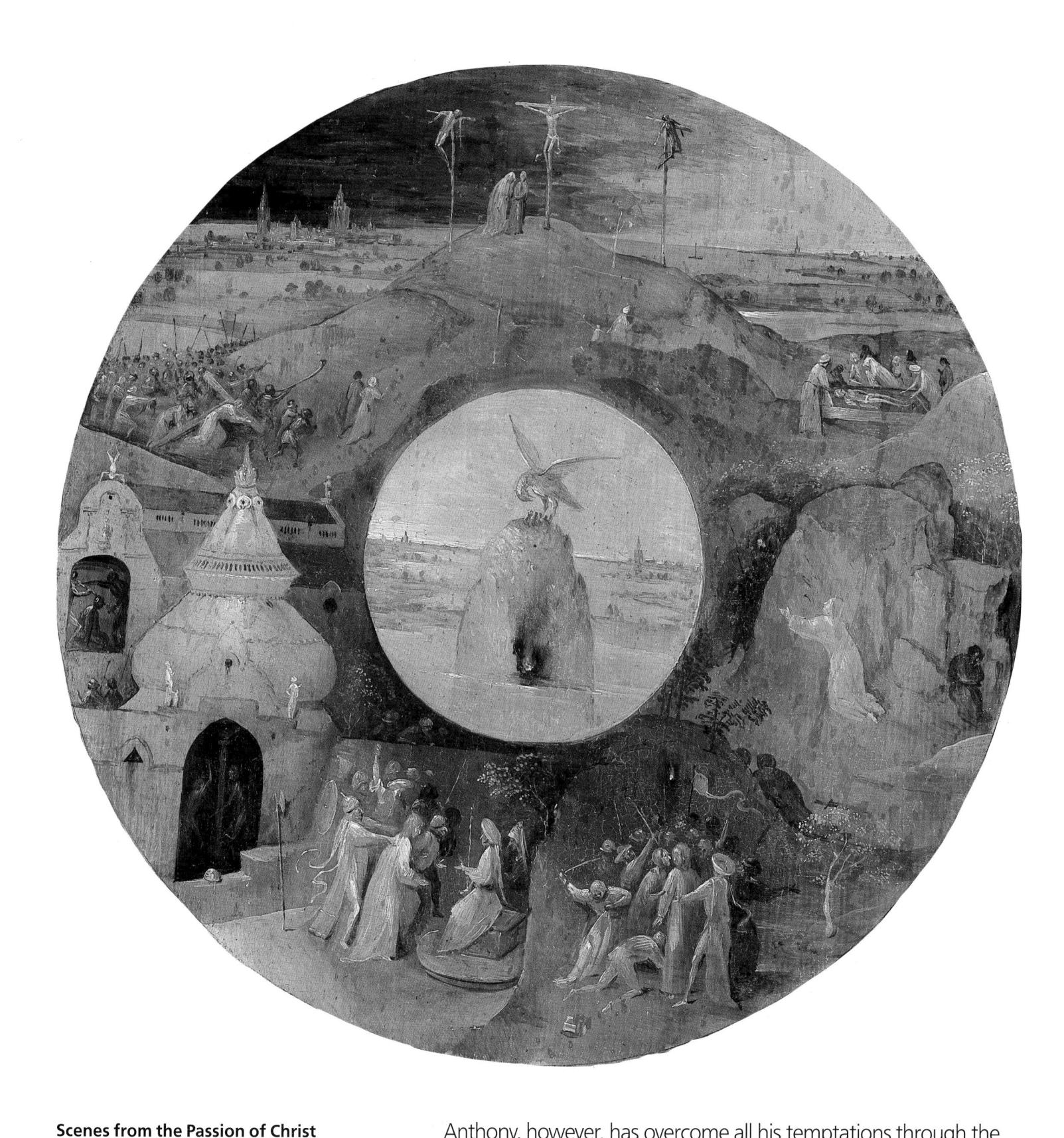

and the Pelican with Her Young Reverse of »St John the Evangelist on Patmos« Grisaille on panel; diameter of

roundel: c. 39 cm Berlin, Gemäldegalerie

St John the Evangelist on Patmos Oil on panel, $63 \times 43,3$ cm Berlin, Gemäldegalerie

Anthony, however, has overcome all his temptations through the strength of his faith. This faith is expressed in his gesture of benediction, thought to be particularly efficacious against the Devil; and the steady gaze which the hermit directs towards us is one of comforting assurance, as if he were saying, in the words attributed to him in the »Lives of the Fathers«: »though an host should encamp against me, my heart shall not fear. « (Psalms 27:3.) It is the same gaze which we have encountered in the face of Christ which looks out at us from the Madrid »Christ Carrying the Cross« and the London »Christ Crowned with Thorns«. When Anthony recognized the presence of Christ in the miraculous light, he cried out:

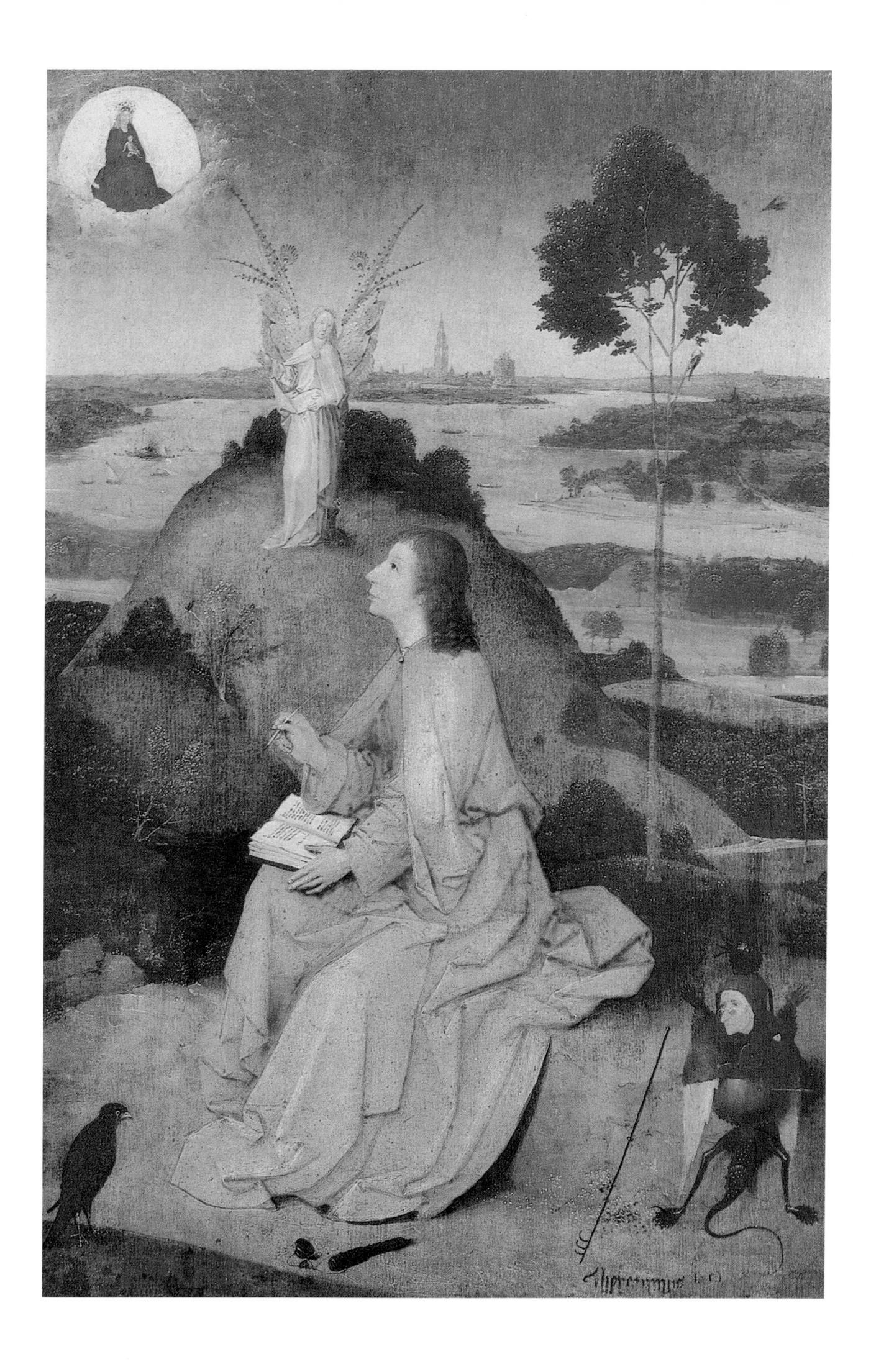

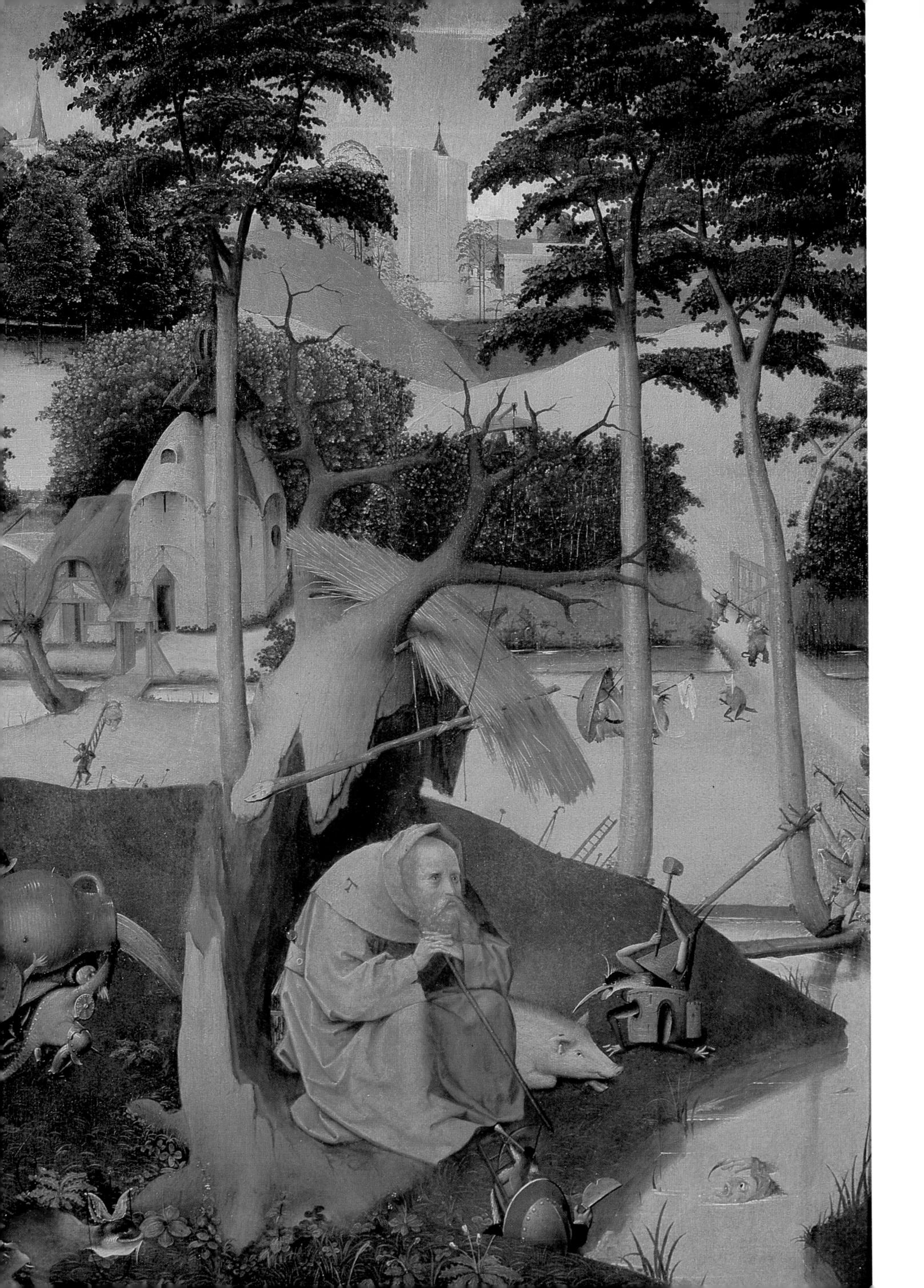

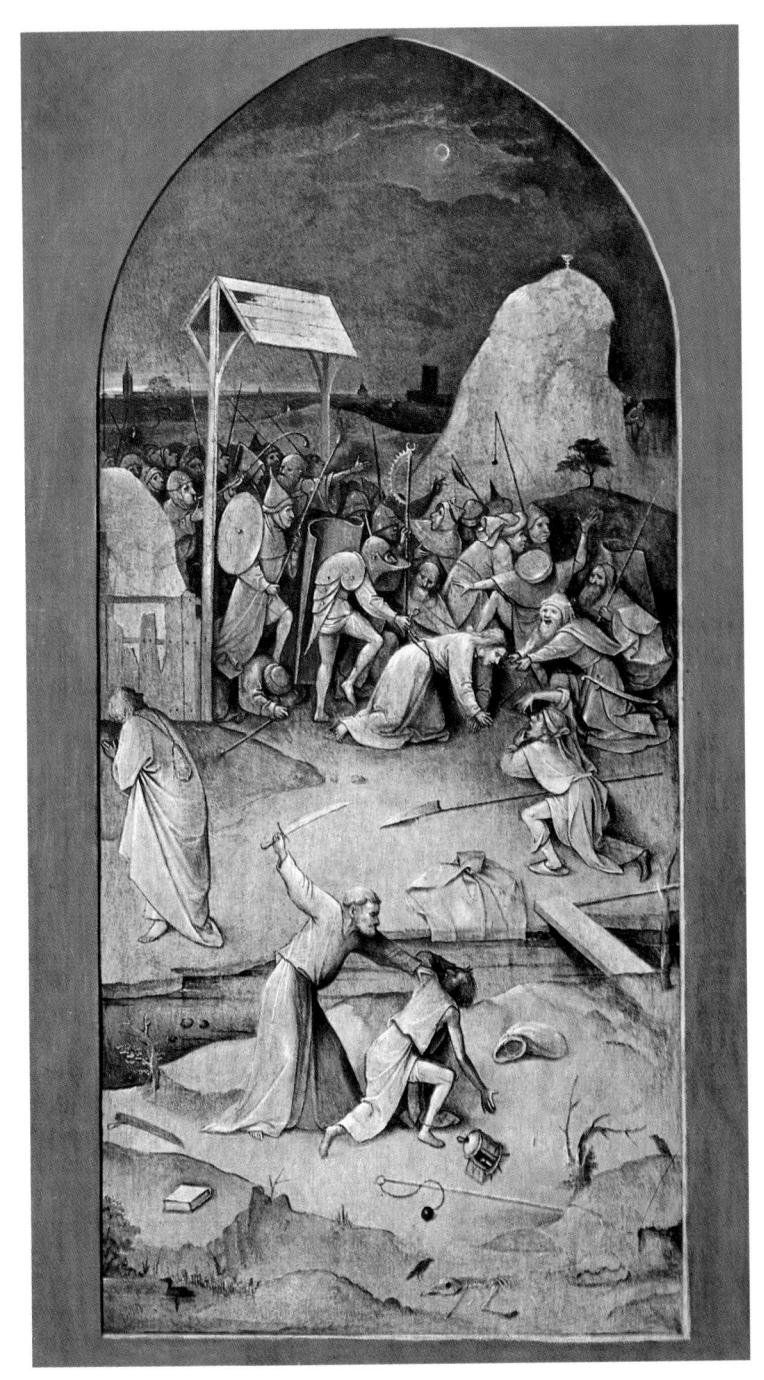

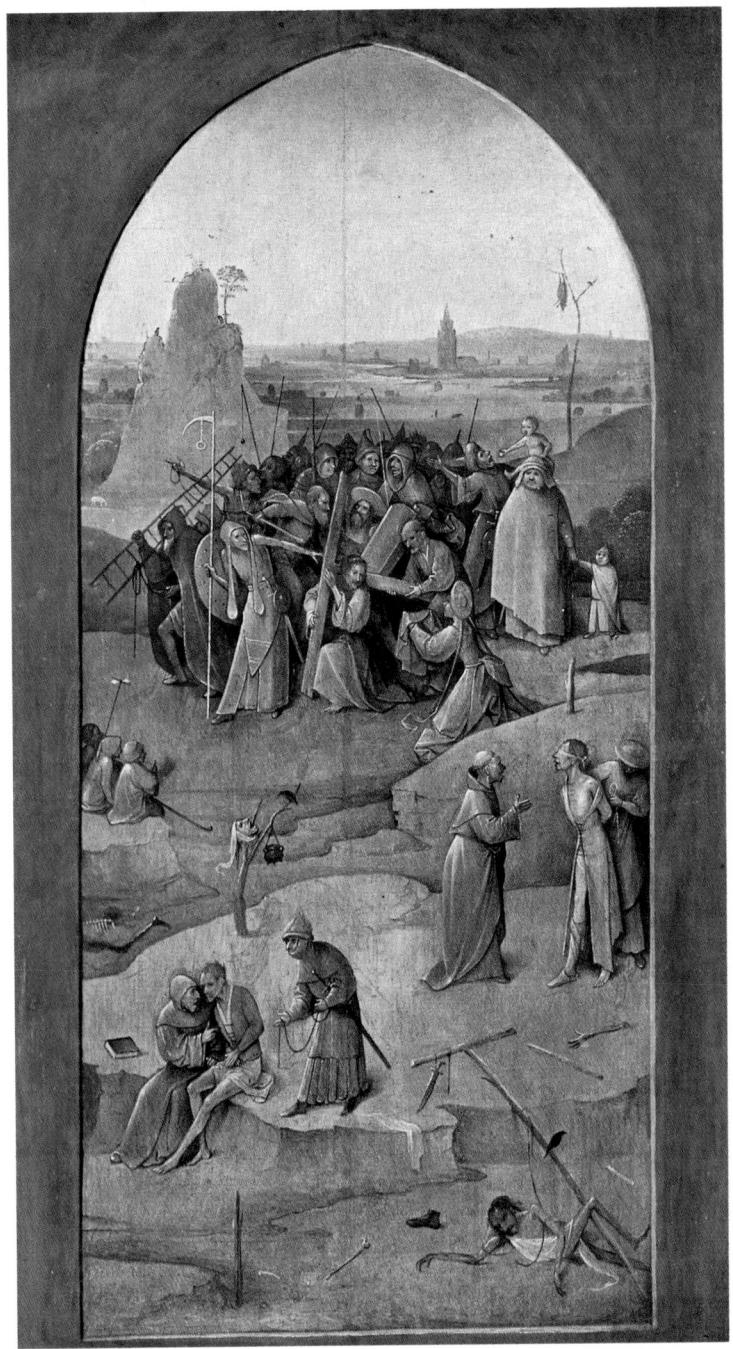

»Where wert thou a while ago, O good Jesus? Why didst thou not come to me then, to succour me and heal my wounds? « To which Christ replied, »Anthony, I was here, but I wanted to see thee fight, and now that thou hast fought the good fight, I shall spread thy glory throughout the whole world. « While the wings of the Lisbon triptych show Anthony tempted and tormented, the central panel thus shows him triumphant.

This last-mentioned episode of the central panel casts light on a frequently misunderstood aspect of Bosch's art. In representing Anthony and other saints tormented and tempted by the Devil, Bosch did not reflect a Zoroastrian dualism, as some scholars have suggested. He did not view the world as a stage upon which was enacted the struggle between equally powerful forces of good and evil, for this would have denied the omnipotence of God. On the contrary, Bosch and his contemporaries knew that God permitted Satan to send tribulations to men for the good

Temptation of St Anthony

Outer wings of the triptych Grisaille on panel, 131 × 53 cm Lisbon, Museu Nacional de Arte Antiga

LEFT OUTER WING:

Arrest of Christ in the Garden of Gethsemane

RIGHT OUTER WING:

Christ Carrying the Cross

I FFT

Temptation of St AnthonyOil on panel, 70 × 51 cm
Madrid, Museo del Prado

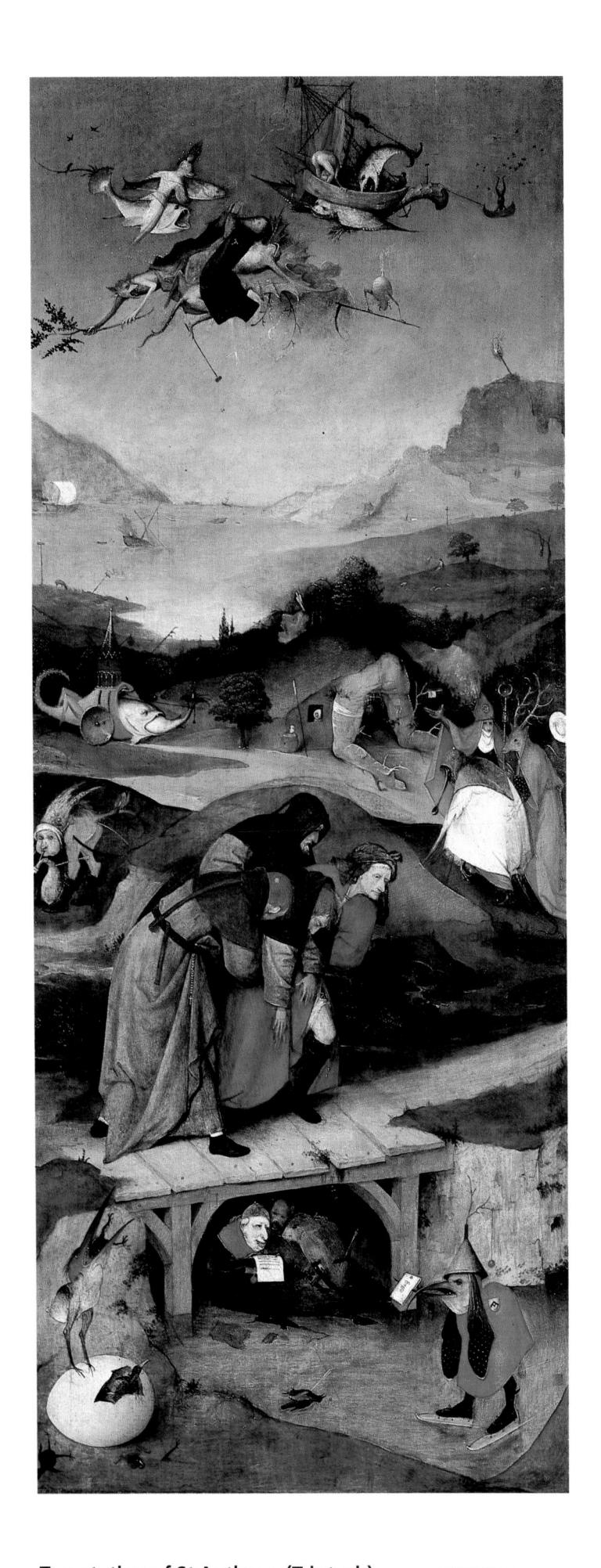

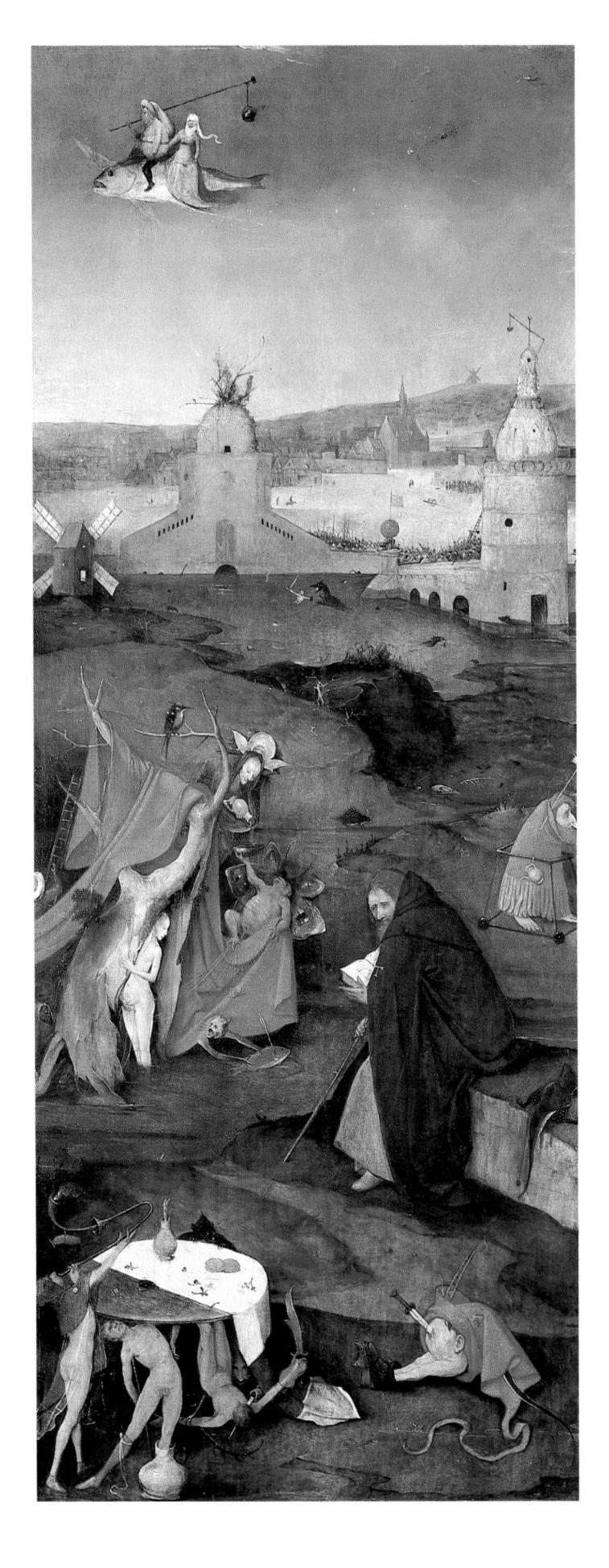

Temptation of St Anthony (Triptych) Oil on panel, 131,5 × 225 cm Lisbon, Museu Nacional de Arte Antiga

LEFT WING: **Flight and Failure of St Anthony** Oil on panel, 131,5 × 53 cm

RIGHT WING: **St Anthony in Meditation** Oil on panel, 131,5 × 53 cm

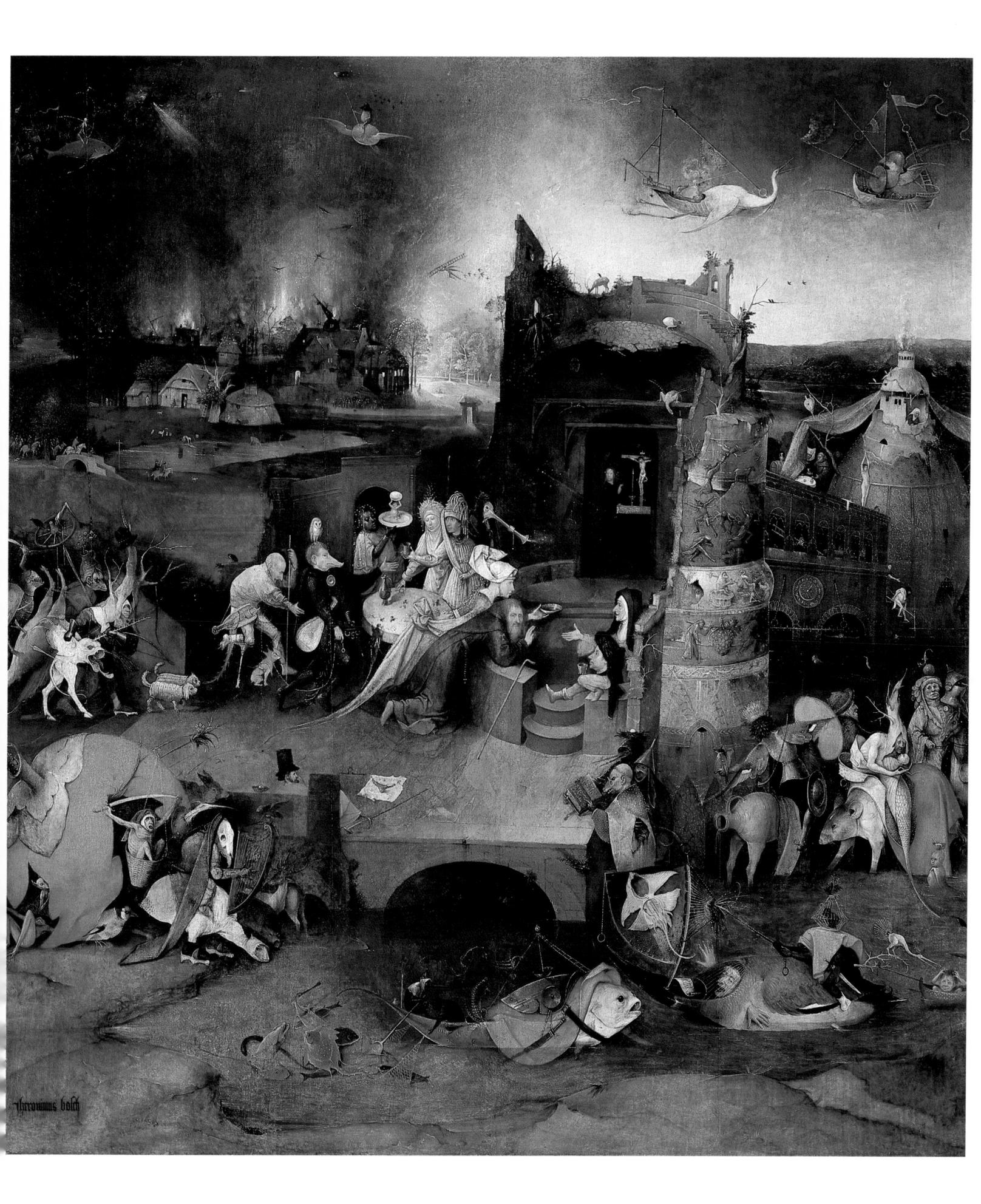

CENTRAL PANEL: **Temptation of St Anthony**Oil on panel, 131,5 × 119 cm

PAGE 94/95: **Demon-Priest and Monsters**Detail of the central panel

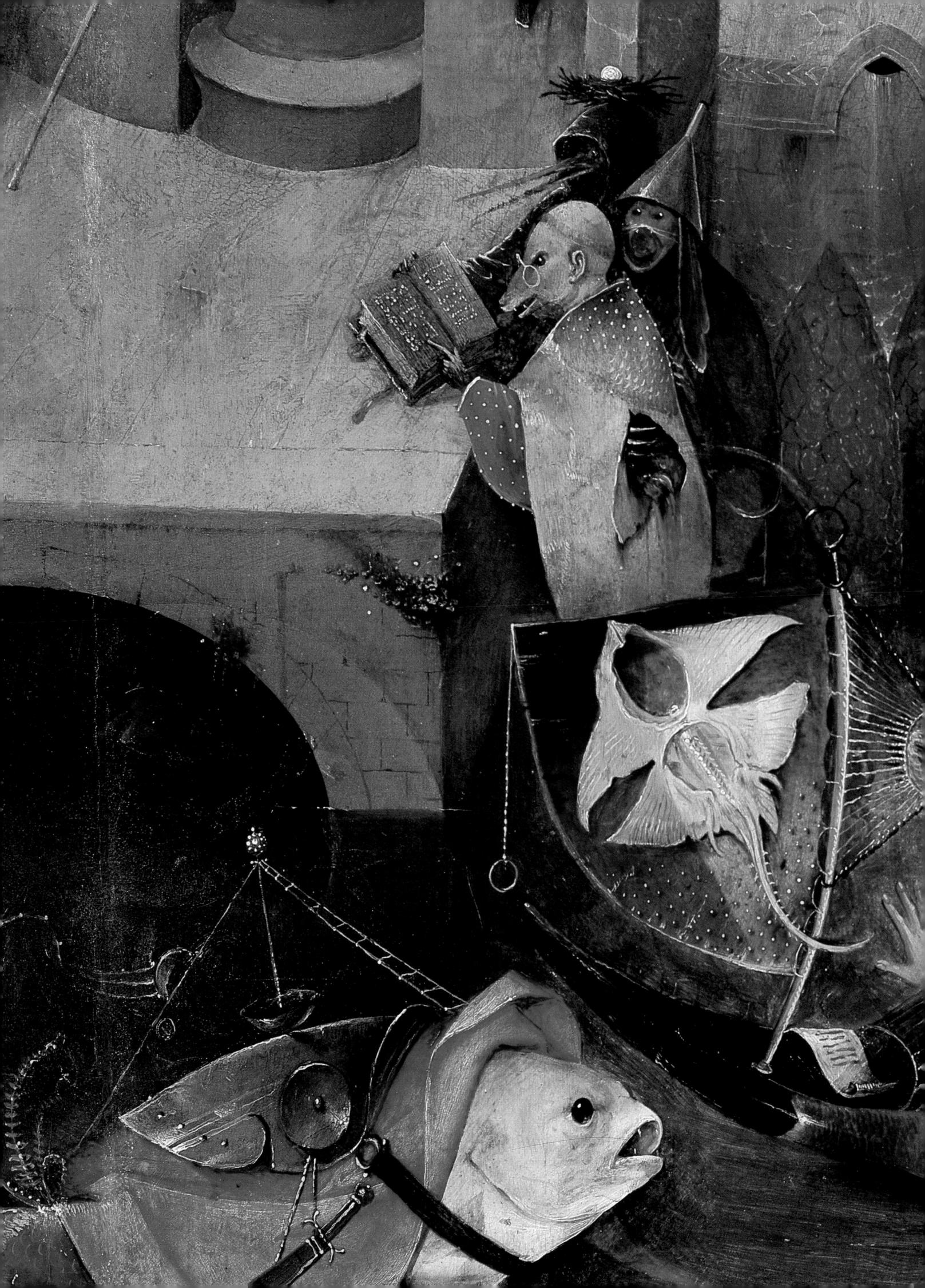

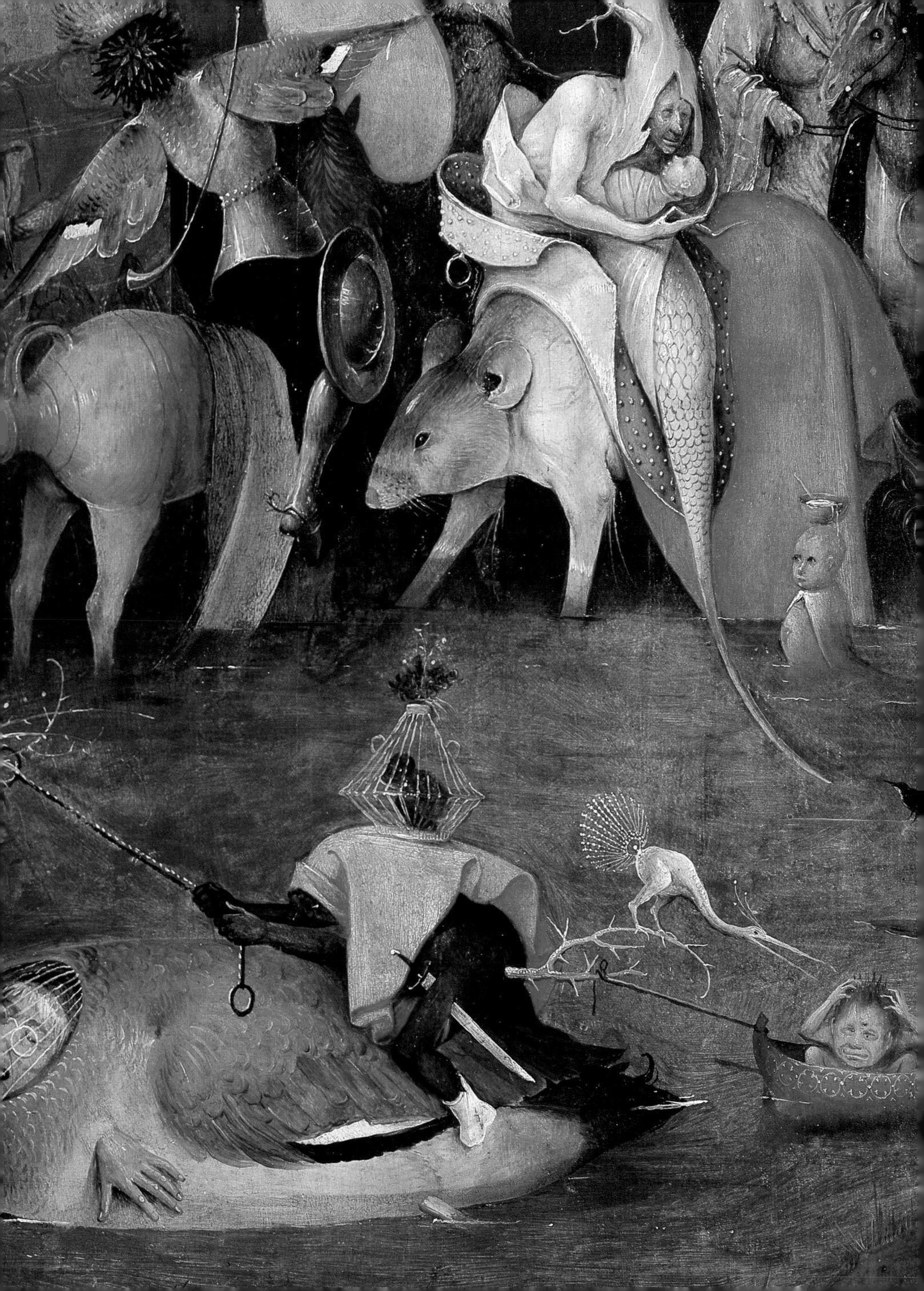

Selected Bibliography:

Combe, Jacques: Hieronymus Bosch, London 1946

Baldass Ludwig von: Hieronymus Bosch, New York/London 1960

Cinotti, M.: L'opera completa di Bosch (Classici dell'Arte, 2), Milan 1966

Tolnay, Charles: Hieronymus Bosch, London 1966

Friedländer, Max Jacob: Geertgen tot Sint Jans and Jerome Bosch (Early Netherlandish Painting, V), Leiden/Brussels 1969

Reuterswärd, Patrick: Hieronymus Bosch, Uppsala 1970

Linfert, Carl: Hieronymus Bosch, New York 1971, London 1972

Marijnissen, Roger-H.: Hieronymus Bosch, Geneva 1972

Orienti, Sandra and René de Solier: Hieronymus Bosch, New York 1979 See also notes on pp. 7, 8, 36 and 51 of their souls. God lets the Devil attack the saints, explains St Augustine, »so that by outward temptation they may grow in grace. « (»City of God «, xx, 8.) In his voluntary submission to these troubles, the man of God achieves the most perfect imitation of Christ.

It is most appropriate, therefore, that Anthony's sufferings are echoed on the exterior of the same altarpiece in two grisaille scenes from Christ's Passion (p. 91). On the left, soldiers overwhelm Christ in the Garden of Gethsemane as viciously as the devils attack Anthony on the reverse, while Judas hurriedly steals away with his thirty pieces of silver. In the other panel, Christ's collapse beneath the weight of his Cross has halted the procession to Golgotha, allowing St Veronica to wipe the sweat from the Saviour's face. The executioners can hardly restrain their impatience at this delay, and the bystanders look on more with idle curiosity than with sympathy. Below, the two thieves confess to hooded friars whose disreputable characters have been deftly portrayed.

The Lisbon triptych thus sums up the major themes we have encountered in the art of Bosch. The spectacle of sin and folly and the shifting horrors of Hell are joined to the images of the suffering Christ and of the saint firm in his faith against the assaults of the World, the Flesh and the Devil. To an age which believed in the reality of Satan and Hell, and in the imminent appearance of Antichrist with the Last Judgment not far behind, the serene countenance of St Anthony looking at us from his haunted chapel must have offered reassurance and hope.

Yet, even as Bosch painted the Lisbon triptych, men were questioning the values for which St Anthony stood, particularly the cloistered life spent in solitude away from one's fellow men. Erasmus and other humanists were already teaching that salvation could be achieved by living and working in this world, while in 1517, only one year after Bosch's death, Luther nailed his ninety-five theses to the door of a Wittenberg church and thereby initiated the events which completely disrupted the old order. Like Luther, Bosch frequently castigated the corruption of the clergy and the monks, but this was an old complaint and it is difficult to discern in his work any rejection of the medieval Church. His visual images were highly original; but they served to give a more vivid form to religious ideals and values which had sustained Christianity for centuries. In Bosch's art, the dying Middle Ages flared to a new brilliance before disappearing for ever.